# WATERCOLOURS
# UNLEASHED

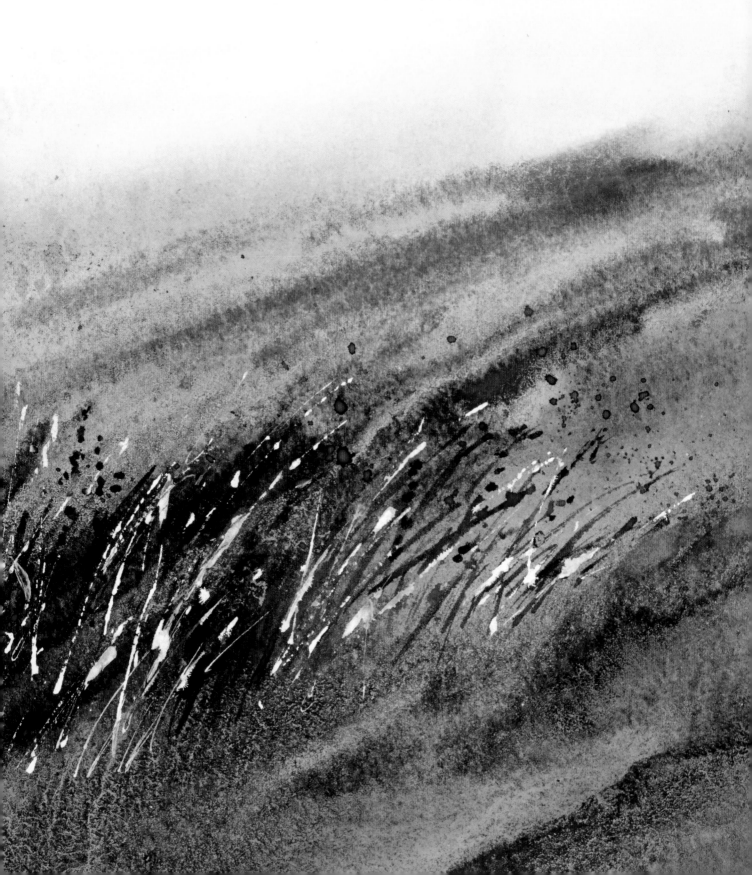

# Dedication

I dedicate this book to my late parents, who
would have been so proud.
To my daughters, Charlotte and Grace, and
especially to my wonderful husband, Alan.

# WATERCOLOURS
# UNLEASHED

Jane Betteridge

Search Press

First published in 2015

Search Press Limited
Wellwood, North Farm Road,
Tunbridge Wells, Kent TN2 3DR

Text copyright © Jane Betteridge 2015

Photographs by Paul Bricknell at Search Press Studios
Photographs and design copyright © Search Press Ltd
2015

ISBN: 978-1-78221-035-1

**Suppliers**
For details of suppliers, please visit the Search Press
website: www.searchpress.com

You are invited to the author's website:
www.janebetteridge.com

Printed in China

## Acknowledgements

Thanks to Roz and the team at Search Press,
for giving me the opportunity to write this
book and for making me so welcome.
To Paul, Juan and especially to Edd, my
editor, for his patience and guidance – I feel
we made a great team. To my friends and
family, who have always been ready to help
and advise and to my loyal students, for their
continued support over the years.

Thanks also to my special friends,
Phyllis Laycock and Peter Chadwick, who
have encouraged me and helped give me
the belief I needed to pursue this project.

Finally, to Peter Saw and Keith Moore,
for getting me hooked on watercolour
when I first started painting.

**Publisher's note**
All the step-by-step photographs in this book feature
the author, Jane Betteridge, demonstrating watercolour
painting. No models have been used.

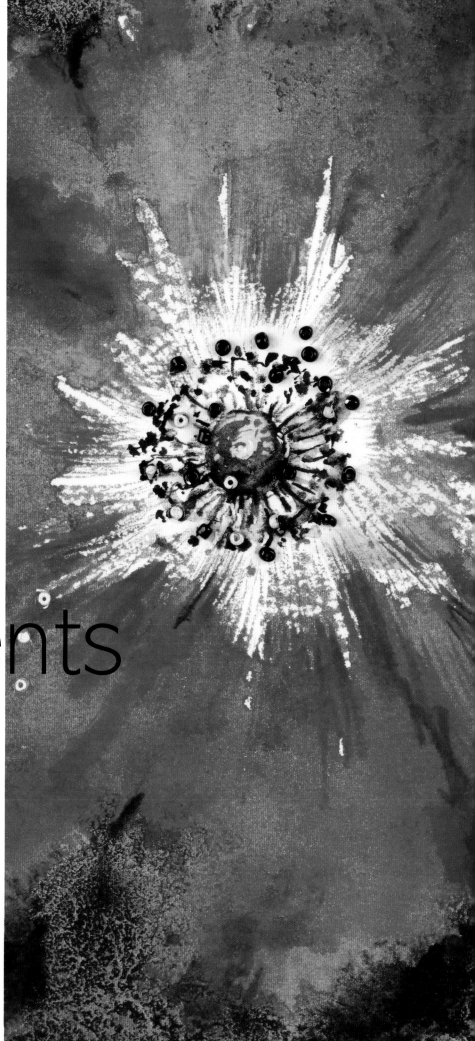

# Contents

# Introduction

The phrase 'watching paint dry' is defined by the Cambridge dictionary as 'an activity that you consider extremely boring'. How wrong this is! Watching paint dry can be extremely exciting, especially when using watercolour. Throughout this book you will see what I mean, as I take you through some innovative techniques and projects.

Watercolour has always been my favourite medium – my passion, no doubt about it. My best work has always been produced using watercolour and now I get chance to share with you all of my tips, techniques, and quirky ways of working which will make all the difference to your work and to you as an artist.

I am going to take this opportunity to go against the idea of 'golden rules'. In my career as an artist, there are no rules, no rights or wrongs. My type of painting is based on feeling and expression, and I hope that you will find your own style through experimenting with what you learn from my book.

First and foremost, do not worry about anything. Painting should never feel like a chore. Do not get frustrated if you are not happy with your work at the first attempt – it is only a piece of paper, so rip it up and start again if you wish. Alternatively, take a step back and look at your work from a different angle or in a mirror. Place it somewhere where you catch a glimpse of it when going about your day-to-day business, and sometimes the part that makes you unhappy with your efforts will become apparent and hopefully rectifiable.

Try not to be too tentative and timid. Free yourself up. Unleash your passion for watercolour by keeping an open mind, experimenting with techniques, and enjoying yourself by trying new ideas. The watercolour medium has a mind of its own and characteristics that bring joy, life and pleasure to our painting. Its unique – and sometimes uncontrollable – properties help bring freedom to your painting and let you work magic on paper.

Join me on this journey of finding new experiences in watercolour. I hope by the end of this book you will see watercolour in a new and exciting light that inspires you to change the way you paint forever.

**Deep in the Forest**
*A combination of watercolour, inks and granulation medium help to give this painting its magical feel.*

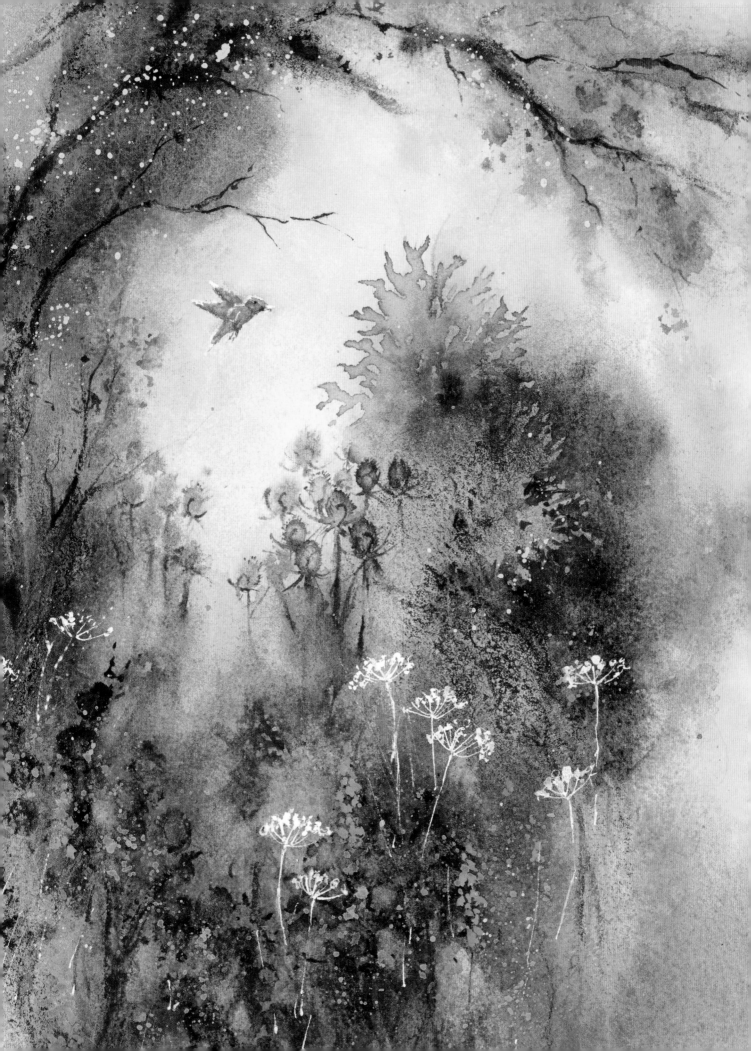

# Materials and equipment

At their best when used swiftly and fluidly, watercolours are the most spontaneous of all painting media. Only a drop of water is needed to begin painting, so you can try to capture a feeling or image while it is still fresh in your mind. Even though it is a great medium on its own, combining it with other materials can achieve some amazing results. Using pre-prepared surfaces that react with the nature of the watercolour pigment can be another exciting way to bring out the best of the watercolour medium.

The following pages explain some of the different materials and equipment that can be used to explore the qualities of watercolour and unleash its potential.

# Watercolour paints

Watercolour paints consist of very finely ground pigments that are bound together in a solution called gum arabic. The gum enables the paint to be heavily diluted with water to make thin, transparent washes of colour, without losing adhesion to the paper. Glycerine is added to the mixture to improve solubility and prevent the paint from cracking. The final ingredient is a wetting agent, such as ox gall, which ensures an even flow of paint across the paper. Some paints have different qualities from others. For example, some granulate (which I like) and some do not. Some are transparent, some semi-transparent and others opaque.

Watercolour paints can be bought in tubes which can be squeezed out on to your palette. These tubes range in size from 5ml up to 37ml. When trying new colours, I always buy a small 5ml tube to see whether I like it before buying the more expensive larger ones. Watercolours are also available in pans, which are solid blocks of paint designed to fit neatly into tailor-made metal or plastic paintboxes, the lid of which usually doubles as a palette when opened out. Colour is released from pans by stroking it with a wet brush. I find that these are fine when working on a small scale but prefer to use tubes when painting bigger pictures so I can squeeze out large amounts of paint.

Watercolours are commonly sold in two qualities – cheaper, lower quality, students' ranges and more expensive, higher quality, artists' ranges. When you first begin to paint in watercolour, it is more economical to use students' quality materials. Once you become more familiar with the medium, you can buy some core colours (see pages 20–21) in artists' quality and gradually replace all of the remaining students' quality tubes with the better artists' quality ones as they run out.

There are several manufacturers that make good quality paints, my favourite being Winsor & Newton. The brand Daniel Smith produces some really unusual highly pigmented and luminous paints – a particular favourite of mine is iridescent electric blue, which also has sparkly bits in it. Another brand, much cheaper but still very good quality, is Shinhan.

## GRANULATING WATERCOLOUR

Some pigments are quite coarse. As they dry, tiny granules of pigment floating in the wash settle in the hollows of the paper, creating a mottled effect.

## TRANSPARENT WATERCOLOUR

Some pigments are transparent, allowing rays of light to pass through and reflect the white of the paper, giving luminosity or brilliance to the colour.

## OPAQUE WATERCOLOUR

Some pigments block the light rays penetrating through the colour. These are called opaque colours. When mixed with other opaque pigments, these colours can become quite dull and muddy.

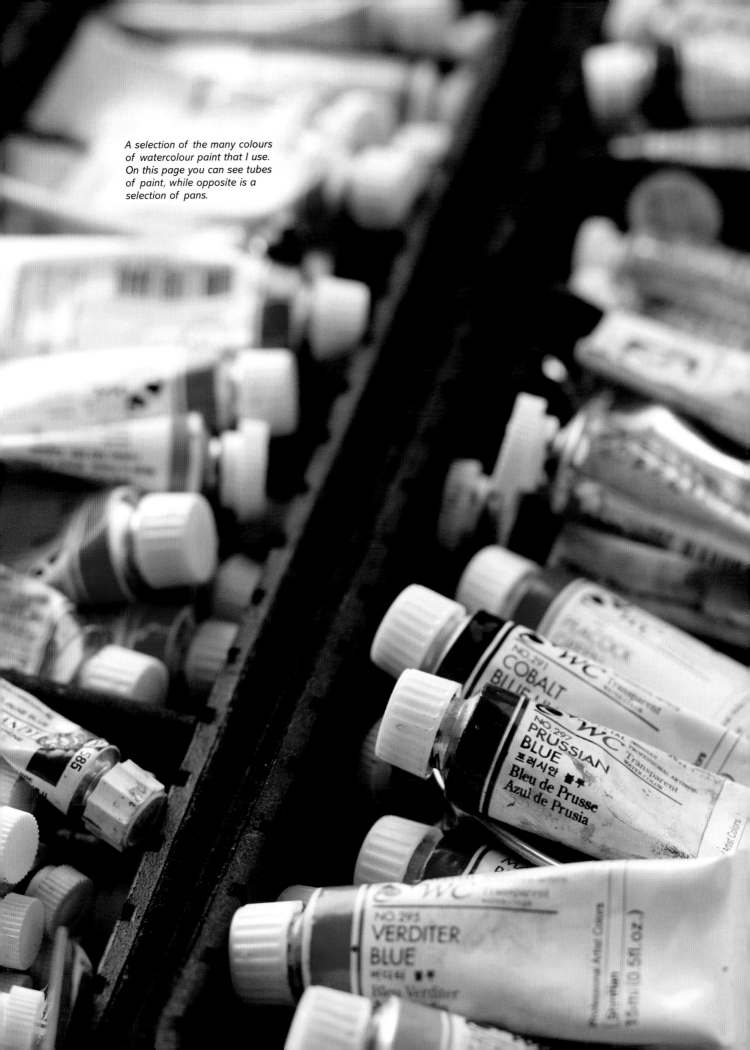

*A selection of the many colours of watercolour paint that I use. On this page you can see tubes of paint, while opposite is a selection of pans.*

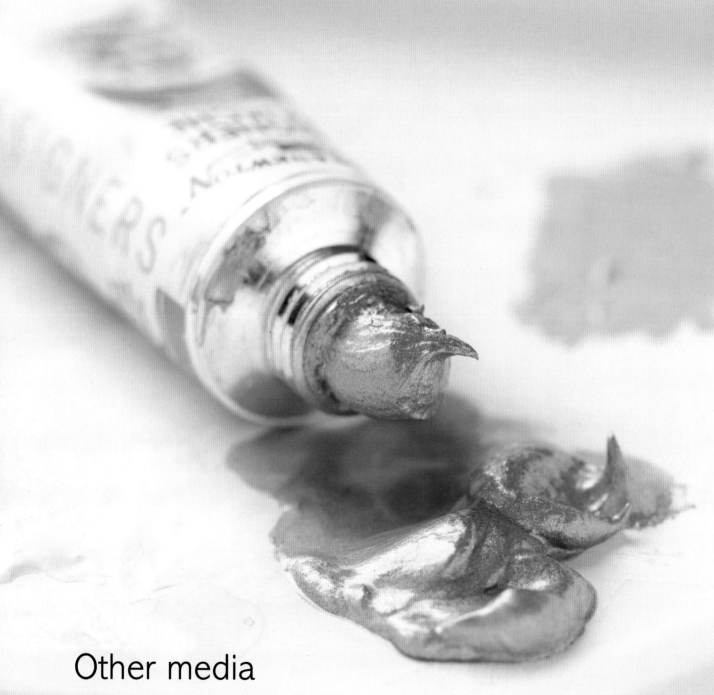

# Other media

## Gouache

I occasionally use gouache paints. Along with its opaque quality, gouache's matt, chalky appearance when dry makes it a quite separate and distinct medium from pure transparent watercolour. Nevertheless, the equipment, supports and techniques are more or less the same for the two media, so they form a natural complement to each other.

When I paint with gouache, it is mainly white that I use, as this can be painted over watercolour if an area needs to be lightened. I also use a little gold, silver or other brightly coloured gouache paints in some of my work when I feel it needs a little bit of help to strengthen the tones.

*Gouache paints, like this metallic gold, have a lovely, rich quality.*

## Inks

Inks add vibrancy, depth and strength to your painting, whether used on their own or when mixed with watercolours. My favourite is acrylic ink, which is made up of tiny speckles of pigment that create interesting effects in a painting. This effect can be further enhanced by adding granulation medium (see page 18).

I use acrylic inks a lot in my work. The white is very strong and covers well while being really thin and easy to use. Sepia and burnt umber are also favourites of mine as they are highly pigmented and, when granulation medium is added, can create lovely speckled effects.

The inks I use in my work – a brand called AW Artists' Acrylic Inks – come in small bottles with droppers, which are ideal for using as a drawing tool or dribbling the ink on to the paper. These inks are water-resistant, and come in a wide range of colours, some of which are translucent and some opaque, such as the white. They are fully intermixable, both with themselves and with watercolour. Look for these qualities in the inks you choose.

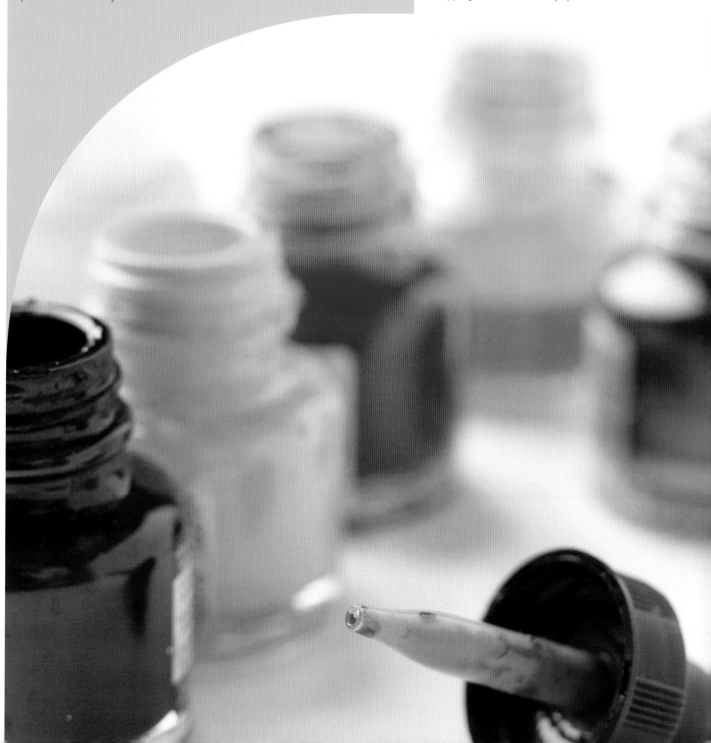

*A selection of some of the coloured inks I use. The pipette, or dropper, in the lid of the bottles, is used for dropping the ink on to the paper.*

# Brushes and palette knives

## Brushes

The smaller the brush, the tighter your work will be. I would always advise you to paint with as large a brush as possible, as this will make your work more loose and free. When selecting brushes, I look for those with a mixture of sable and synthetic hair that keep their point and springiness, last well, and are reasonably priced. I never buy very expensive brushes, as I use them with many different types of painting media and, beyond rinsing and cleaning them, do not treat them as well as perhaps I could. Having said that, I never buy cheap brushes either – they are a waste of money. The SAA and Pro Arte Prolene Plus ranges of brushes have the qualities I like, and they are the ones I have used in this book. Experiment and look for the qualities described above in the brushes you choose.

While I occasionally use a flat brush, I stick mainly to round brushes as I find these more versatile. They hold plenty of water or paint and have a good point too. I use a range of sizes from 2 to 16 along with a really big wash brush and a size 1 rigger. Riggers have long fine hairs and are especially useful for painting fine lines and delicate things such as stamens and tree branches. I also have a small hog hair brush for scrubbing out, and a slanted chisel brush for lifting stems or distant tree trunks out of background washes. Flat brushes are very useful for sharp edges, flat petals such as poppy petals, and also ideal for reflections when dragged down in a wet wash.

Whatever brushes you choose, cleaning your brushes properly after use, especially the metal ferrule, will keep them in good condition longer. I save old brushes to use with masking fluid as this ruins brushes and it is not a good idea to use your best brushes with this medium.

## Palette knives

Palette knives are available in plastic and metal, and are mainly used in oil painting and acrylics for applying the paint in bold large strokes. I find them useful in watercolour painting for various reasons: painting straight lines and for flicking paint on to the paper – something I do a lot in my backgrounds. I also use a palette knife to flick and spatter masking fluid when painting a subject that requires either a bit of sparkle or a speckled effect. When I am preparing a surface, I use a palette knife to apply the gesso.

*A selection of the brushes I use.*

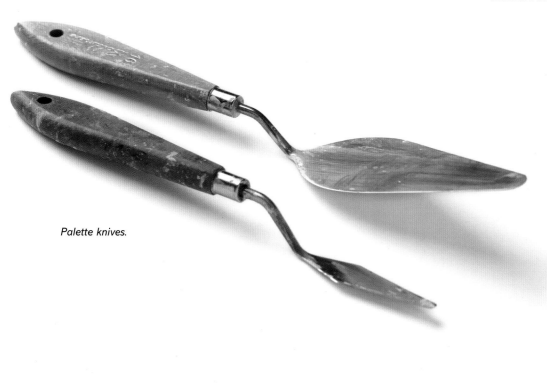

*Palette knives.*

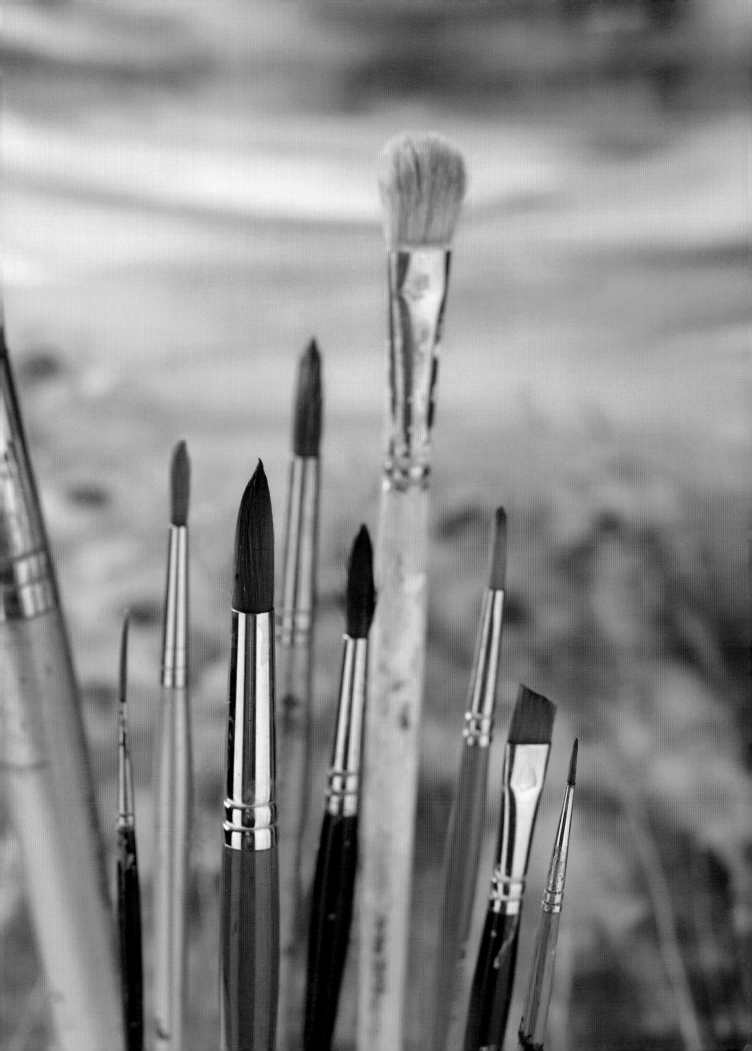

# Materials for adding texture

**Contour medium** This water-based medium, made from gutta-percha – a natural form of rubber – is normally used for outlining a design on silk before silk paint is applied. I use it in my work to add texture and interesting marks in various colours. The paper must be bone dry when receiving contour medium and it is best left overnight to dry.

**Salt** I use salt an awful lot when working; it is really useful in adding vitality and sparkle to your work. It is a useful tool to use when you have quite a plain area in a painting that needs a little something. It is also excellent for textural effects on stone walls and roofs and for adding a bit of life and sparkle to water and snow scenes.

**Sand** When working on a surface primed with gesso (see page 18), I sometimes add sand when I want to create a lot of texture. This is just sprinkled on top of the gesso and then worked in. It is great for seascape foregrounds, rocks and stone.

**Beads** Flower paintings really come to life with the addition of some tiny seed beads or seed pearls to the centres. Usually I use very tiny ones, but I will use slightly larger beads if they are an interesting shape and colour. I stick them to the surface with white glue to add interest to foregrounds, suggesting flowers and other detail. Sequins are also useful for certain subjects.

**Shells** Shells are great for sticking on seascape paintings. You can add texture by breaking them up and sprinkling them on to a surface covered with gesso, or you can stick them on individually using superglue or white glue. Really tiny shells that are ideal for leaving whole without looking too big can be sourced on the internet.

**Leaves** I sometimes place fresh leaves on top of wet paint. When the paint has dried and you remove the leaf, it leaves impressions of lovely veins and other details from the leaf's surface and edges in the paint. This is ideal for suggesting background foliage. I also sometimes paint the backs of interestingly marked leaves and stamp them on to my work.

**Seeds** Seeds of all shapes and sizes can be used to add interest to a piece of work. I either leave them in their natural organic form or paint them with acrylic ink if I require a particular colour. Like beads, seeds can also be stuck on top of a painting with white glue or superglue.

**Leaf skeletons** Made from a fine synthetic material, these represent the skeletal form of leaves – the interesting veins and markings. These are very useful when working on a textured painting or collage. They can be bought quite cheaply from craft shops or online and come in natural shades as well as coloured or with metallic effects. I use white glue to attach these to the painting surface.

**Gauze/hessian/lace** Material that can be frayed, stretched or made ragged is great for sticking on to a surface primed with gesso to create interest and texture. It can also be added to wet paint in different areas of your work to create fascinating marks. Netting from bags of fruit is great for this too, as well as lace, which can suggest flower shapes.

**Cotton thread** I sometimes use separate strands of cotton thread in the same way as gauze – by taking different thicknesses and dropping them into a watercolour wash. When dry, you can brush them away, leaving lovely marks suggestive of branches and grasses in the paint.

**Plastic food wrap and cellophane** Plastic food wrap placed on top of a watercolour wash leaves fantastic interesting shapes and textural marks. It has to be left to dry for a couple of hours to achieve the best results. Similarly, cellophane placed on top of wet paint creates other marks that will add interest to your work.

**Tissue paper** Tissue paper, either crumpled or smooth, can be added to a painting and stuck down with watered-down white glue. The paint will make interesting marks when it seeps into the creases of the dry tissue paper. An underpainting can be applied to the watercolour paper first, and then covered all over with the glue once dry. The glue dries clear, so you will be able to see the underpainting through it. You can then paint on top of the tissue paper, and allow some of the underpainting to show through.

**Textured wallpaper** You can get wallpapers that have fantastic textures, ideal for stamping into wet paint to leave different markings. I sometimes stamp specific shapes taken from textured wallpaper – a tree, or foliage shapes, for example – on to a dry painting.

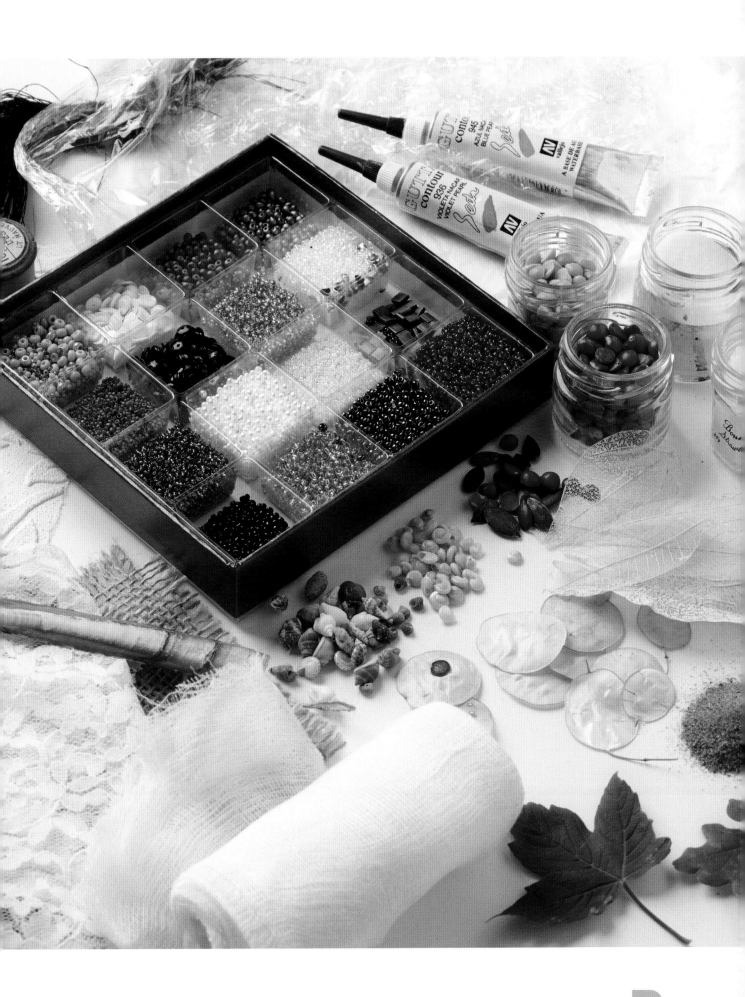

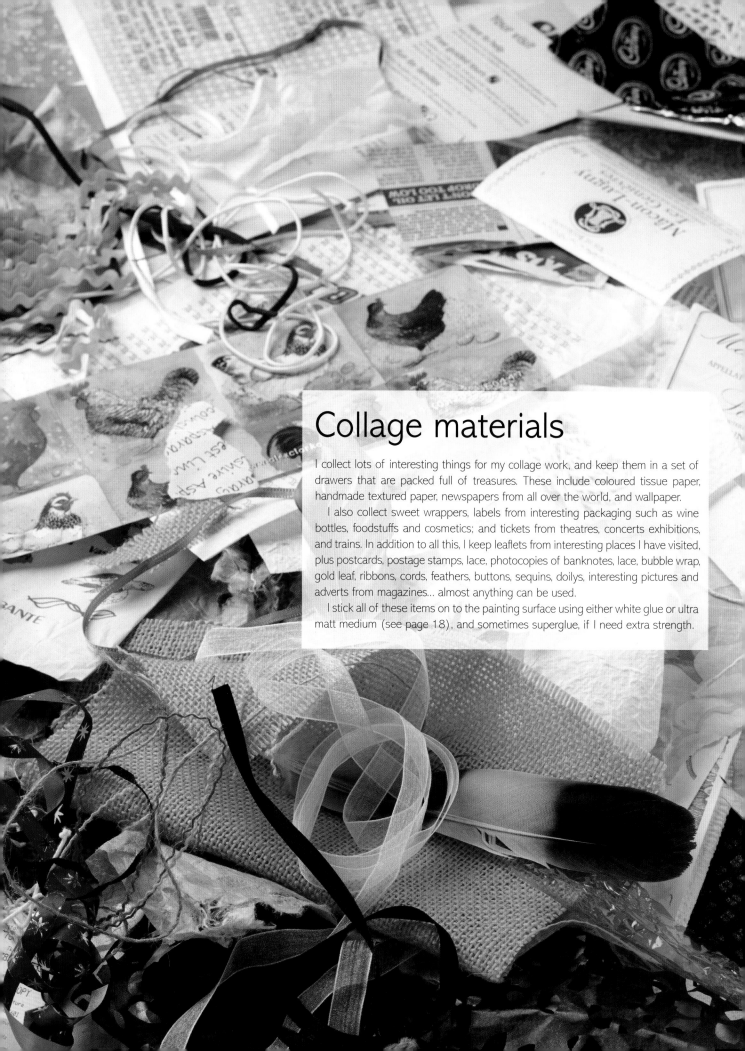

# Collage materials

I collect lots of interesting things for my collage work, and keep them in a set of drawers that are packed full of treasures. These include coloured tissue paper, handmade textured paper, newspapers from all over the world, and wallpaper.

I also collect sweet wrappers, labels from interesting packaging such as wine bottles, foodstuffs and cosmetics; and tickets from theatres, concerts exhibitions, and trains. In addition to all this, I keep leaflets from interesting places I have visited, plus postcards, postage stamps, lace, photocopies of banknotes, lace, bubble wrap, gold leaf, ribbons, cords, feathers, buttons, sequins, doilys, interesting pictures and adverts from magazines... almost anything can be used.

I stick all of these items on to the painting surface using either white glue or ultra matt medium (see page 18), and sometimes superglue, if I need extra strength.

# Painting surfaces

## Paper

Watercolour paper is available with three different surfaces. The first surface texture is Rough, which is great for achieving textural effects with paint alone. The brush can skim over the textured surface to just catch the top of it with paint and leave broken textural marks. It is good for catching the effects of light on water and texture on brick and stone work. A paper with a Hot-Pressed (sometimes abbreviated to HP) surface is completely smooth and is used mainly for very detailed work, such as botanical painting or pen and wash. Pen nibs glide over this paper easily without snagging, enabling fine details. The third surface type is Not surface – short for 'Not hot-pressed' – which sits between the two extremes and has a slightly textured surface. Not surface papers are ideal for most subjects.

Watercolour paper can be bought in loose sheets, packs or blocks. Blocks are good when painting *en plein air* as the edges are gummed all around and this stops cockling and also acts as a board too.

Most watercolour papers are both internally and externally sized. Sizing reduces the absorbency in the paper. Without it, the paper would act as if it was blotting paper. The correct side of a paper is the side where the watermark can be read more clearly. In my experience, however, there is not really much of a difference and I use both sides.

I never stretch paper as I find this too time-consuming, so for most of my work I use the heaviest paper I can find, which is 640gsm (300lb) in weight. It withstands lots of water and does not cockle. Watercolour paper is also available in lighter weight, such as 300gsm (140lb) and 165gsm (90lb). Anything under 640gsm (300lb) in weight really needs stretching if you use a lot of water in your painting, as I do.

My favourite paper is made by Saunders Waterford. It has a Not surface and is available in two shades, a normal creamy colour and a pure white called 'high white', which I prefer. Experiment with different brands. Once you find a paper with the characteristics that suit your work, you will likely stick to that particular brand.

## Mount card

I sometimes paint directly on mount card; it is very strong and versatile. If used in this way, the card has to be prepared (primed) with gesso beforehand. This forms a surface to take the paint.

However, mount card is not just a substitute for watercolour paper: it is also another way of adding variety to your painting surfaces. Torn-off pieces of mount card can be quite useful for making marks and assisting with your painting. You can use it to scrape away wet paint to suggest rocks, or use it to provide a straight edge, for example.

# Other equipment

**Granulation medium** This gives a mottled, grainy effect to colours that do not normally granulate and emphasises the granulation in colours that do. You can add this liquid to your water when mixing the colour or dribble it directly on to wet paint on the surface using a pipette. This effect will add interest and dimension to otherwise flat areas in a painting.

**Masking fluid** This latex material is used to mask certain parts of a painting to protect those areas from receiving paint when applying a watercolour wash. It comes either tinted or colourless in plastic bottles and is best applied with a rubber-tipped shaper or old brushes. Masking fluid is available from several manufacturers. My favourite is called Pebeo drawing gum. This is grey in colour, easy to apply and does not thicken up. I find it kinder to the paper than some others.

**Gesso** I sometimes work on a surface primed with gesso. It is meant to prepare canvasses for acrylic painting but some really unusual effects can be achieved when painted over it with watercolour. It can be applied either very thinly for a smooth finish, or more thickly for a textured result.

**Ultra matt medium** I use this for sticking collage materials and other items on to my painting surface. Ultra matt medium adheres well and is waterproof. It can also be mixed with acrylic paints to increase the flow and extend the drying time of the paint.

**White glue** This is very useful for sticking down materials for adding texture, such as beads, seeds and skeleton leaves.

**Hair dryer** A hair dryer is useful to speed up the drying process of a wash. However, I think it is important not to use one immediately after applying the wash, because the pigment requires a certain amount of time to mix and mingle on the paper to work its magic. Wait until the paint has lost its sheen.

**Spray bottle** A fine spray bottle is a very helpful piece of equipment, and I always keep one to hand. When working wet-in-wet, if your paper starts to dry a little bit, a quick spray can save a wash. I apply paint quite thickly sometimes and like to make it move around the wet paper. This can be achieved by spraying to push the paint – it can be quite forceful.

Paper can be dampened by spraying water on to it rather than using a wash brush. It will not cover as well but can sometimes create an unusual effect because of this. If an area of a painting is a little too heavy, try spraying it to dilute the pigment and mingle it into its surroundings. One other very useful tip is to use a spray bottle to spray the paints in your palette to moisten the dried pans which aids easier mixing. This is something I do first of all every painting session.

**Palettes** There are lots of different palettes available in all shapes, sizes and materials. One of my favourites is a metal one with a lid that works as an additional palette when opened out, and pans for paint, which I fill up from tubes (much more economical). This is very handy when painting *en plein air* as it is less messy when transporting. When working on a larger scale, I use a large plastic palette with large separate mixing sections or, for really big work, individual dishes. The shape, size and design of the palette you choose really is a matter of individual taste.

**Pipette** I find pipettes very useful. I add water to my paint with one when mixing up my colours and also to dribble granulation medium into paint and ink.

**Kitchen paper** A roll of kitchen paper is vital to me when painting. I use it to mop up excess water and also to lift out paint sometimes. It can be used as a mask when spattering to prevent any marks straying into areas you wish to keep clear.

**Masking tape** As well as taping paper to a board, masking tape is very useful to mask an area when painting a straight line such as a horizon level or water. It is important to take a bit of the stickiness off first by sticking it down on some pieces of scrap paper several times before using it on your work, as if it is too sticky it could tear the paper when removed.

**Water pots** I change my painting water regularly. I use old pickle or jam jars for water and usually use four at a time, standing on an old plastic chocolate tray. I have folding plastic pots for when I paint outdoors.

**Sponge** A natural sponge's markings are non-uniform, which gives a much more natural effect than a synthetic sponge when used for applying paint for foliage or rock patterns. A sponge is especially useful when painting woodland scenes – a little touch of opaque lemon yellow sponged here and there suggests a fresh, springlike look to subjects like bluebell woodlands.

**Scissors** Really sharp scissors are important for cutting out and trimming collage materials.

## TIP

I do not use an easel very often, as I like to work mainly flat or at a slight tilt. However, when painting outdoors I use a lightweight metallic folding easel that fits into a shoulder bag for ease of carrying.

**2B pencil** I find this the ideal pencil for drawing and sketching – not too heavy but strong enough to see outline drawings when painting.

**Putty eraser** Unlike harder plastic erasers, putty erasers are not harmful to watercolour paper. They can be pulled into different shapes if you need to rub out very fine detail.

**Fine permanent black pen** Ideal for sketching or using in pen and wash work, a pen can also be used to work back into paintings to highlight any details.

**Ruler** If you need to draw a line, then use a ruler and make it a straight one. The plastic see-through ones are what I like to use.

**Roller** Brilliant when working on a large scale, a roller can be used to apply paint or gesso. When sticking down objects in collage work, it is useful to place some greaseproof paper or baking parchment over the top of the objects that need sticking and then use the roller over it to help press them down securely.

**Pot lids** Ideal for holding glue, inks, gesso and other liquids. Just throw them away when you have finished.

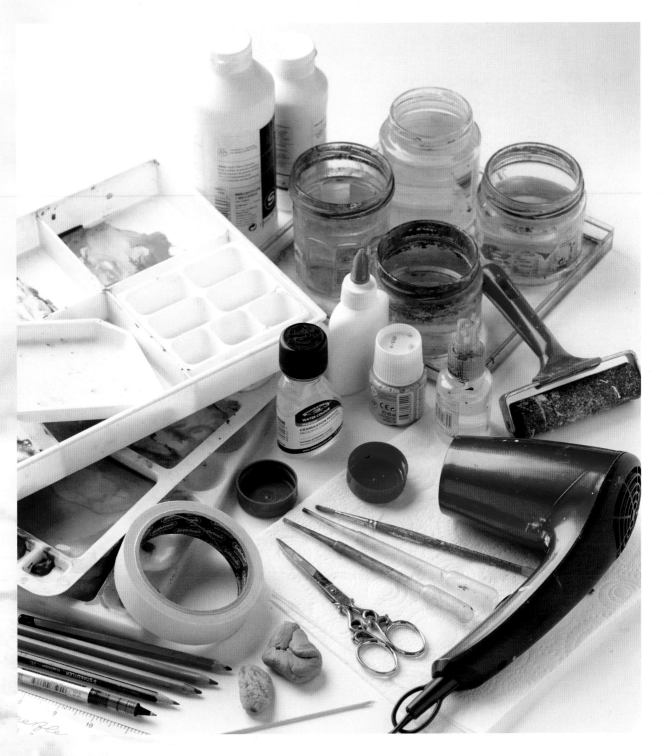

# Colour

Colour choice is very personal. We are all different, and just as we choose colours for our clothes and decoration in our homes, the colours in our paintings will reflect a little of our own personality.

Well-chosen colours can make all the difference between a painting's success or failure. Some artists have a natural and instinctive response to the subtleties of colour and appreciate its complexities, while others rely on a more analytical approach.

The differences between artists' palettes is what gives the world of art such huge variety. It is up to you to experiment and see what colour combinations suit your taste and style.

## Your basic palette

My basic palette is continually changing. I am always actively seeking new colours and get really excited when I discover one I have not tried before. However, colours I know I will never stop using and will remain in my palette are the following:

**Green-gold** This is one of my favourite colours, vibrant and equally useful for flower painting, foliage and landscape work. This is a transparent and non-granulating paint.

**Bright violet** A bright, luminous paint. It is such a beautiful colour that I only rarely add any other colours to it.

**Indigo** The very deepest of the blues, indigo is opaque and does not really granulate. I use it when I need a really dark mix, mainly in the backgrounds of flower paintings. When painting white flowers, an indigo background makes them appear even whiter.

**Winsor yellow** A semi-transparent paint, when well-diluted this is a very subtle and warm glowing yellow; yet when mixed with less water it is very vibrant. This makes it a good all-round yellow, useful for everything. It is also good to mix with blues to make vibrant greens.

**Alizarin crimson** This paint is transparent and non-granulating. I use it for flowers and autumn foliage. When mixed with blues, it produces some lovely purples.

**French ultramarine** This is great for skies and, when mixed with yellows and browns, for making greens. It is transparent and it granulates too.

**Raw sienna** I use this transparent, granulating paint for lots of things. It is brilliant for glowing skies, and with a touch of added blue, distant fields. Raw sienna can be used as a first wash for tree trunks, to which darker colours are added on one side, leaving the raw sienna showing through where light is catching. It is also fantastic for stone and brickwork on buildings.

**Bright rose** Another fantastic luminous colour that adds 'zing' to your work. I use it mainly for flower painting and sometimes tone it down with a touch of blue.

**Burnt sienna** Great for autumn leaves and foliage, burnt sienna is transparent and great for mixing with other colours (such as French ultramarine) to make interesting browns. Like raw sienna, burnt sienna is great for tree trunks and background washes.

**Scarlet lake** I do not use a lot of red in my work, but this is a good semi-transparent pillarbox red that I use mainly in flower painting. I do not often mix it with other colours.

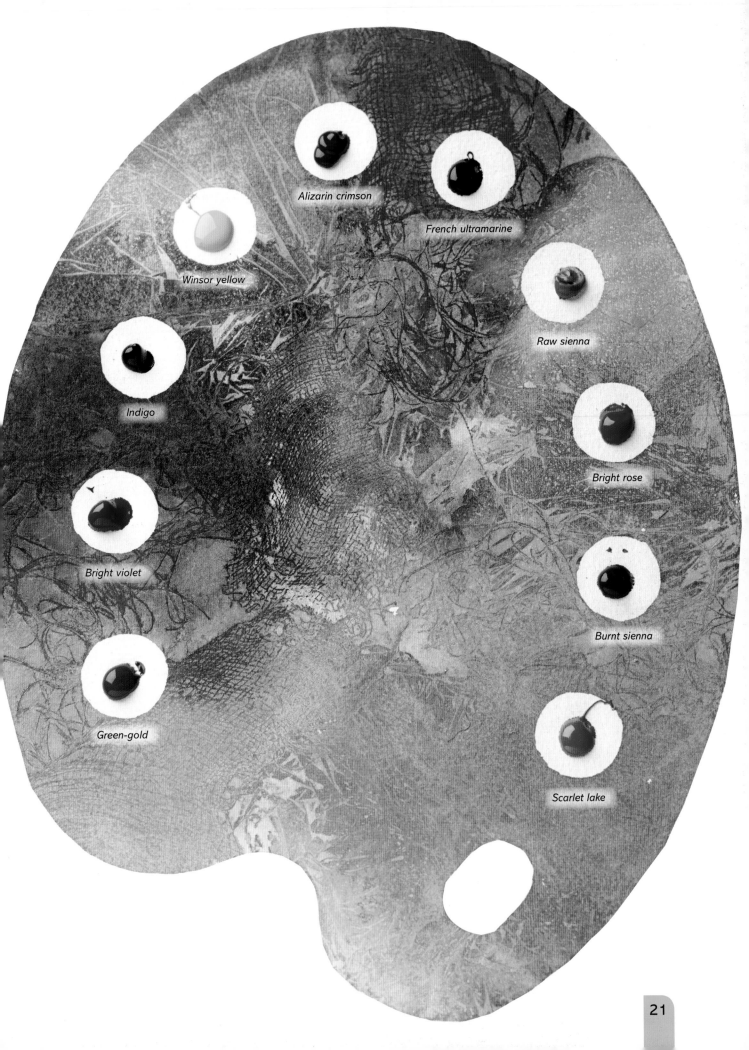

Alizarin crimson

French ultramarine

Winsor yellow

Raw sienna

Indigo

Bright rose

Bright violet

Green-gold

Burnt sienna

Scarlet lake

# Other colours

I must have sixty or so colours in my studio and I love nearly all of them. At some time or another, these extra options have proved perfect to have to hand. I find that I have just the colour I'm looking for, even if I have not used it for ages. Some of my favourites additional colours are:

**Marine blue**  This is a blue that errs slightly towards green, and as a result, is great for seascapes. It is semi-transparent.

**Quinacridone gold**  This is a transparent vibrant gold that I use in landscapes, skies and flower painting.

**Horizon blue**  This is a really bright turquoise colour which works well for contemporary landscapes. It is opaque so does not really mix well with other colours.

**Cobalt violet**  A lovely subtle pink-violet, this is great for flower painting and bluebell woods when mixed with cobalt blue. It is semi-transparent and it granulates.

**Cobalt green**  This is a lovely unusual turquoise colour that I use in lots of paintings where I want to add a bit of unexpected interest to a particular place. It is semi-transparent.

**Light red**  Light red is very useful for stormy skies, brickwork and stonework when mixed with a touch of French ultramarine. It is semi-opaque and granulates well.

**Iridescent electric blue**  A vibrant shocking blue that contains sparkly bits which make it wonderful for water and skies.

**Permanent mauve**  This is great for flowers and landscape hues. It is semi-transparent and granulates extremely well.

**Olive green**  I like olive green because, to me, it is just how you would want a green to be if you had mixed it yourself. It is semi-transparent. I use it a lot in landscapes and flower painting.

**Cobalt blue**  A shade lighter than French ultramarine, cobalt blue is ideal for skies and seascapes. Like cobalt violet, it is semi-transparent and granulates.

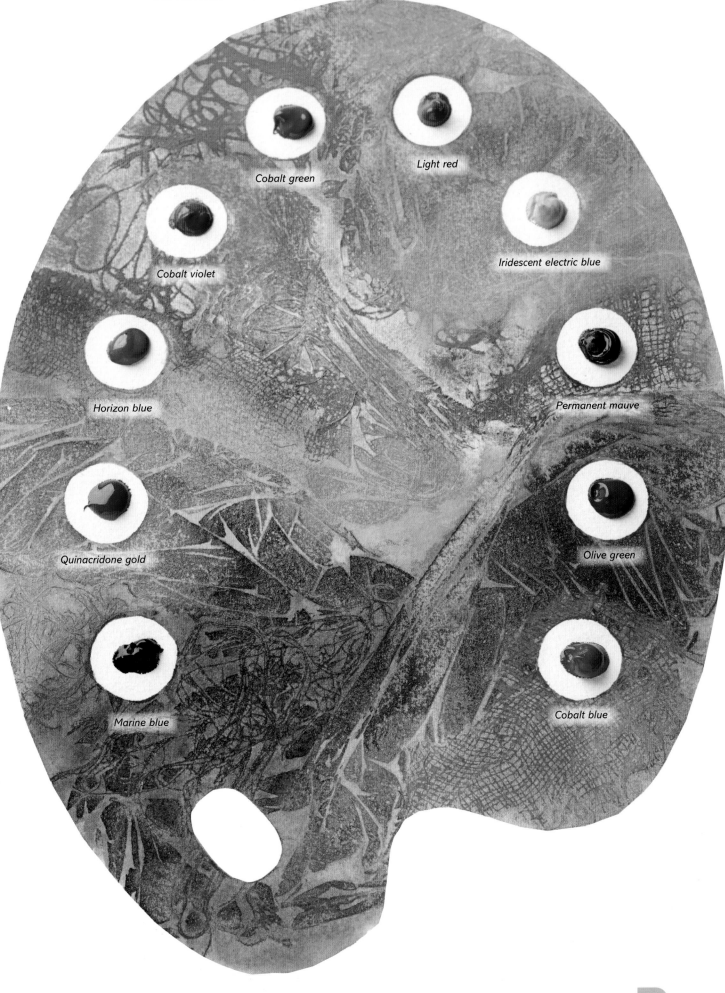

Cobalt green

Light red

Cobalt violet

Iridescent electric blue

Horizon blue

Permanent mauve

Quinacridone gold

Olive green

Marine blue

Cobalt blue

# Colour theory

The colour wheel – as shown opposite – is an arrangement of colours which helps the artist to see at a glance the relationship between the colours and the effect they have on one another. Some colour terms you may come across are:

**Primary colours** The three colours yellow, red and blue cannot be mixed from other colours. They form the basis from which all other colours are mixed.

**Secondary colours** Violet, orange and green are the three secondary colours, which can be created by combining two primaries.

**Tertiary colours** Mixing a primary colour with a secondary colour adjacent to it – blue with green or red with violet for example – will produce a tertiary colour. Red can be combined with its neighbour to the right (orange), to get red-orange. If you combine red with its neighbour to the left (violet), you get red-violet. By adjusting the proportions of the primary and secondary colours you use, you can create a wide range of subtle tertiary hues.

**Complementary colours** Any two colours that lie opposite one another on the colour wheel. When used adjacent to each other in a painting, the intensity of each of the colours is heightened. Purple will look more intense next to yellow, for example. The same is true for green and red, and blue and orange, amongst others.

**Colour temperature and recession** Colours help with perspective in a painting. Cool colours such as blues, blue-greens and greys recede into the background and make things look more distant. This effect is called recession. Warmer colours – including reds, oranges, warm browns and yellows – appear to come forward and so are best used in foregrounds.

## TIP
Recession applies to soft edges and hard edges too: soft edges appear to go backwards, while hard edges come forward.

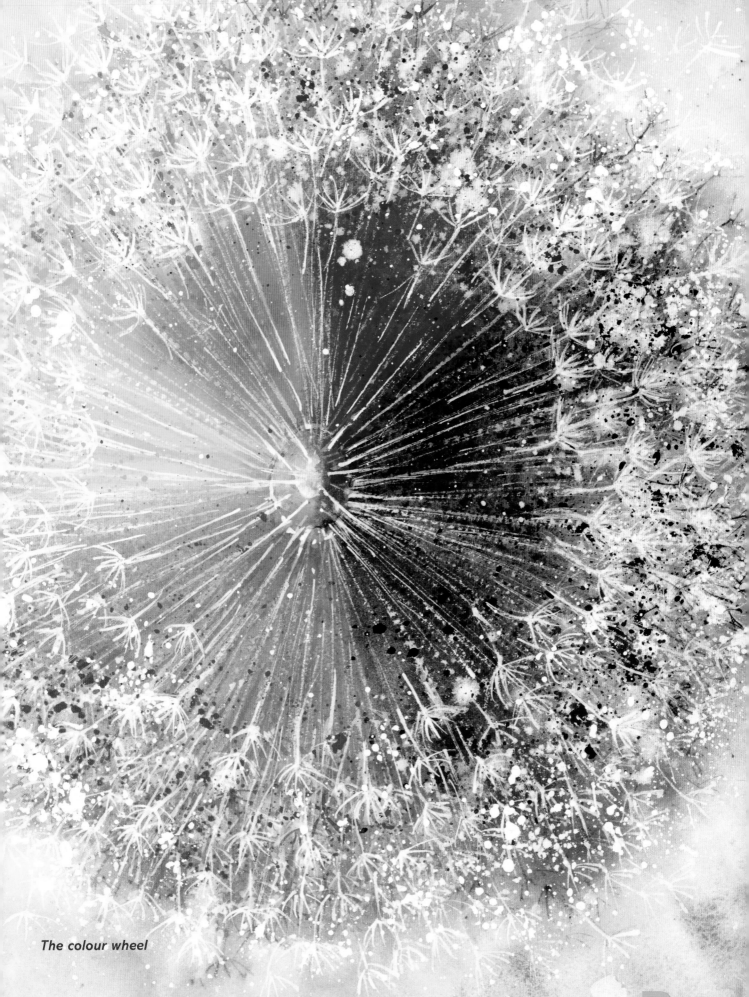

*The colour wheel*

# Preparing paints

As their name suggests, watercolour paints are mixed with water to make them workable. The method differs, depending on whether you use tubes or pans. As the paint dries it will become slightly lighter, so prepare your wells of paint slightly stronger than you want the finished effect.

## Tubes

Watercolour paint in tubes is fluid, so it is quick and simple to mix up.

**1** When using tube paints, simply squeeze it out into a mixing well in your palette. Use about as much as you would toothpaste on your brush.

**2** Using either a pipette or the brush, gradually add clean water and work it into the paint with your brush. I always aim to mix my paint to the consistency of single cream, especially if working on wet paper as this will further dilute the paint even more.

## Pans

Pans are dry and compact. This makes them ideal for transporting, if you are painting away from your studio, but it does mean preparing paint from pans takes longer than from tubes. Use old brushes when mixing from pans as it can wear out brushes over time.

**TIP**
Use a spray bottle to moisten the pans.

**1** If using pans, you will need to work the colour into a liquid pool in a mixing well and build it up. Wet the brush and gently work water into the pan.

**2** Lift the paint over to the palette to build up a small well of colour. Once the consistency is that of single cream, the paint is ready to use.

**3** Test the paint on a scrap piece of paper to check whether it is the strength of colour required. You will also be able to see if the mix flows or if it is too thick or thin. You can add more paint or more water to the prepared well to adjust the consistency if it is not correct.

# Mixing colours

With practice and experience, mixing and adjusting colours becomes second nature to an artist. Some artists mix three or four colours together to get the colour they are looking for, but care must be taken. The more paints you mix together, the more likely you are to get a muddy mix.

Check the translucency of your paints. As a general rule, paints stay clean and fresh-looking if transparent colours are used. If semi-transparent and opaque colours are mixed together, they can muddy a mix.

1 When mixing two colours together, a natural effect can be achieved by mixing them very loosely in the palette. Starting with the lighter colour; place one prepared colour in the well, then add the other.

2 Use the brush to draw the colours together. Let the colours merge partially and naturally in the well as shown, rather than scrubbing them together into a uniform hue.

3 Lift the colour out of the palette and brush it on to the paper where further merging will appear, especially if working wet-in-wet. By not completely mixing the colours in the well, you get the benefits of seeing the individual colours and also the colour they make when merged together. This helps keep your painting fresh and not flat-looking.

**TIP**
Never be tempted to mix white gouache in with a mix to lighten it, as this will simply make it denser and opaque. To lighten watercolours just add more water.

## Some useful colour mixes

These pages show some of my favourite mixes. However, the list of potential colour mixes is huge; so I tend to ad lib, adding colours to washes as and when I think they are needed.

If a colour is a little too bright, it can be toned down by adding its opposite on the colour wheel (see page 25). Just a little touch of red to a bright green mix, for example, will tone it down without creating a muddy mix. To keep my colours really fresh, I prefer not to mix more than two colours together at a time.

A common problem in mixing colours for landscape or floral work is creating convincing, vibrant greens. As a general rule, mixing French ultramarine with Winsor yellow, Indian yellow or raw sienna will give a range of greens suitable for most of this sort of work; so try those out as a starting point and adjust the proportions. These can be seen on the facing page.

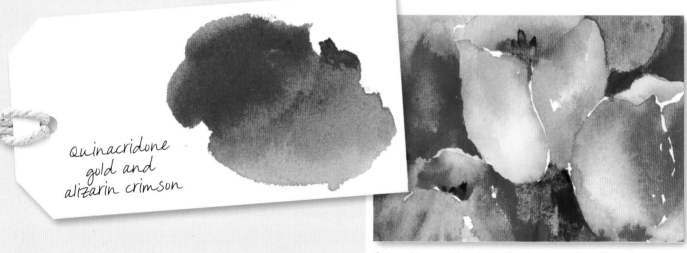

*quinacridone gold and alizarin crimson*

*Quinacridone gold and alizarin crimson work well together, as shown in the lovely natural colouring of these tulips.*

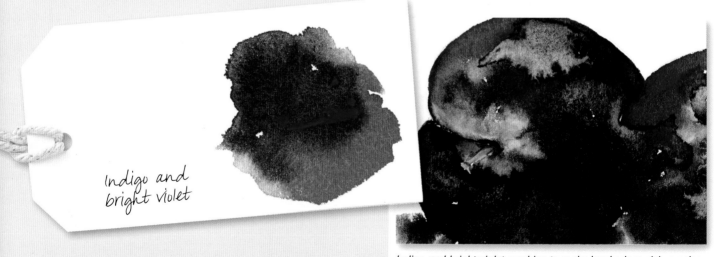

*Indigo and bright violet*

*Indigo and bright violet combine to make lovely deep rich purples that are perfect for flowers and fruit.*

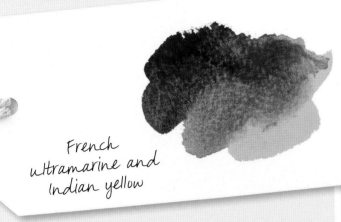

French
ultramarine and
Indian yellow

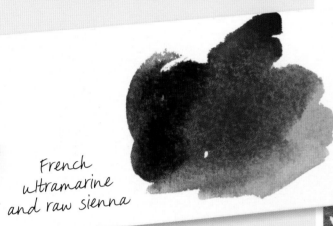

French ultramarine and Indian yellow make a rich,
glowing, medium green shade useful for most foliage.

French
ultramarine
and raw sienna

Mixing French ultramarine with raw sienna will result in a
more subdued mossy green, which tends to recede. This
makes this mix useful for background foliage.

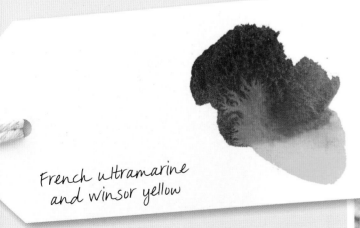

French ultramarine
and winsor yellow

Winsor yellow and French ultramarine, in varying strengths, can be
used for trees and spring foliage.

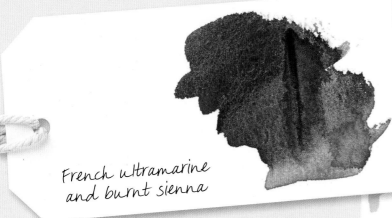

*French ultramarine and burnt sienna*

A French ultramarine and burnt sienna mix is good for tree trunks. When dropped into a wet raw sienna wash, this mix is also good for any branches and grasses.

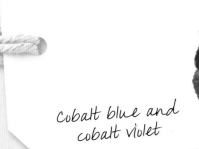

*Cobalt blue and cobalt violet*

Cobalt blue and cobalt violet make a lovely combination for bluebells and bluebell woods. It is also useful for flower painting and landscapes in general.

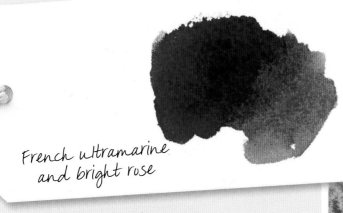

*French ultramarine and bright rose*

French ultramarine and bright rose can be combined for a very lively, bright and vibrant pinky-purple, which is ideal for summer flowers.

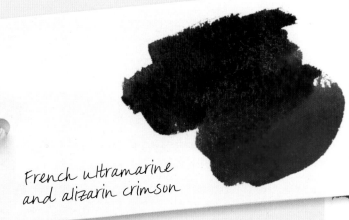

French ultramarine
and alizarin crimson

*When left to mix together on the paper, French ultramarine and alizarin crimson make a perfect mix for autumn leaves.*

viridian and
burnt sienna

*Viridian and burnt sienna are ideal to mix for really dark foliage such as fir trees.*

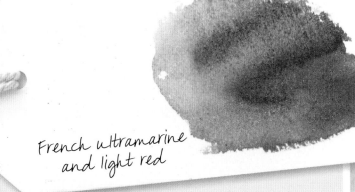

French ultramarine
and light red

*French ultramarine and light red make a really very useful mix for distant hills, skies, brick and stonework.*

# Finding your subject

I take a sketchbook and camera with me when out searching for interesting scenes. When I am sketching, I forget myself and the hours just fly by. If you decide to try this approach for gathering material, do not think to yourself 'I have been here before, I don't need my sketchbook', as you will always find a new and interesting subject.

A viewfinder is handy to help condense and simplify the view to frame just a small part of a busy scene that interests you. A viewfinder can be made from two small L-shaped pieces of card. When placed together like a frame, they help you to focus on a particular area of a scene or subject that interests you, by eliminating everything around it. By moving it around and making it bigger or smaller you can find the best possible composition.

Try to look at things in a different way. The scene may be familiar, but get closer: see and feel textures such as a rusty old anchor and chain; notice the colours, the peeling paint, the rust and the seaweed. Get out and soak up the atmosphere: it is this that will inspire you to paint. For example, when I am on holiday at the seaside, I like wandering around the streets or being by the harbour and on the beach. Watching the crashing waves of a rough sea while hearing squawking gulls just makes me want to paint a seascape. The finished painting may look nothing like the reference photographs I have taken, but I can still catch the essence of the subject.

When my holiday has finished I look forward to getting home, sorting through the mound of photographs and sketches and starting work. I usually have enough material to keep me going for months. When it is a cold, dark winter's day, it is refreshing to fetch out these preliminary pieces and get stuck into some you have not finished. Similarly, in spring and autumn, the changing colours of the leaves, foliage and flowers like snowdrops and bluebells in woodlands cannot help but inspire you.

You will enjoy painting a subject more if it appeals to you, and you will be inspired and make a better job if the subject interests you.

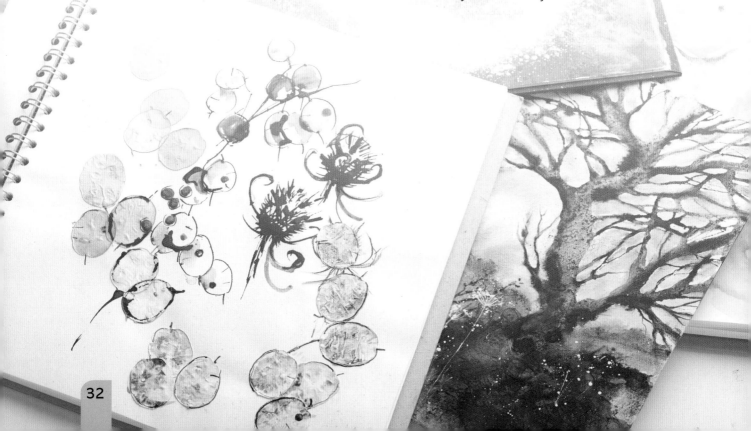

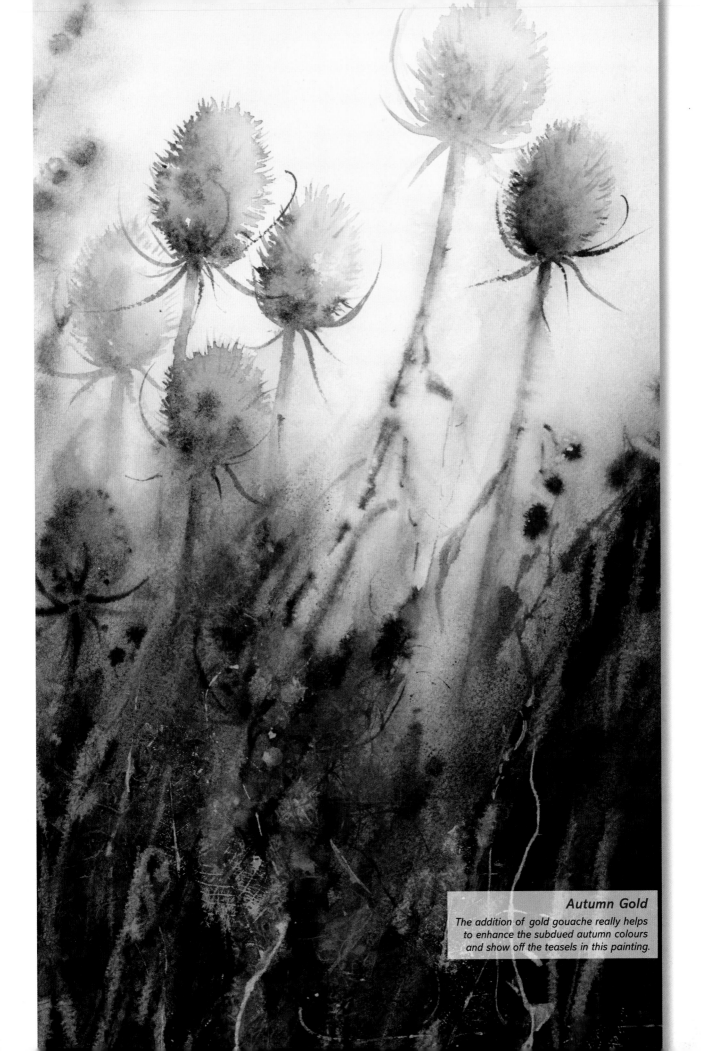

### Autumn Gold
The addition of gold gouache really helps to enhance the subdued autumn colours and show off the teasels in this painting.

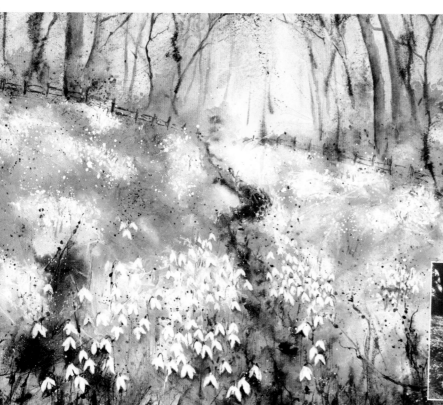

# Painting from photographs

The paintings shown on these pages are accompanied by photographs of the places that provided their inspiration.

### Field of Snowdrops

*Following a winding path through a field of snowdrops, I felt this was an ideal composition for a wintry landscape painting. The light was beginning to fade and the sky had a purple-grey tinge to it as the sun was going down.*

### Bluebell Wood

*This bluebell wood was just a mass of blue and mauve bluebells last spring. No artist could fail to be captivated by such a sight. I had to get home as quickly as I could to get painting using the quick sketches I had made and photographs I had taken as reference. The little dotted bluebell heads reminded me of tiny jewels, so I added some beads to my painting.*

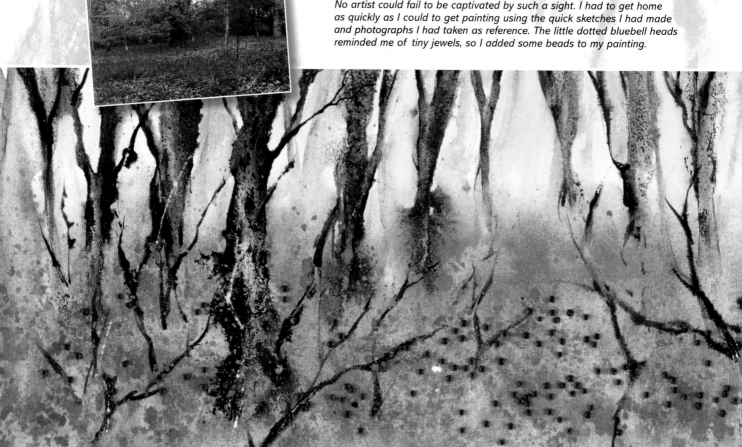

### Snowdrop

*Looking closely at the delicate structure and shape of individual snowdrops inspired me to paint a single flower head. A textured background adds interest to such a simple subject.*

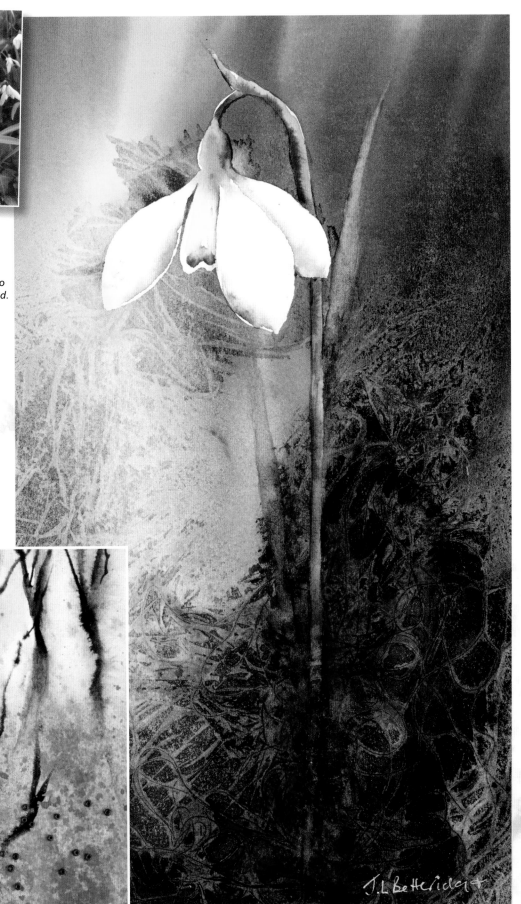

# TECHNIQUES

*Plastic wrap, salt, tissue paper, beads, cotton, shells, leaves, collage materials...*

This part of the book is where I explain both my regular and more unusual painting techniques, and where we start to have some fun with our watercolours.

It is time to think outside the box and experiment with your work. The list at the top of the page might sound like a shopping list or school nature table, but these are just some of the more unusual materials I use in my work.

Enjoy yourself – you will be surprised at the wonderful works you can create if you give it a go.

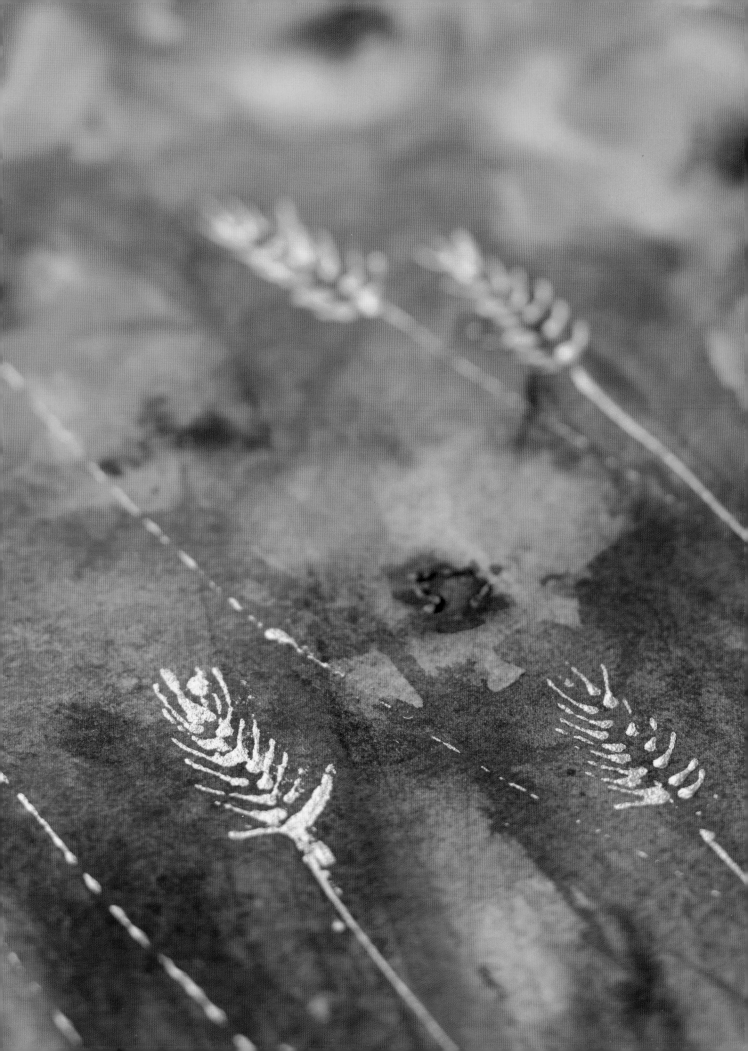

# Getting started

The very first thing I do when starting a painting is some preliminary sketches and colour shots. The colours are determined by the subject, what background colours will show the subject matter off to its best advantage, and also what kind of atmosphere you are trying to convey. I usually have the colours in mind, but until tested on scrap paper you really do not know if they are going to work or not – and it is better to find out earlier rather than later.

When I have decided on composition and colours, I always begin my painting by sketching a simple outline to guide me. I never draw complicated sketches as I like to paint loosely and you can get too bogged down in detail. If I need to mask anything out (see pages 40), I would do this next, after the initial sketch.

I usually work with a flat or only slightly tilted board. I do not tape my paper to the board as I like to lift the paper up and tilt and move paint around sometimes. In any case, I usually use heavy 640gsm (300lb) paper or mount card which is thick enough that it does not cockle when wet. Next I squeeze out the colours I have chosen into my large mixing palette for the initial big washes. After this I will work from my paint box, which contains all of my basic palette colours plus lots of the extras I sometimes use. I mix up the colours I need with water from a pipette and make a start. If I am working wet-in-wet, I always wet the paper first.

With these preparations made, any of the techniques on the following pages are possible – try them all out and experiment!

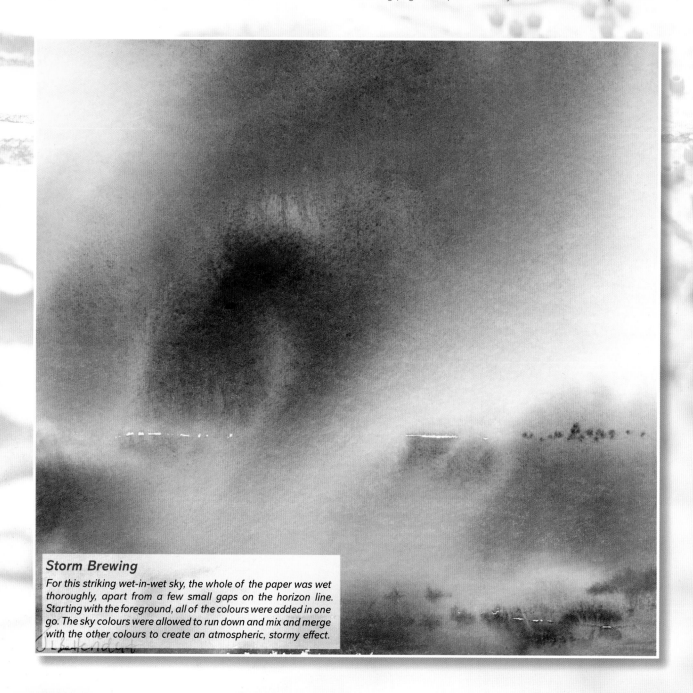

**Storm Brewing**
For this striking wet-in-wet sky, the whole of the paper was wet thoroughly, apart from a few small gaps on the horizon line. Starting with the foreground, all of the colours were added in one go. The sky colours were allowed to run down and mix and merge with the other colours to create an atmospheric, stormy effect.

# Wet-in-wet

This is my favourite technique. The atmospheric results achieved with this method never cease to amaze me. Wet colour is applied to wet paper, which allows the colours to mix on the paper's surface rather than on the palette. It produces soft edges, which are ideal for diffusing shapes when too much detail is undesirable. Because of its soft effect, it is ideal for aiding perspective in work, as soft edges go back and hard edges come forward. Bear in mind that you can only control the paint to a certain degree with this technique – it will naturally spread and diffuse.

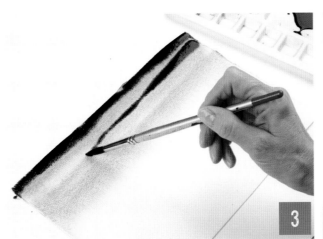
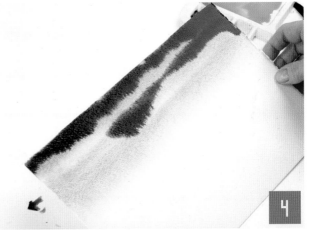

1   Prepare two wells of colour – cerulean blue and indigo, in this example – using a size 10 round brush. Change to a size 16 round wash brush and use it to wet the entire piece of paper with clean water, right to the edges.

2   Pick up the first colour (cerulean blue) with the size 10 brush and, working down from the top of the paper, use broad horizontal strokes to lay in a wash.

3   Rinse your brush and pick up some of the second colour (indigo). Use this to draw strokes of colour across the wet area of the first colour.

4   You can tip and tilt the paper to encourage the colours to blend and merge on the paper.

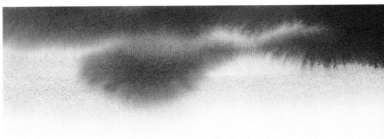

*Allow the paint to dry for the finished effect.*

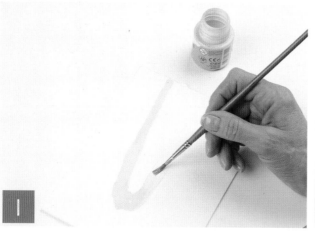

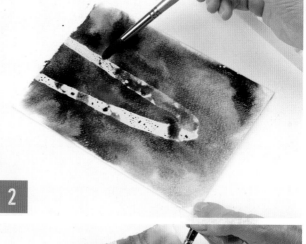

# Masking and lifting

Masking fluid is useful when areas of the painting surface need to be kept clean and protected from receiving paint. It can be applied with an old brush or a rubber-tipped colour shaper (be careful, as these can mark the paper). Masking fluid goes on more smoothly when applied with a brush, and the softness of the bristles means that you do not risk marking or scratching the painting surface.

It is imperative that your paper is completely dry before removing masking fluid; otherwise you risk removing the surface of the paper when rubbing it away. If you are not sure whether a wash is properly dry, heat it gently with a hair dryer from both the back and front of the paper, leave it until it cools, then rub it off using either a putty eraser or the tip of a clean finger.

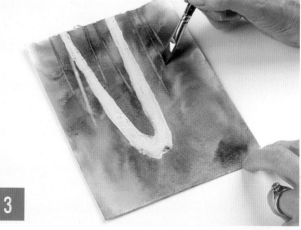

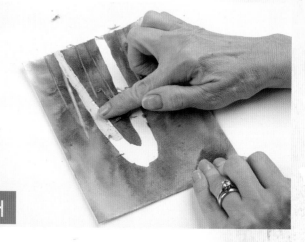

1  Lightly sketch the basic shapes on your paper, then wet an old brush and use it to apply the masking fluid over the shapes you want masked. Apply the masking fluid as though it were paint, and allow to dry completely before continuing.

2  Prepare your colours and paint over the top. In this example, I have laid in a loose wash of indigo then added in areas of green-gold and burnt sienna. Allow this to dry completely.

3  Wet a 10mm (⅜in) angled flat brush and draw the brush upwards to lift out some of the paint to create the impression of faint tree trunks in the background. Allow this to dry thoroughly.

4  Use a clean finger to gently rub away the masking fluid to reveal the clean paper; which you can then leave as is or work over as appropriate for the painting.

## TIP

Once masking fluid gets to about six months old, it starts to thicken and is very difficult to apply. Throw it away and get a new pot. I have seen students' work ruined after they have applied gooey old masking fluid which could not be applied cleanly because of its thickness; and also because the old fluid did not dry properly.

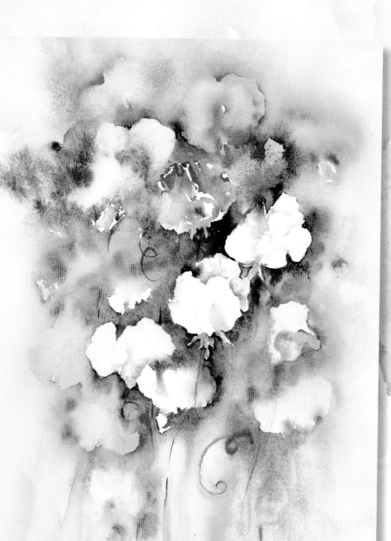

## Sweet Peas

The flower heads that I wanted to keep white were masked out before everything else in the background was painted. Detail was added to the white flowers after the background had dried and the masking fluid removed.

## Silver Birch Trees

You can really go to town on creating an interesting background when the main subject matter is masked out. After applying lots of paint and spattering granulation medium over the surface, I lifted out some distant trees before removing the masking and working on the main trunks.

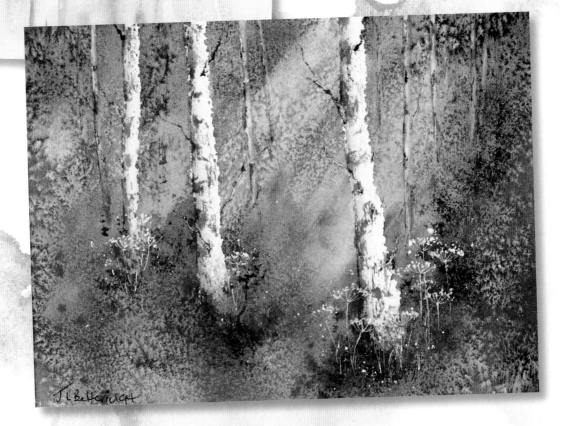

# Using gesso

I sometimes work on surfaces that have been prepared with gesso. This material is meant mainly to prime canvasses, but you can apply it to any surface really. It can create some really unusual effects when watercolour is painted over it.

If I am completely covering a surface of my support with gesso, I will work on mount card, as there is no point in completely covering the surface of expensive watercolour paper. However, if I am just partially covering areas of a painting, I use watercolour paper as I want to benefit from that surface for the areas left gesso-free.

Gesso can be applied either thinly or thickly, with a brush or palette knife, and left smooth or textured depending on the marks you want to create. A palette knife leaves it really smooth, whereas brushes can leave texture. Make sure you do not use good brushes for this as they will be ruined. I always use cheaper hog hair brushes and rinse them immediately after I have finished.

1  Use a palette knife to cover the entire surface of the hardboard with a smooth layer of gesso.

2  Draw a coarse hog hair brush over the top part to create brushmarks and lines that suggest direction in the sky.

3  Wrap a piece of masking tape around your fingers, sticky side out, and secure it into a loop. Attach a small piece of card to the front and press it into the wet gesso near the bottom. Lift it away again to create a random, rocky effect. Repeat across the lower two-thirds of the surface.

4  Add some sand over the rocky area, then drape some small pieces of gauze over the same area to suggest texture and foliage. The gesso will hold the sand and gauze in place as it dries Use the hog hair brush to tease out a few loose strands from the gauze for longer grasses.

5  Once dry, you can paint over the gesso. Prepare the paints at a double cream consistency when painting over gesso, as the smooth sealed surface means you will remove quite a lot with each subsequent brushstroke. I used the following colours in this painting: verditer blue, French ultramarine, burnt umber, green-gold, Indian yellow, aureolin, opera rose.

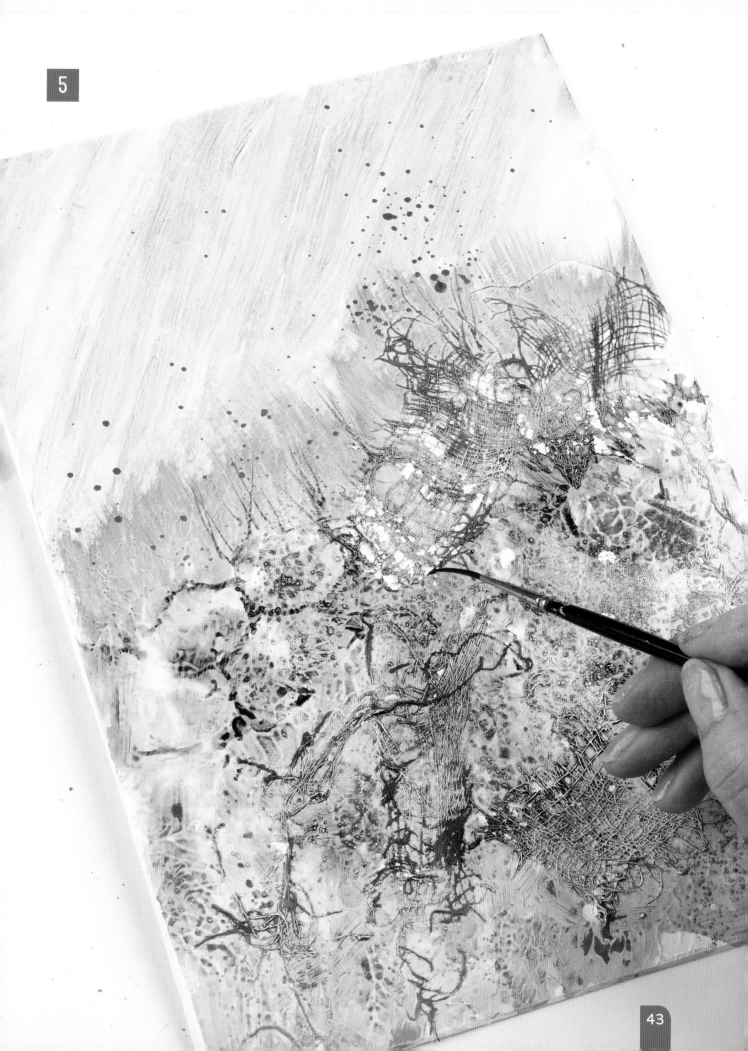

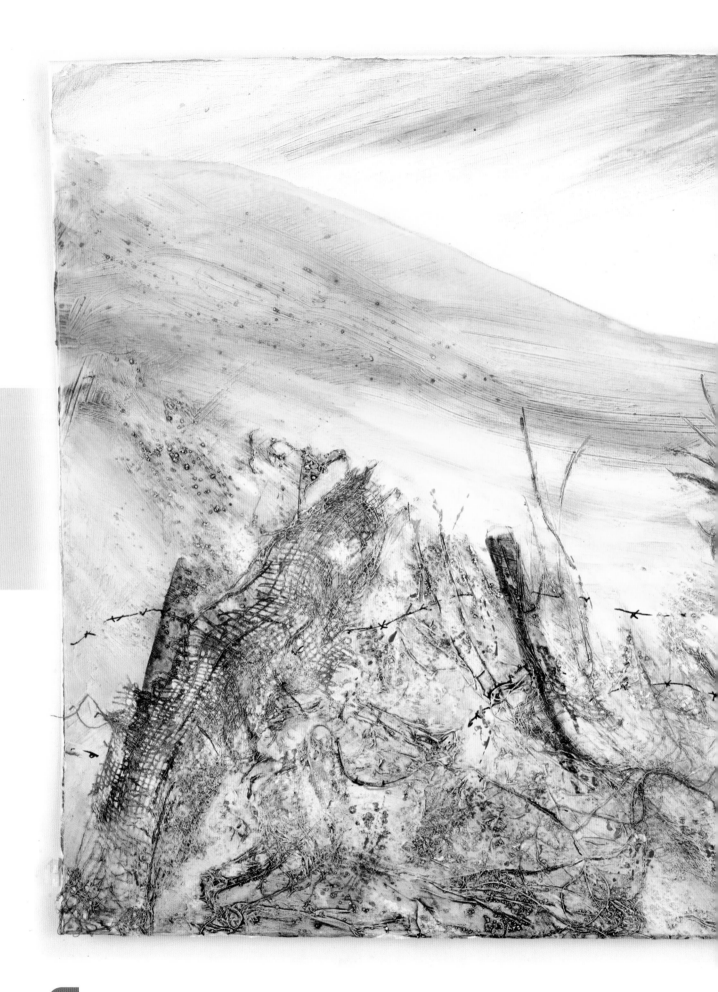

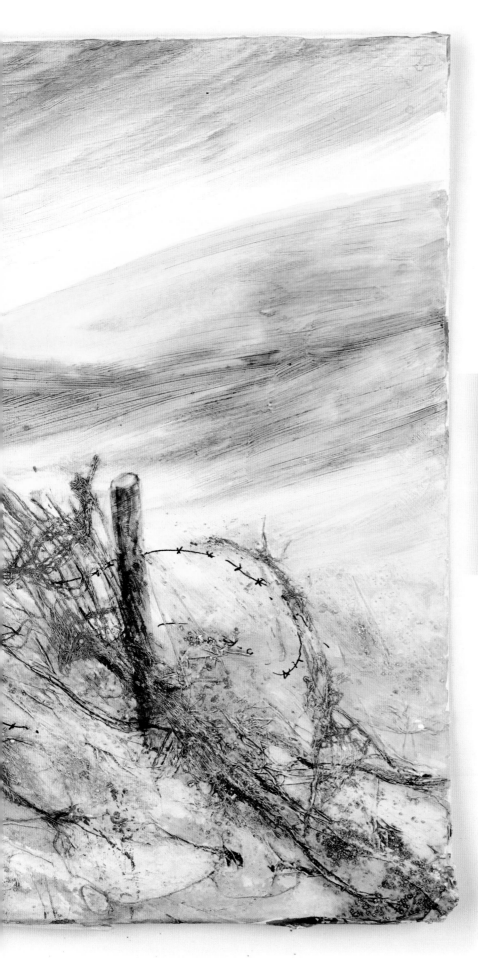

### The Broken Fence

By imprinting gauze, cotton threads and sand into wet gesso, some great textural effects can be achieved. These effects were heightened after watercolour washes were applied over the dry surface, as the paint sank into the recesses and grooves created by the gesso and textural materials.

# Using granulation medium

Granulation is the term for the effect of pigment settling into the texture of the surface, producing a speckled effect. Some pigments – particularly earthy colours – granulate naturally, while others do not. I prefer those that do, as granulation can create or add depth, texture, atmosphere and interest to a painting.

To exaggerate these effects, or to create granulation in a non-granulating paint, you can add granulation medium. Using this medium has made a tremendous difference to my work and it is something I use every time I paint. Using a pipette, you can add it to the paint when you prepare it, or drop pure medium into wet paint on the paper. Once applied, you can simply wait and watch it work its magic. Granulation medium creates a particularly good effect when applied to sepia or burnt umber acrylic ink.

**TIP**
Most paint ranges will indicate on the tube or pan whether the paint is granulating or not.

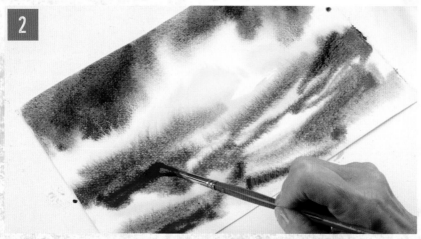

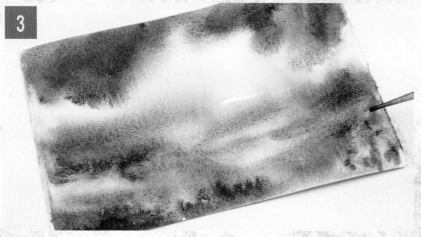

1  Prepare your paints in the usual way (see page 26), but do not dilute them quite as far. Instead, use just a little water, then add granulation medium to take them to the creamy consistency.

2  Paint a simple landscape wet-in-wet (see page 39) using the prepared granulating colours.

3  Pick up some pure granulation medium in a pipette and drop a little into the wet paint, then leave the painting to dry.

4  As the paint dries, the effects of the granulation medium will slowly and gradually develop. In the images on the opposite page, the fresh paint is at the top, and the dry finished piece is at the bottom.

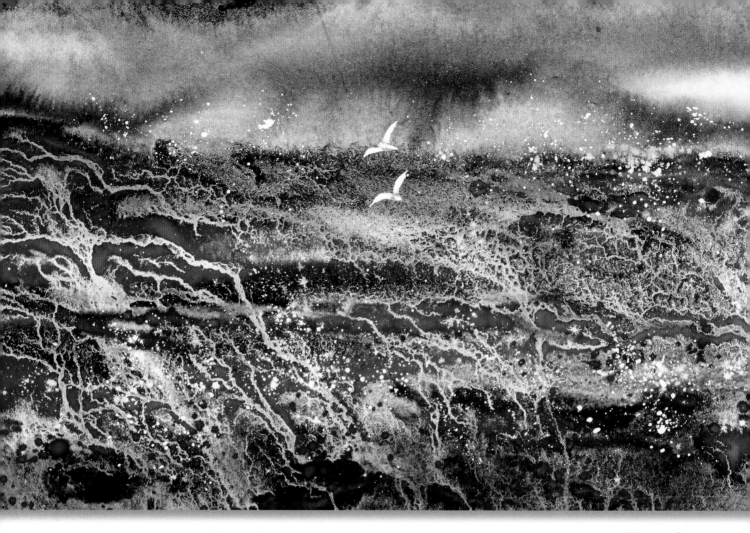

Granulation medium is better suited to a loose contemporary style than highly detailed traditional work such as botanical art. Artists have only a certain amount of control when using it. Once added to the paint, its effects – and the final result – can vary greatly. As a consequence, some artists avoid granulating paints and medium at all costs, as it is either not to their taste or does not suit a particular style of painting.

You should never feel that you have to use any particular technique, tool or material, but I encourage you to try granulation medium out and experiment with it before making up your mind.

### What a Storm

*Adding granulation medium breaks up the washes as the medium penetrates the pigments. This can be used to make dynamic effects. By tipping the paper up while the paint and medium were wet, I encouraged the mix to run down the paper, suggesting really rough waves and running water.*

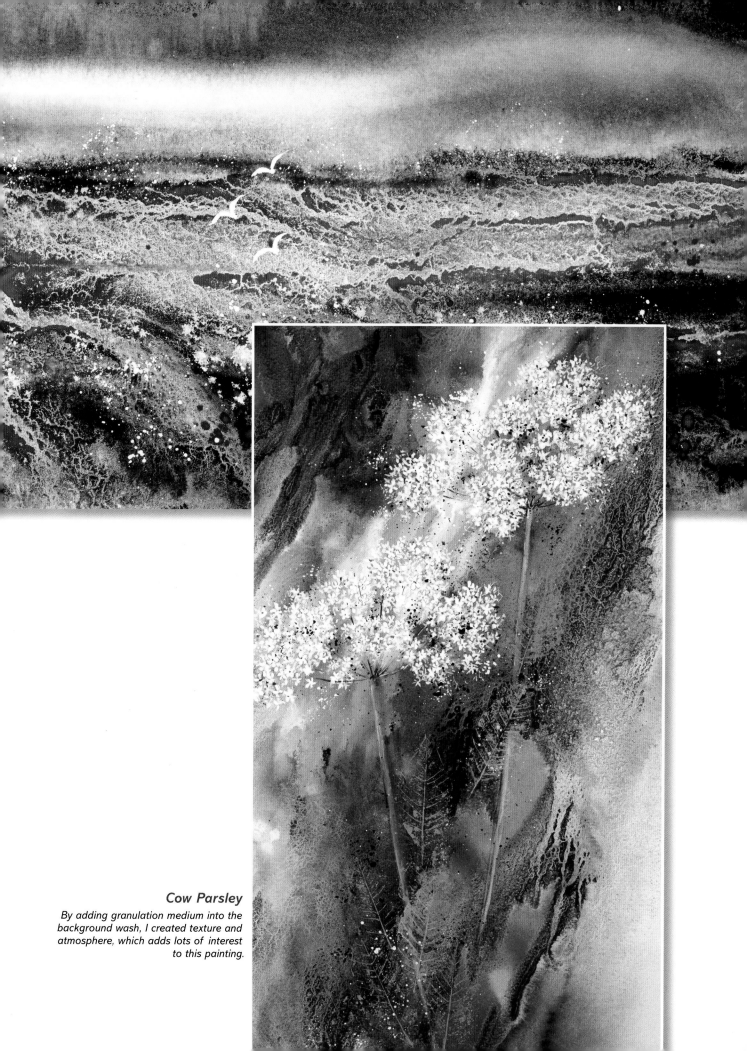

## Cow Parsley

*By adding granulation medium into the background wash, I created texture and atmosphere, which adds lots of interest to this painting.*

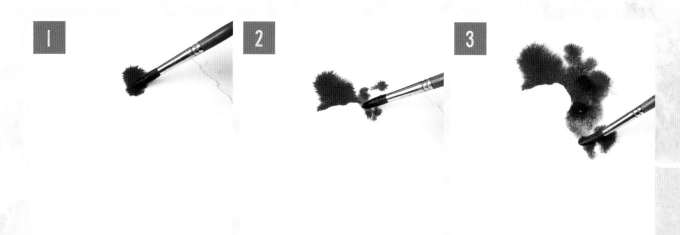

# Using salt and lifting out

When added to a drying wash just as the shine is disappearing, salt will leave white marks that can be really useful for suggesting many things. When the salt hits the wet paint, it pushes the pigment out, creating a little white speck or star shape. Larger, coarser grains of salt, such as rock salt, leave bigger markings. The success of this technique depends on the amount of pigment used and how much water has been added; too much or too little and it will not work as well.

While paint remains wet, you can use a brush to draw away some of the paint, a process called lifting out.

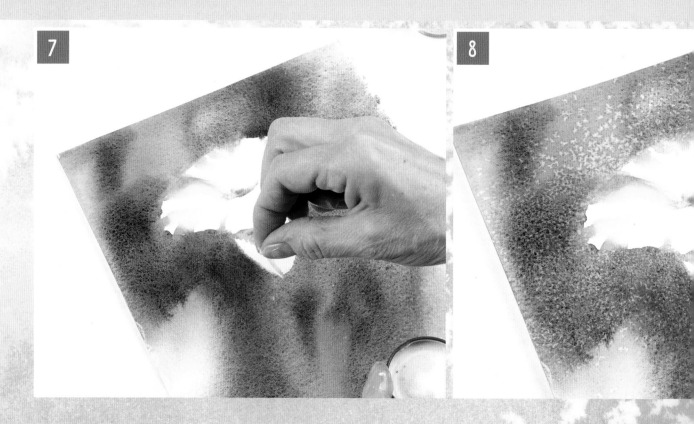

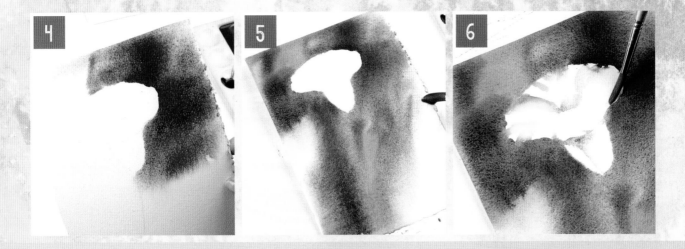

1   Use an 2B pencil to lightly sketch a flower on your paper, then prepare your colours (bright violet, green-gold and French ultramarine in this example). Use a size 16 round wash brush to wet the paper and stem, but leave the petals of the flower dry. Pick up some of the first colour on the brush and touch it to the paper, letting the colour flow out. It will bleed into the wet area, but will not enter the dry part.

2   Draw the colour around a little before lifting the brush away, but do not use full brushstrokes – the appeal of this technique is the loose, random quality.

3   While the surface remains wet, drop in a second colour in a few places nearby, letting it bleed out into the water and also the wet first colour.

4   Pick up the paper and gently tip and tilt it to encourage the colours to blend.

5   Repeat across the rest of the paper, using different colours and longer brushstrokes at the bottom to echo the stems.

6   Using a size 8 round, draw a little of the wet paint into the flower itself to create some shape and shadow.

7   Allow the painting to dry a little. Once the wet sheen has faded, but before the painting has dried completely, lightly sprinkle a few salt crystals over areas of the painting.

8   Allow the painting to dry. As the paint dries, the salt will absorb a little of it, creating an interesting effect. Once dry, you can use your fingers – make sure they are clean and dry – to brush away any salt crystals.

9   To finish the painting, lift out (see page 40) the stem using a wet 10mm (⅜in) angled flat brush; drawing the brush up towards the flower.

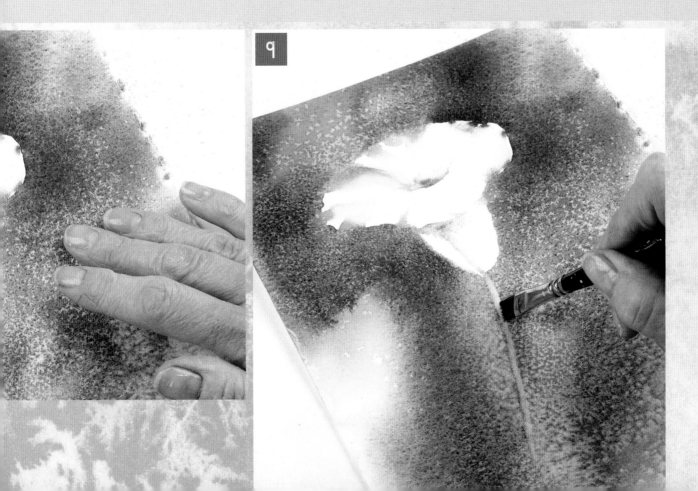

The sparkling effects left by salt added to a watercolour wash are useful for water, skies, landscapes and flower paintings. Experiment and you will find this useful technique can help almost any type of painting.

Generally, adding salt is done early in a painting, as a way of adding interest to the background. The examples on these pages show some work-in-progress artworks so that you can see how they look at this earlier stage.

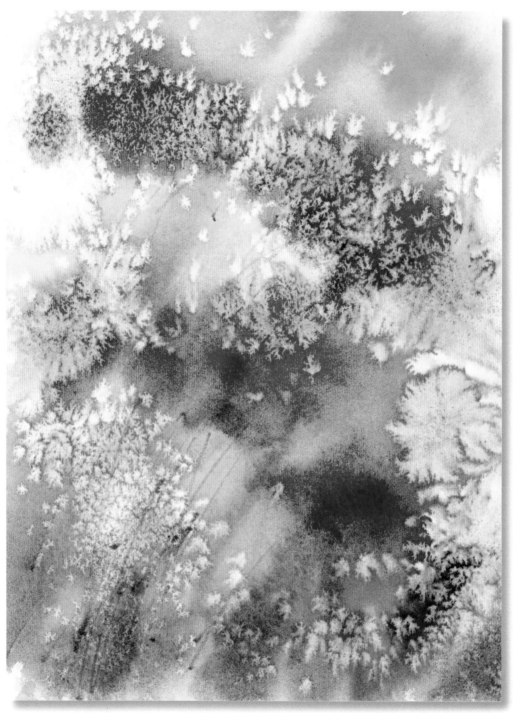

### Tulips
*The background of this painting, made using salt dropped into a wet wash, already looks interesting without any other work being done. From here, I will work back into the tulips first, then see what more needs to be done.*

### Landscape
Rock salt added to this wash created a variety of shapes. Because rock salt crystals tend to be larger and more irregular than table salt, the effects it creates are more varied and random.

### Seascape
The larger marks on the bottom of this painting were made by adding the salt when the paper was very wet. The smaller marks on the top and right-hand side show that the salt was added when the paint had dried a little.

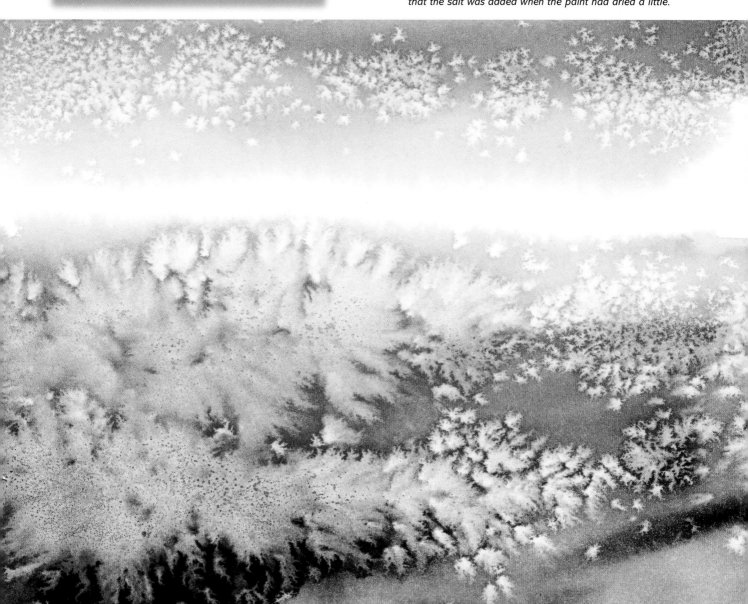

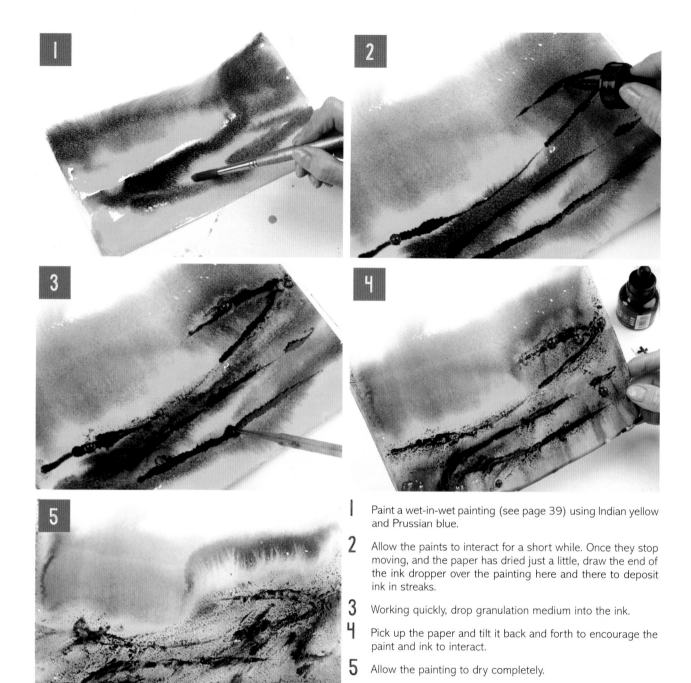

1    Paint a wet-in-wet painting (see page 39) using Indian yellow and Prussian blue.

2    Allow the paints to interact for a short while. Once they stop moving, and the paper has dried just a little, draw the end of the ink dropper over the painting here and there to deposit ink in streaks.

3    Working quickly, drop granulation medium into the ink.

4    Pick up the paper and tilt it back and forth to encourage the paint and ink to interact.

5    Allow the painting to dry completely.

# Combining ink, granulation medium and watercolour

Ink can be combined with watercolour paints. It adds strength and depth to colours that sometimes just are not vivid enough for the artist. I use inks to add interest to flower centres and backgrounds. As mentioned earlier, I like to use the dropper to draw into watercolour washes before adding granulation medium to separate the pigments and produce the granular mottled effect I love.

Other than white, I tend to use only the earthy tones of ink, such as sepia, burnt umber and antelope brown, relying on pure watercolours for brighter colours.

*Opposite:*

### *Snowdrop Magic*

*By adding ink followed by granulation medium into the wet watercolour wash, I created a wintry atmosphere and textural effects that contrast with the pure, clean flower petals. A damp angled brush was used to lift out paint and create the suggestion of stems.*

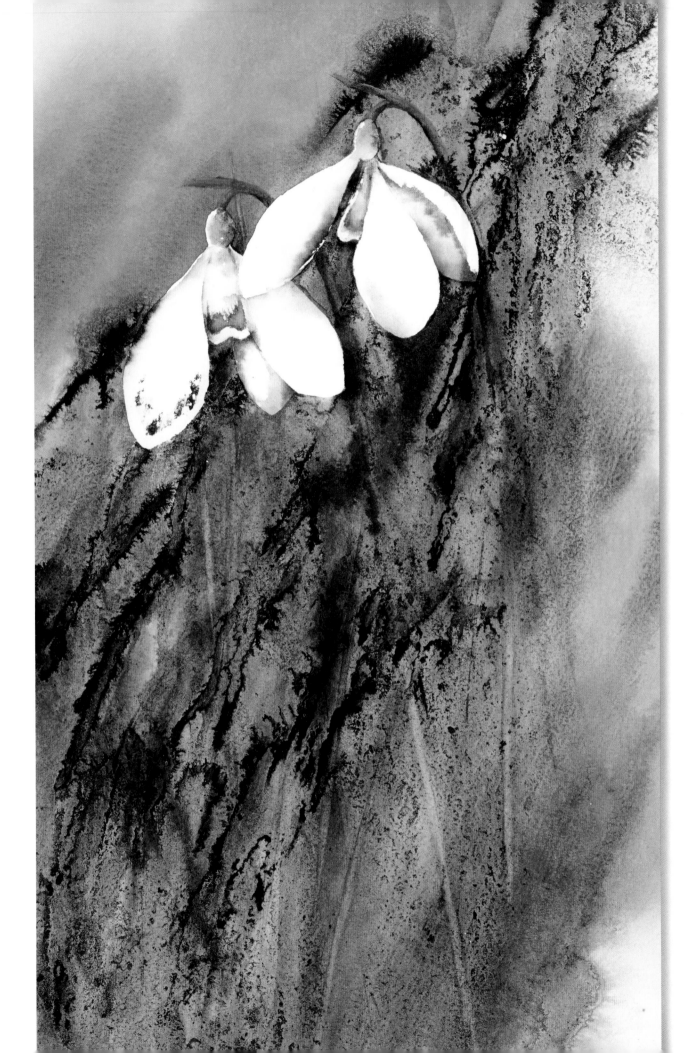

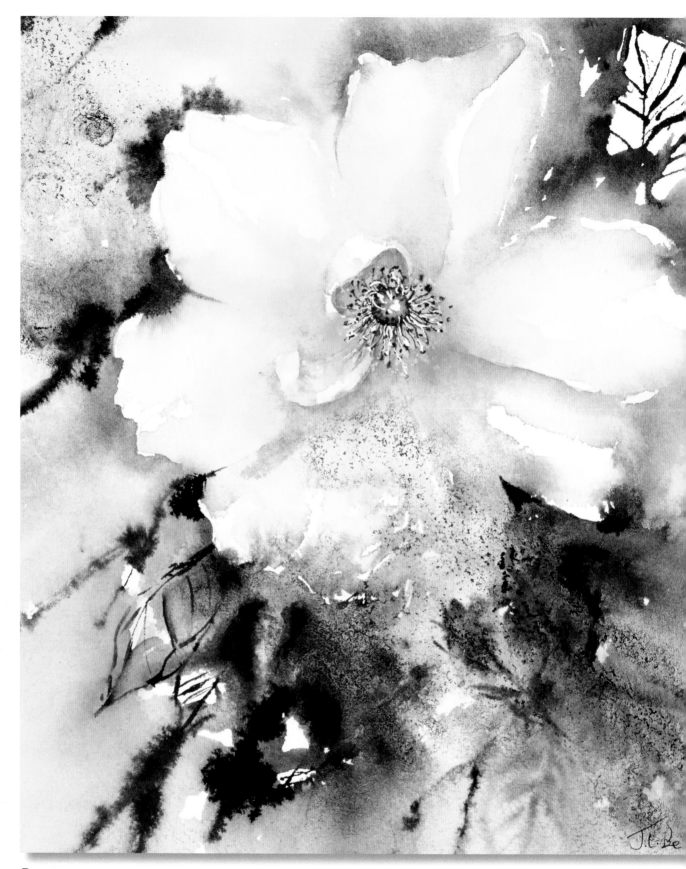

## Rose

*Here, ink and granulation medium were dropped into a wet background wash of watercolour and allowed to filter a little into the main rose itself.*

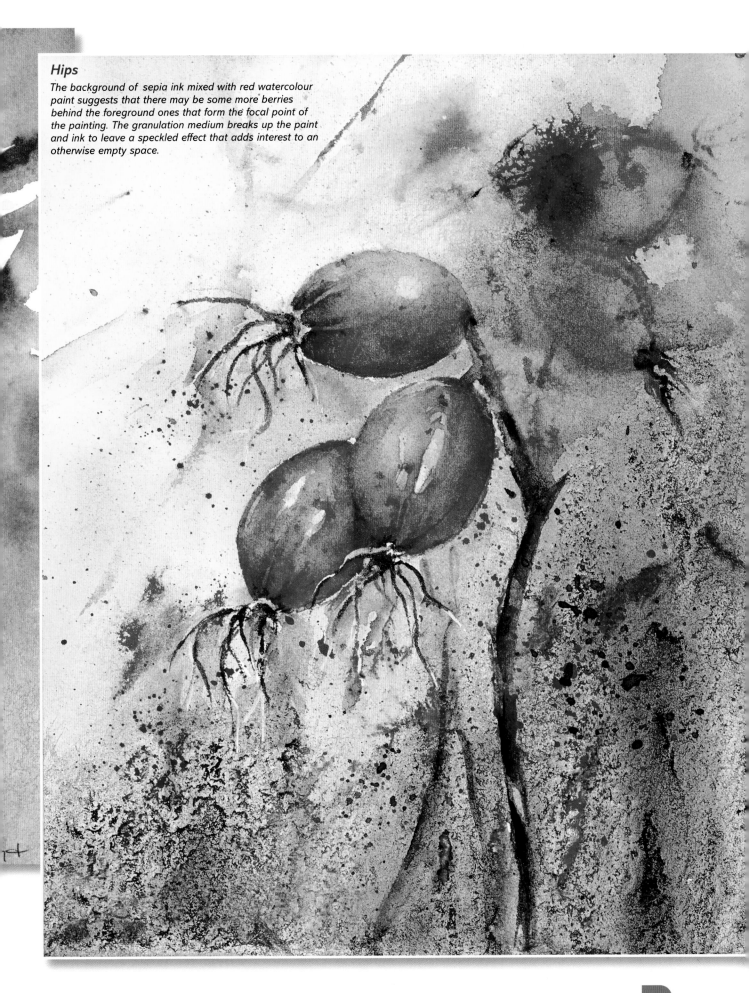

## Hips

The background of sepia ink mixed with red watercolour paint suggests that there may be some more berries behind the foreground ones that form the focal point of the painting. The granulation medium breaks up the paint and ink to leave a speckled effect that adds interest to an otherwise empty space.

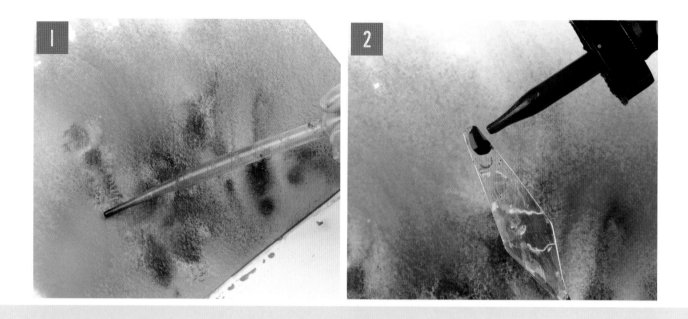

# Spattering

Whether to add sparkle on water, foam on waves, pollen in flower centres or simply some extra interest, spattering is very useful to add a bit of life to your painting. When painting a bluebell wood the spattering technique is ideal, especially when different blues, mauves and pinks are used.

I spatter by putting paint on to the end of a palette knife and flicking it to make the paint spatter on to the paper. The higher up you hold the palette knife, the finer the marks. You can aim the paint once you have practised a little, but it is always a good idea to put a piece of kitchen paper over any areas you want to protect from being spattered. This is because the technique is very unpredictable and can end up on parts of your work where you did not want it.

Some artists use a toothbrush for this technique, which gives even more unpredictable results than using a palette knife. I find that the paint travels a lot further when using a toothbrush, too.

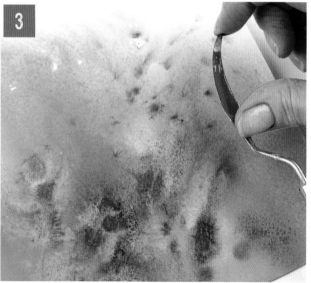

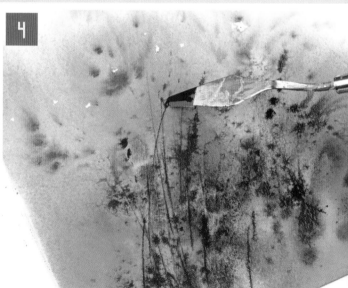

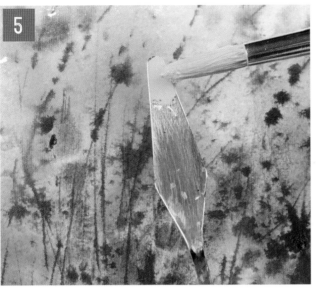

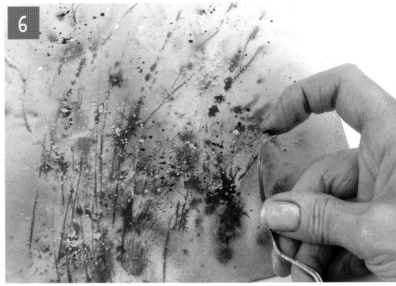

1  Paint a wet-in-wet painting (see page 39) using horizon blue and viridian hue watercolours and antelope brown ink. Add a little granulation medium, if you wish.

2  While the paper is still wet, touch a drop of ink on to the end of a small palette knife.

3  Pull the end of the knife back and flick the ink directly on to the wet surface.

4  Draw the tip of the knife through a few of the dots of spattered ink to create longer grasses.

5  You can also spatter paint. In this example, I have allowed the painting to dry, which creates a different effect. Paint the end of the painting knife (opaque paints like horizon blue work especially well for this).

6  Repeat the spattering technique exactly as for the ink, pulling the end of the knife back and letting it flick out to spatter the paint randomly over the area.

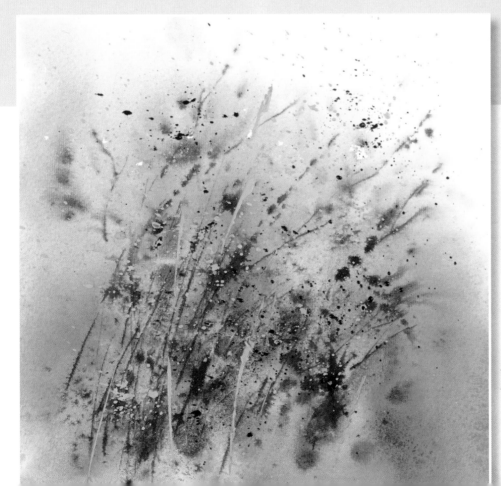

*The finished spattered painting.*

# Adding texture

## Texture using beads

I really enjoy using beads in my paintings. It started off when I was painting a seascape a few years ago and needed some texture for the foreground. I tried sticking some little seed beads on with white glue and really liked the finished result. After this success, I bought a variety of beads to use in different shapes and unusual colours. There is such a huge variety of shapes and colours in craft shops now that I continually have to stop myself from buying more!

I find that tiny blue-purple seed beads are ideal for bluebell woods. When scattered in the foreground they just look like bluebells. It can be quite painstaking to stick them on, as each bead has to be stuck on separately – you need a lot of patience if you want your watercolour to remain fresh. I do this using a cocktail stick and dotting tiny blobs of glue where I want the beads to go, before using tweezers to place them.

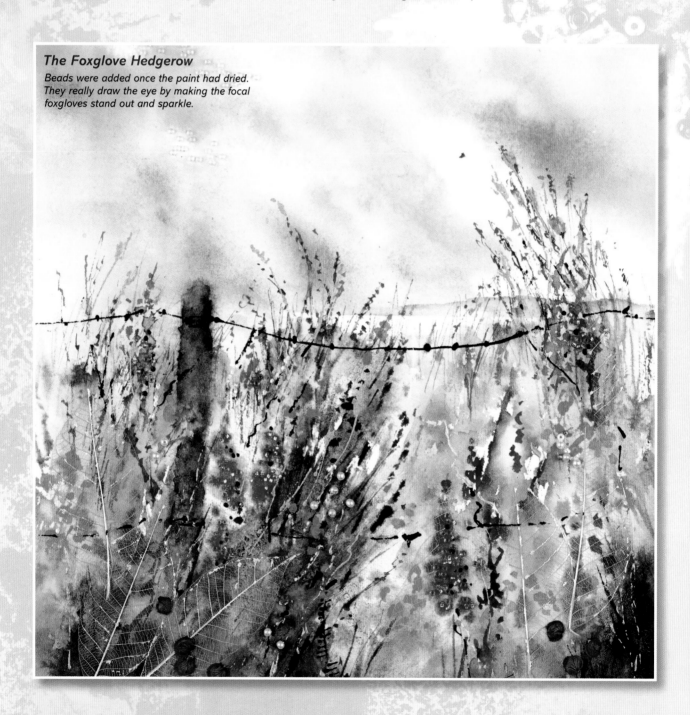

*The Foxglove Hedgerow*
*Beads were added once the paint had dried.*
*They really draw the eye by making the focal*
*foxgloves stand out and sparkle.*

**1**

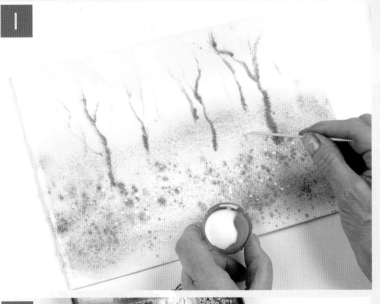

**2**

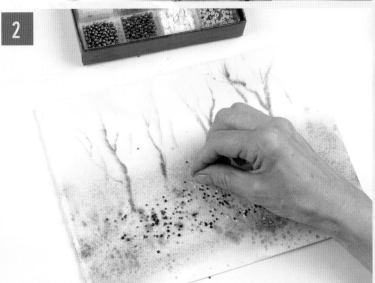

1. Paint a wet-in-wet painting (see page 39) and allow it to dry. For this bluebell wood I have used cobalt blue, cobalt violet, aureolin, and a mix of burnt umber with a touch of French ultramarine. Pour a little white glue into a small container (I am using the lid of a carton of milk). Use a cocktail stick to touch dots of white glue all over the bluebell area.

2. Sprinkle beads all over the area.

3. Gently pat down the beads. Tip the paper up. Some of the beads will roll off, and others remain; you can use tweezers to re-apply some if you want them in a particular spot.

**3**

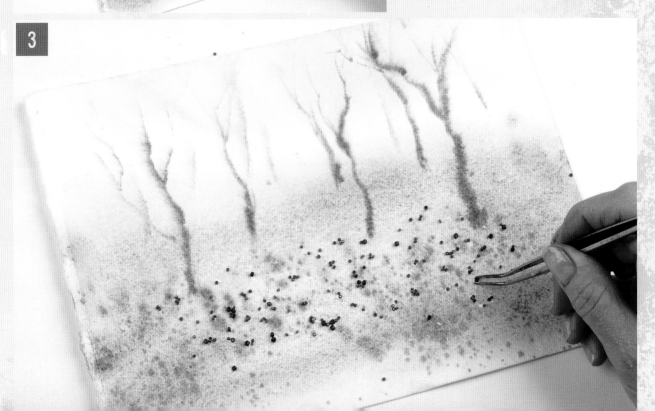

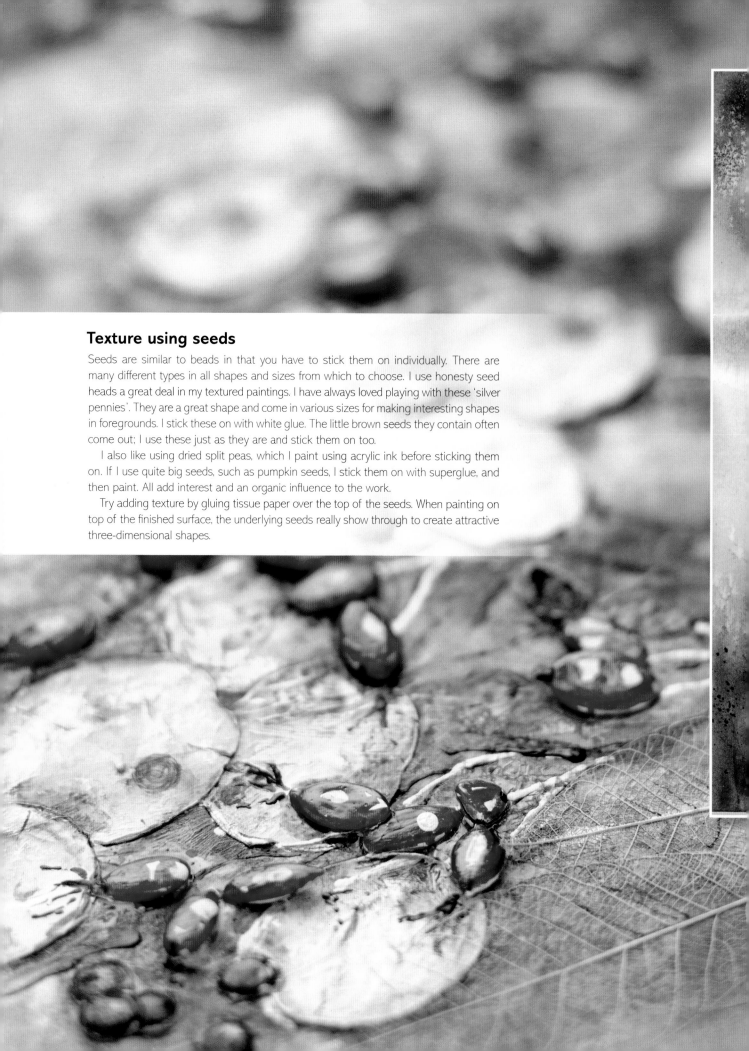

## Texture using seeds

Seeds are similar to beads in that you have to stick them on individually. There are many different types in all shapes and sizes from which to choose. I use honesty seed heads a great deal in my textured paintings. I have always loved playing with these 'silver pennies'. They are a great shape and come in various sizes for making interesting shapes in foregrounds. I stick these on with white glue. The little brown seeds they contain often come out; I use these just as they are and stick them on too.

I also like using dried split peas, which I paint using acrylic ink before sticking them on. If I use quite big seeds, such as pumpkin seeds, I stick them on with superglue, and then paint. All add interest and an organic influence to the work.

Try adding texture by gluing tissue paper over the top of the seeds. When painting on top of the finished surface, the underlying seeds really show through to create attractive three-dimensional shapes.

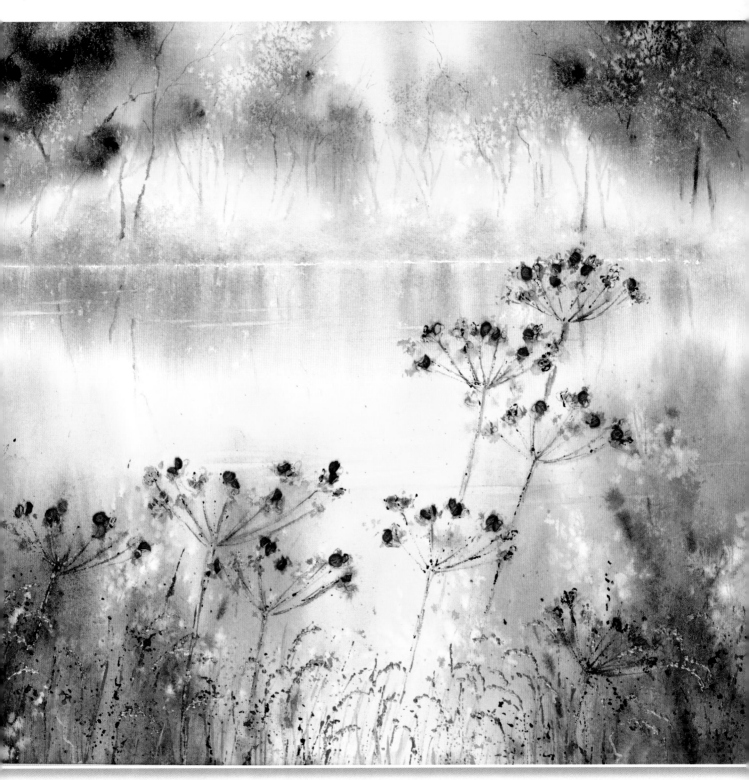

## Bluebells Across the Lake

*Once I had finished painting the hogweed heads, I glued on small seeds. Some were left in their natural state, and I trimmed others with scissors to vary the shapes. Seeds work best alongside other textural effects, such as the contour medium used for the background bluebells.*

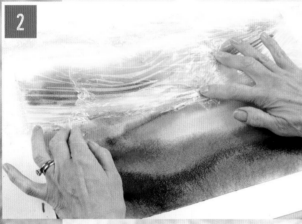

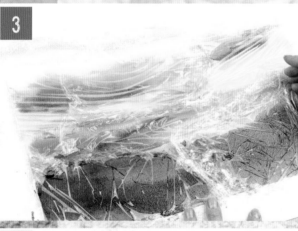

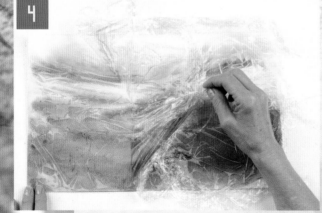

# Using plastic food wrap

This is a really exciting technique to use in your work. Plastic food wrap is an excellent mark-making tool. You can simply leave it flat before laying it on wet paint to create lots of interesting textured shapes with which to work, or stretch it or scrunch it into shape to suggest particular marks.

When applying plastic wrap, it is a good idea to have several pieces ripped off the roll ready and at hand. First of all you apply your normal watercolour washes to your paper (this can either be wet-in-wet or wet-on-dry), then place the plastic wrap directly on top of your paint. Once applied, you can pull and stretch it into specific shapes, or simply place it on top randomly. Depending on whether you press down firmly or lightly, you can create different surface marks. The plastic wrap needs to be left to dry for at least a couple of hours or ideally overnight. When peeled off, you will see what lovely markings you are left with. These markings can either be left as they are or worked back into – perhaps to emphasise marks that suggests the shape of a leaf, for example.

All of your work can be covered with plastic wrap or just different areas to suggest different things in your painting, such as hills and fields or flower petals.

1   Tear off a few pieces of plastic food wrap, each about the size of the painting itself, and place them to one side. Next, paint a wet-in-wet painting (see page 39) using transparent orange, Winsor yellow and viridian.

2   While the paint is still wet, stretch the wrap over the top of the painting and gently smooth it horizontally to create the impression of distant hills.

3   Continue laying the wrap over the paper, encouraging it into more vertical folds at the bottom, to suggest vegetation. Leave the painting to dry for at least two hours, and preferably overnight.

4   Once dry, carefully remove the plastic wrap to reveal the finished effect.

## TIP

For a more pronounced effect, do not wet the paper before you paint. Putting plastic wrap over a wet-on-dry painting will result in a very strong effect which is occasionally useful, though I prefer the more subtle result of using it over a wet-in-wet picture, as in the examples on these pages.

## Cyclamen

When painting the background of this painting, I applied plastic food wrap in a random fashion for an interesting effect. When I came to paint the flower heads later, I applied a little more wrap on the petals to add extra texture on these important features.

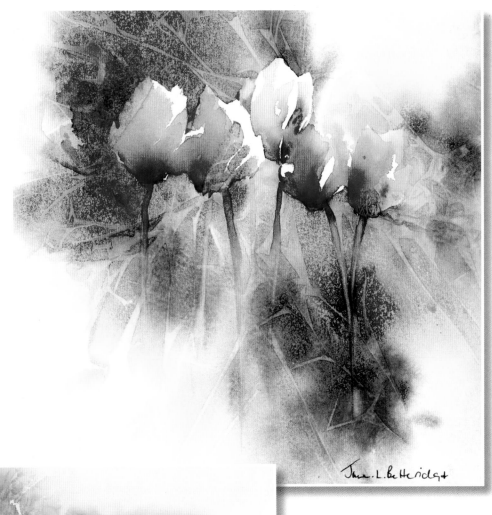

*Jane.L.Betteridge*

*Jane.L.Betteridge*

## Poppies

As I laid the plastic food wrap on the wet paint, I manipulated it loosely into specific shapes to create marks similar to poppy leaves.

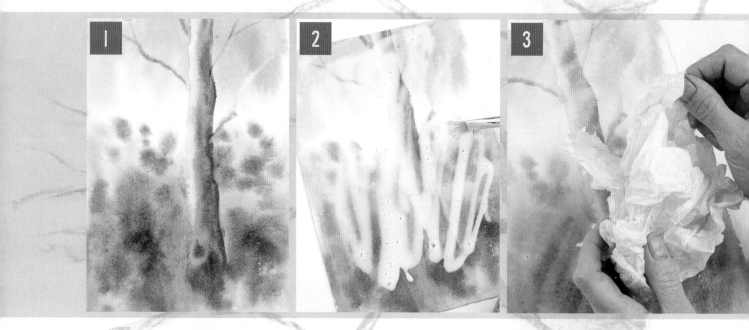

# Using tissue paper

Tissue paper is very delicate, especially when wet. It is hard to imagine that you would be able to paint on top of it, but it can be done. The first approach is simply to stick crumpled-up plain white tissue paper straight on to your watercolour paper using watered-down white glue. Once thoroughly dry – which can take three to four hours – you can paint over the interesting textured surface it creates.

The second way is demonstrated on these pages: a very simple watercolour wash is painted onto the watercolour paper as an underpainting. It is then covered in white glue and tissue paper as described above. Once dry, you can paint over the top.

Keep it simple for the best effect – it is great to see the underpainting showing through subtly from underneath.

1    Paint a wet-in-wet painting (see page 39) and allow it to dry. For this example, I have used horizon blue, French ultramarine, bright violet, sap green and burnt sienna. Allow it to dry thoroughly.

2    Water down white glue to a 1:1 ratio, then use a large old hog hair brush to spread it all over the painting.

3    Tear a piece of tissue paper larger than the painting, then scrunch it up to create interesting creases.

4    Open the ball out and lay it over the painting. Press it down, but gently, so that you retain the creases.

5    Wrap the excess tissue paper round the back of the painting, then leave it to dry for at least two hours, and overnight if possible.

6    Once dry, unwrap the excess tissue paper and cut it away using a pair of scissors.

7    You can now paint over the surface using the same colours as the underlying painting. If you use wash techniques, the watercolour will collect a little in the creases, creating effects like bark.

8    A rigger can be used to suggest a few branches and twigs by picking out suitable creases and highlighting them with the same paint as the tree.

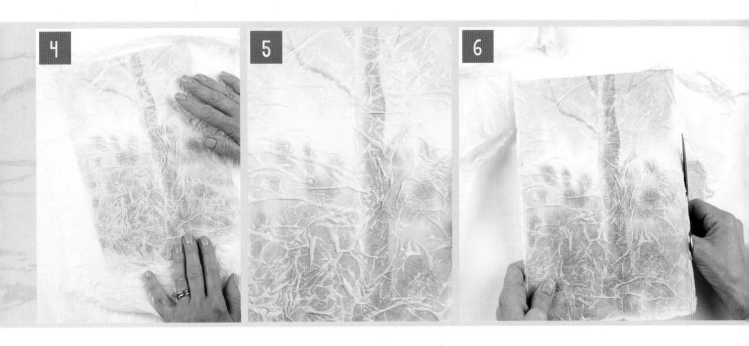

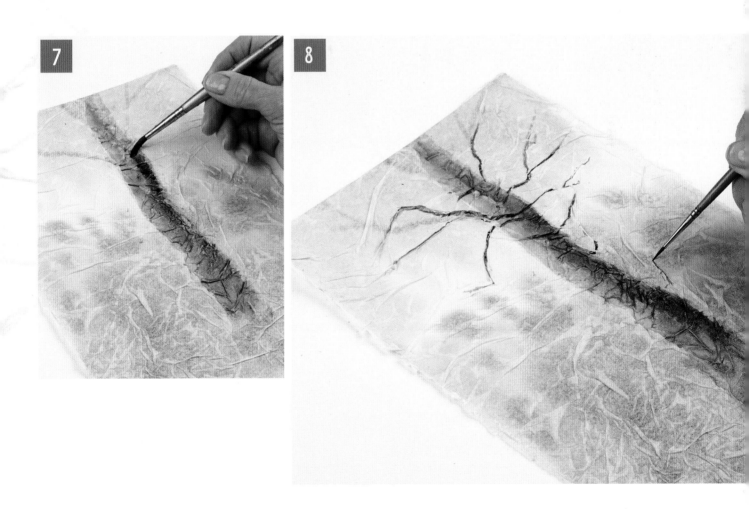

# Incorporating cotton thread

Dry cotton thread can create some really interesting tangled effects when dropped into a wash and left to dry with the paint. For more prominent marks, the thread can be dipped in paint first before being added to the wet wash and left to dry. I usually remove the cotton once the wash has dried, but you can leave it in place for an even more textural finish.

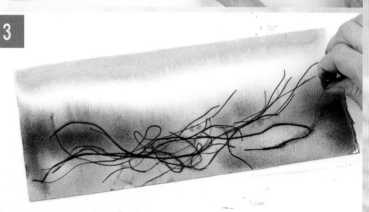

1 Prepare wells of colour. For this example, I have used cerulean blue, burnt sienna and two wells of Prussian blue. Drop a number of lengths of black cotton thread; some roughly 4in (10cm) and others roughly 6in (15cm) long, into one of the Prussian blue wells.

2 Paint a wet-in-wet painting (see page 39) using the normal wells of paint.

3 Lift a group of the threads out of the well of colour and lay them over the foreground of your painting, arranging them into the shapes you want. You can use individual threads if you want to add more controlled touches.

4 Press down on top of the threads using a sheet of baking parchment, then leave the painting to dry completely.

5 Once dry, gently peel away the threads with your fingers to reveal the finished effect.

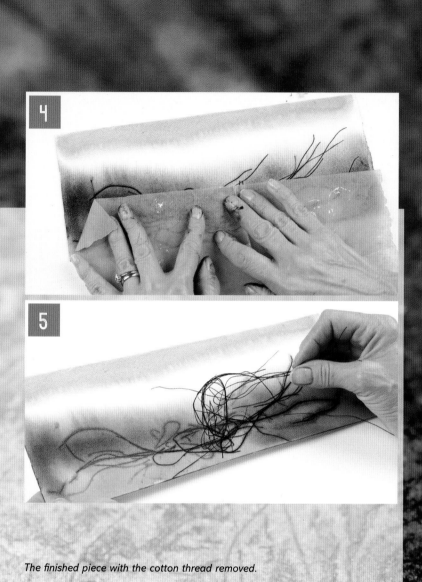

The finished piece with the cotton thread removed.

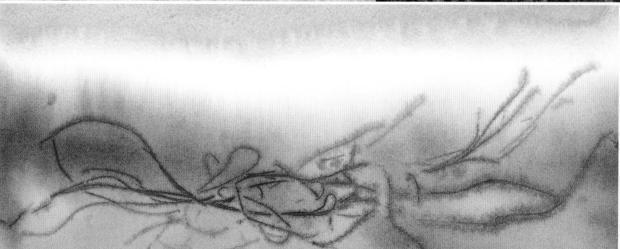

# Using collage

What an exciting way to add some excitement to your work! Collage can be used in either a very subtle way or in a more prominent striking style; it all depends on individual taste.

I usually stick important collage pieces on using ultra matt medium and white glue after I have drawn out the composition. I also coat whatever I am sticking down with the ultra matt medium as well; this protects it from more water and paint. Some papers such as bags, newspapers and photocopies are so very thin and absorbent that the paint would be soaked straight in and cover up whatever you wanted to be seen.

I try to connect the subject matter with whatever material I am sticking on without it being too contrived or twee. For example, a landscape could include part of a photocopy of a local leaflet so the name of something related shows through. Once everything is in place, I start my painting in the usual manner, ignoring the collage materials and painting as if they were not there. If they stand out too much a little white gouache, subtlety painted over, helps to tone them down.

I vary the amount of collage I add depending on how the painting comes along as I am working. Things can also be stuck on afterwards if you feel like you want to add more.

1  Use a 2B pencil to lightly sketch the basis of your painting, in this case a lemon. Next, tear up some small pieces of relevant collage material (in this case, some food wrapping, newspaper dining review and a doily) and use white glue to attach them to the picture, using the sketch to suggest where you should place each piece. Once in place, you can adjust them with a piece of kitchen paper over your finger – this is less likely to stick than your finger itself.

2  Continue building up the collage with more pieces of material.

3  Use a hog hair brush to apply some gesso loosely over the edges of the collage material, and also over a few areas of the paper. This helps break the abrupt changes between the watercolour paper surface and the collage material.

**4** Once dry, begin to paint over the surface as normal. For this example, I have used lemon yellow to paint over the lemon; notice how the gesso touches over the collage material help blend it in to the overall painting,

**5** Continue painting over the background, ignoring transitions or breaks between the areas of collage and simply treating the whole piece as a single surface. This ensures the collage remains a subtle background addition rather than the focus. For this example, I have used cobalt green, lemon yellow, French ultramarine and burnt sienna paints.

*The finished piece.*

The thing I love about using collage is that it is so versatile. It can be used for absolutely any subject matter, from flowers and landscapes, to industrial scenes, still life and portraiture. It is especially good for expressing your personality and artistic preferences because they are reflected in the materials you choose as well as how and where you apply them.

## Pears

*The collage materials for this picture were themed around items relating to pears or food in general – such as labels, bits of a shopping receipt and a recipe, just visible on the right. Inks were also used in the background.*

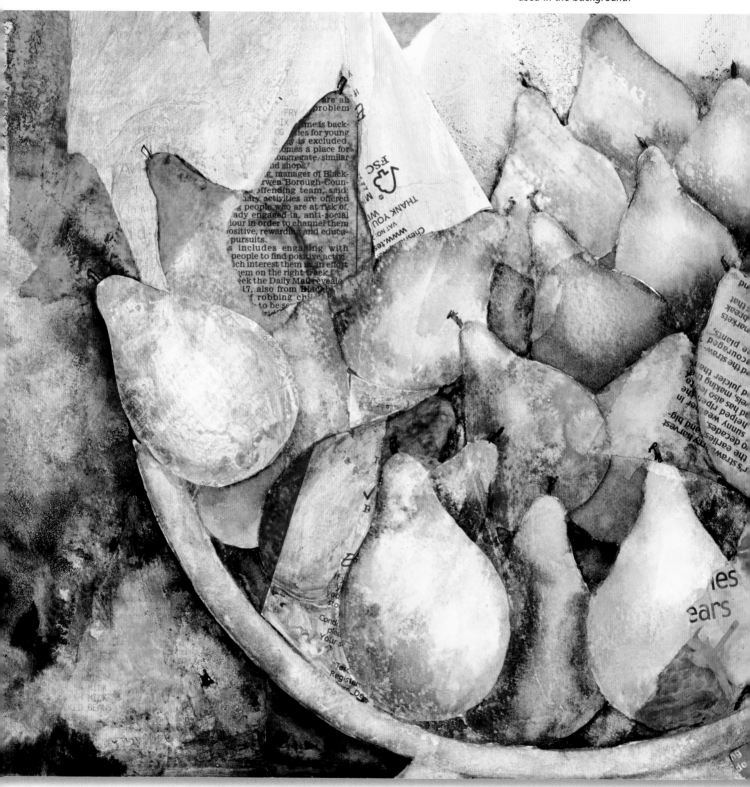

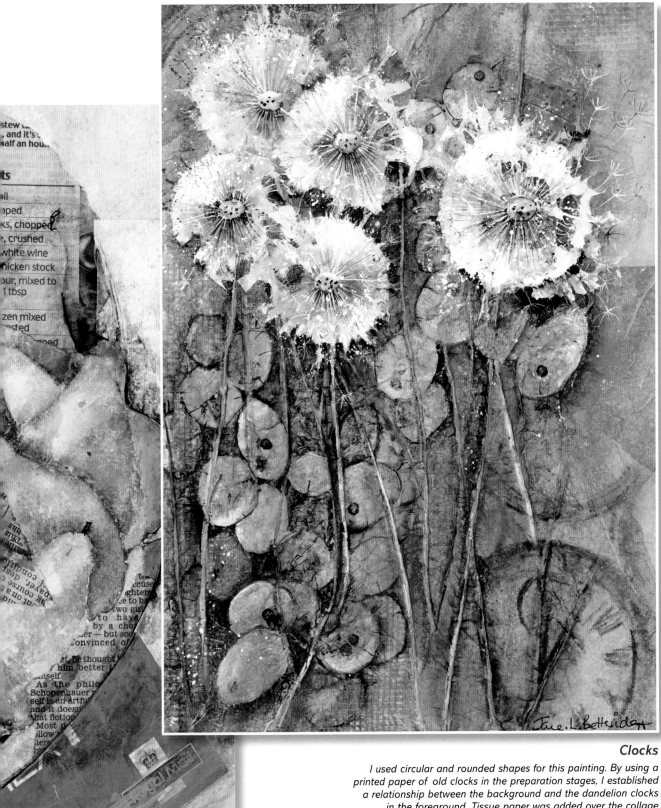

### Clocks

*I used circular and rounded shapes for this painting. By using a printed paper of old clocks in the preparation stages, I established a relationship between the background and the dandelion clocks in the foreground. Tissue paper was added over the collage materials to give a crinkled effect before I began painting.*

73

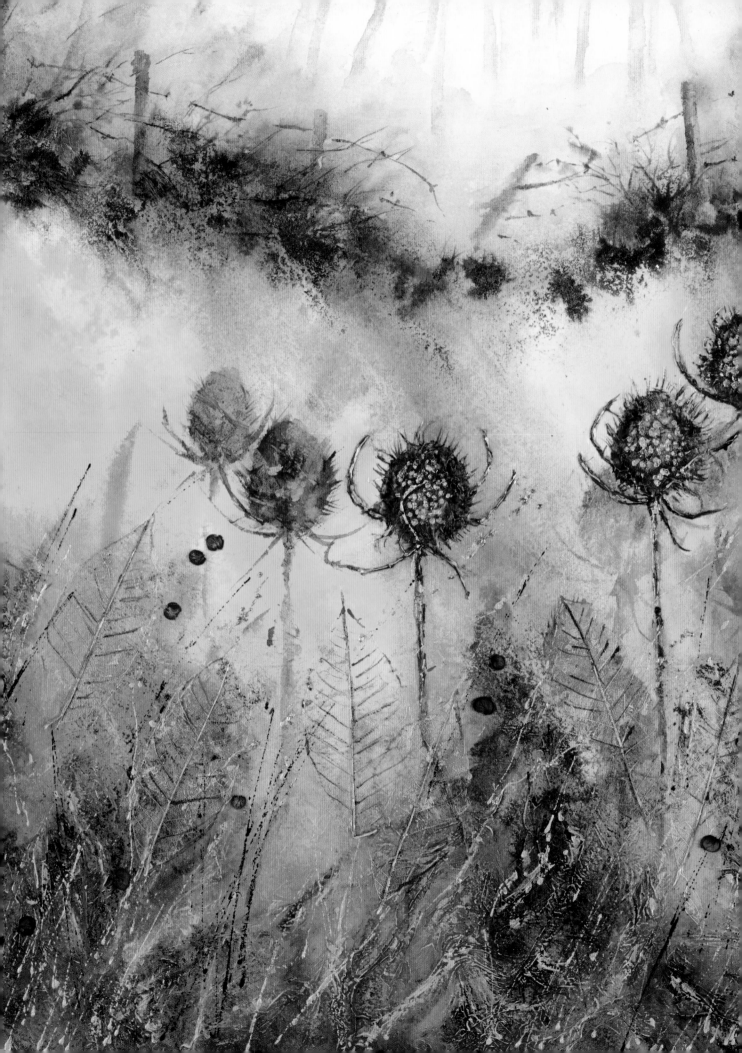

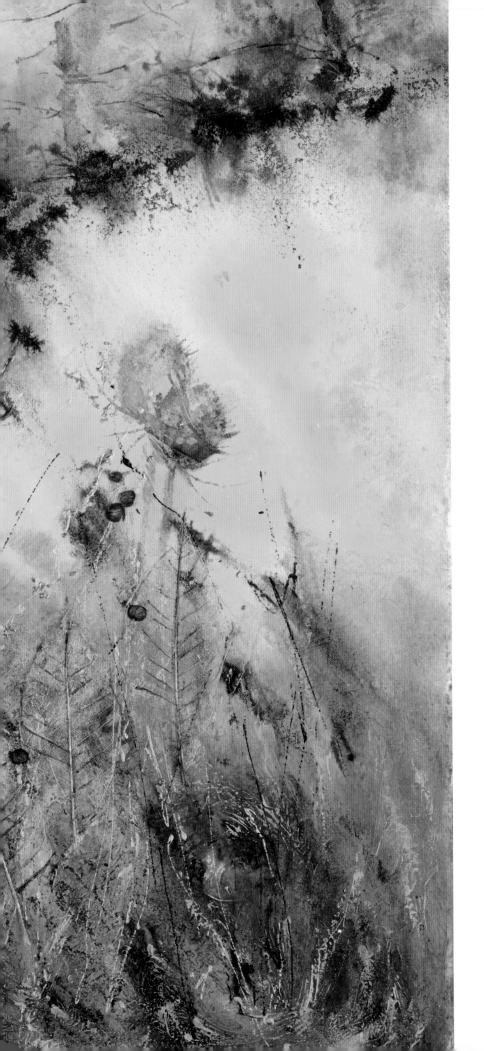

# COMPOSITION

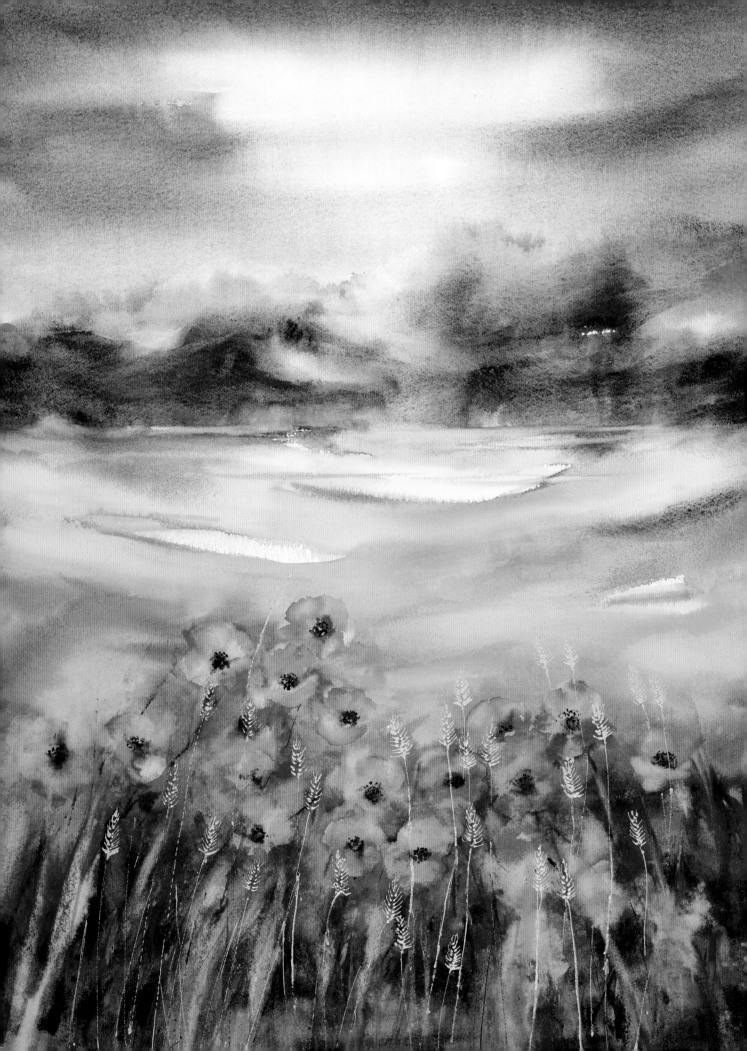

# Composition

Before starting a painting you must think about the composition. Once you have an idea of the subject you wish to paint, carefully select colours and values, and arrange a balance in the picture.

## The rule of thirds

While composition is largely down to personal choice, there is one generally accepted format to achieve a balanced painting: the rule of thirds. Essentially, this means that you divide your paper into three, both horizontally and vertically.

The composition of *Harvest Time*, the painting on pages 74–75, shows good use of the rule of thirds. The top third of the painting contains broken fencing and hedgerow, while the detail in the lower two-thirds is larger in scale and more detailed, which pushes the upper third back into the distance. The effect is further enhanced by the soft, pale shapes of the distant trees which recede further still into the background.

By positioning the main elements of your picture in or around the corner areas (top left or right, or bottom left or right), you will achieve an interesting balance.

## Depth and distance

When painting, you often want to depict the impression of depth and distance. This can be achieved through use of perspective by arranging objects in a certain way to encourage the eye to move from foreground to background. The correct viewpoint needs to be selected for an effective result.

Parallel horizontal lines receding into the distance – fences, railway tracks, paths, or avenues of trees, for example – will appear to converge at a vanishing point on the horizon and add depth to your painting.

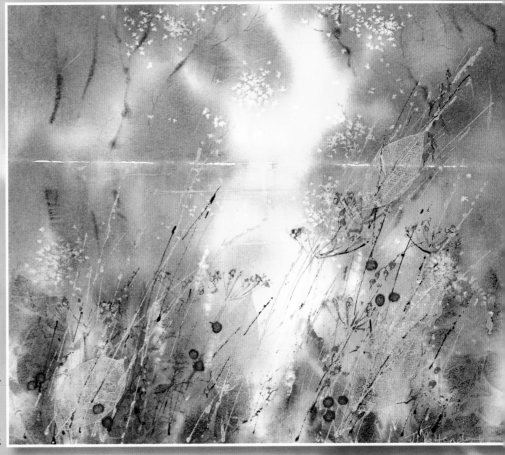

*Opposite:*

**Poppy Field**

*This is a typical example of the ideal three-part composition. The painting shows the distant landscape, then the middle distance and the foreground. A warmer colour and more detailed work at the front bring the poppies further forward to the eye.*

**Water's Edge**

*The less definition an object is given, the more it will recede into the background. In this painting, I have made only soft marks and shapes to represent the distant trees and foliage. For the foreground, the addition of collage pieces and extra detail draw the eye to the main subject matter.*

# PROJECTS

I hope you are enthused by the techniques that I have shown you. Now is the time for you to get started and have a go at incorporating them into your own painting.

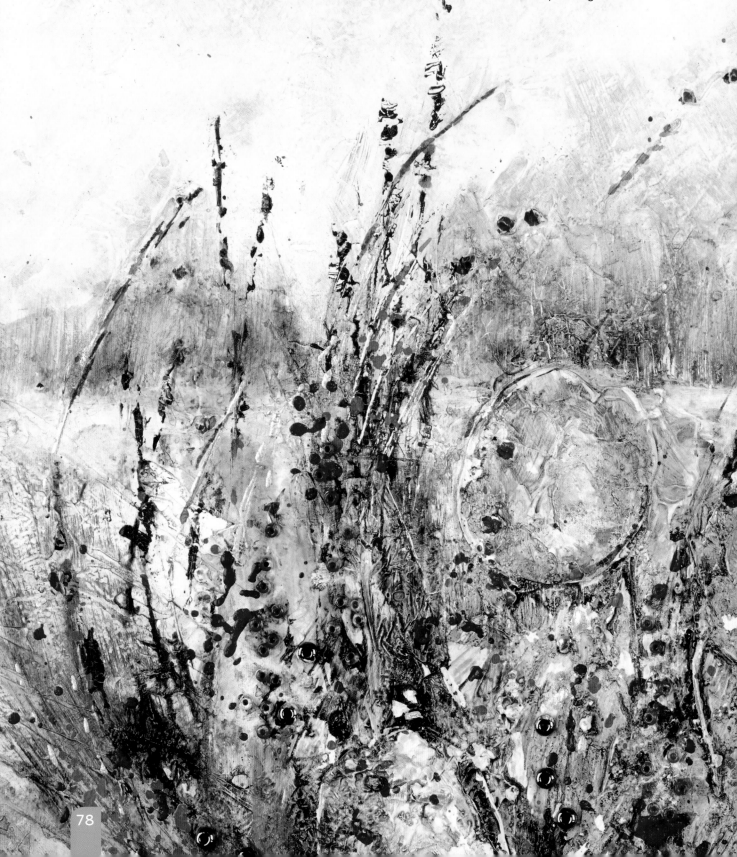

The following section of the book will take you through a diverse variety of subjects, ranging from castles, flowers and woodlands to seascapes and misty moorland. Each subject appealed to me for different reasons, and after photographing and roughly sketching them, I could not wait to get back to the studio and start work.

All the materials needed are listed and each step is accompanied by explanatory text and a photograph to help show you how I approached each part. I hope by the time you have worked on these projects, it will whet your appetite and encourage you to use these techniques on the subjects that inspire you.

Many of the methods shown can be intermingled with one another, there are no set rules. You may find that you prefer some of the techniques to others – just use the ones that interest you at first; before you realise it, you will find yourself keen to carry on experimenting.

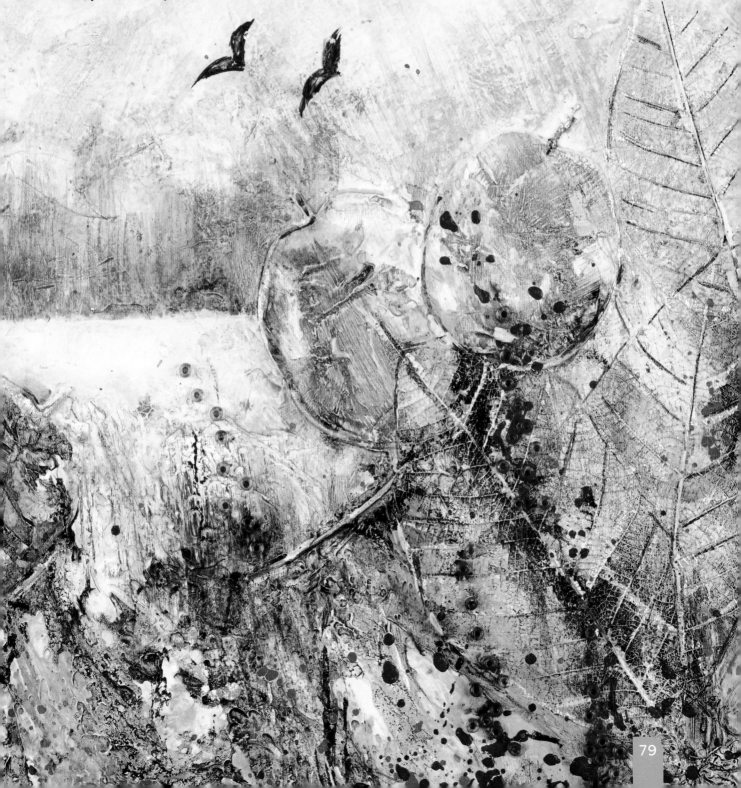

# DAFFODIL

The appearance of flowers, in all their shapes and uplifting colours, always makes me want to get painting. The first sign of spring to me is always the vibrant yellows of daffodils. As soon as they poke their heads through the ground I always think that the worst of winter is behind us.

I focused on one flower head and decided to concentrate on the iridescent warm and cool yellows that make the daffodil so striking. In this project, we will look how to use contrasting blues and violets to make yellow stand out, and make interesting shapes on some of the petals using plastic food wrap.

## You will need

28 x 38cm (11 x 15in) 535gsm (250lb) Not surface watercolour paper

Watercolour paints: Winsor yellow, permanent yellow deep, French ultramarine, green-gold, bright violet

Brushes: size 12 round, size 4 round, size 2 round

2B pencil and putty eraser

Masking fluid and old brush

Plastic food wrap

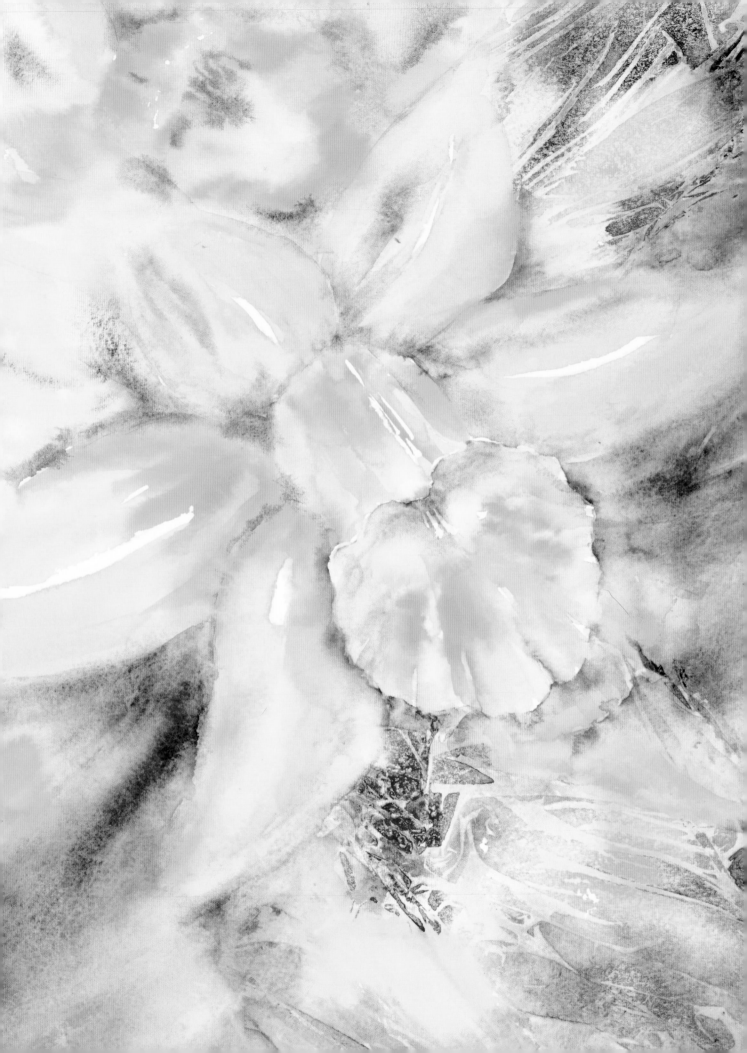

1   Use a 2B pencil to sketch out the basic shapes, then use an old brush to apply masking fluid to the highlights on the trumpet as shown. Prepare wells of Winsor yellow, permanent yellow deep, French ultramarine, green-gold, and bright violet. Mix up plenty of paint to ensure you do not run out at an important point.

2   Use a size 12 brush to paint the base of the topmost petal with Winsor yellow, then draw out the colour with clean water to add a highlight towards the top and tip of the petal. Add in a little permanent yellow deep at the bottom, wet-in-wet.

3   Draw the colour out with water, then drop in a little French ultramarine beyond the edge of the petal.

4   Drop in some bright violet near the corner, then start working down the painting, adding in touches of French ultramarine and green-gold wet-in-wet.

5   Still using the size 12 brush, begin to build up the background around the top right-hand corner with these colours, working towards the adjacent petals. Add a subtle shadow on the topmost petal using a little French ultramarine and draw it out towards the corner.

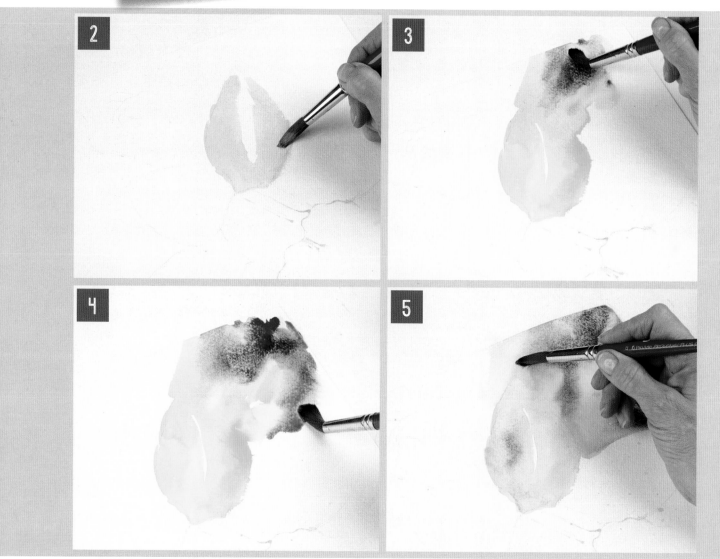

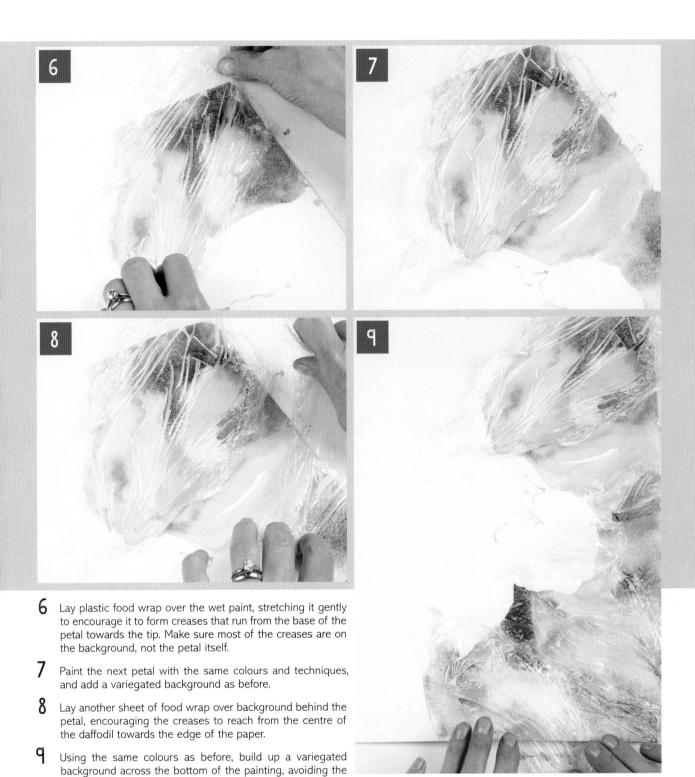

6  Lay plastic food wrap over the wet paint, stretching it gently to encourage it to form creases that run from the base of the petal towards the tip. Make sure most of the creases are on the background, not the petal itself.

7  Paint the next petal with the same colours and techniques, and add a variegated background as before.

8  Lay another sheet of food wrap over background behind the petal, encouraging the creases to reach from the centre of the daffodil towards the edge of the paper.

9  Using the same colours as before, build up a variegated background across the bottom of the painting, avoiding the edge of the trumpet and lowest petal, and lay more plastic food wrap across the wet paint, encouraging the crease to fall as though radiating from the centre of the daffodil.

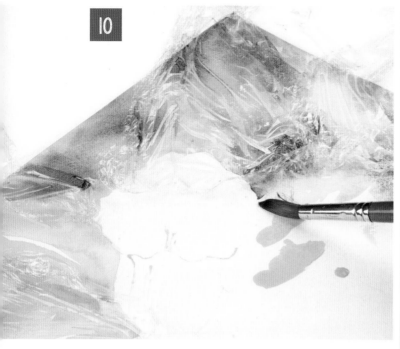

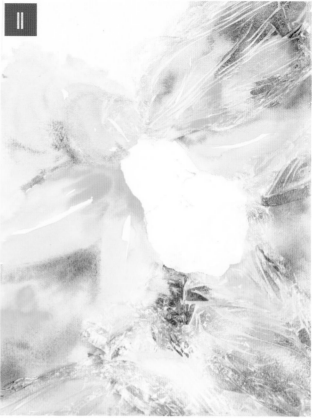

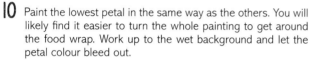

**10** Paint the lowest petal in the same way as the others. You will likely find it easier to turn the whole painting to get around the food wrap. Work up to the wet background and let the petal colour bleed out.

**11** Continue working round the painting with the same colours and techniques, adding in the other petals and surrounding background. Use more Winsor yellow for the background on the left-hand side, and do not cover it with food wrap.

**12** The top-left corner contains a smaller background daffodil. Paint this area with Winsor yellow, then suggest the trumpet with permanent yellow deep.

**13** Suggest a little more shape with the same colour, then add touches of French ultramarine and bright violet wet-in-wet for soft details.

**14** Change to a size 4 brush and use negative painting to add deeper shadow inside the trumpet. Leave a few yellow lines in the trumpet, to suggest the stamens through negative painting. Use the same brush to add a few more details using the colours in your palette, but keep them subtle and leave the overall impression light.

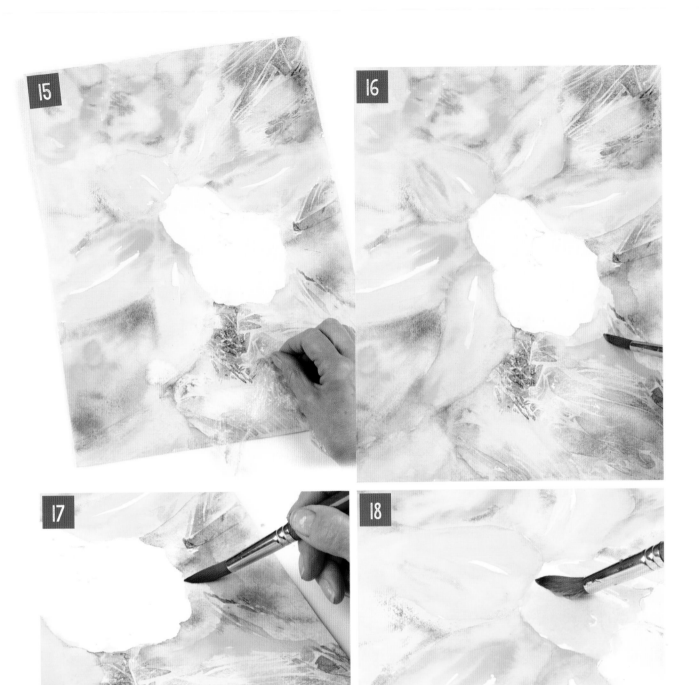

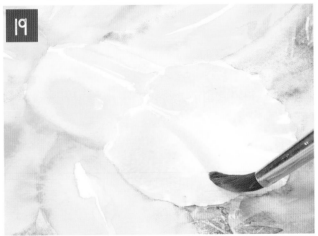

15  Allow the painting to dry for a few minutes, then carefully remove the food wrap.

16  Use the size 12 brush to develop the darker parts of the daffodil petals with permanent yellow deep, and draw in a little French ultramarine for shading. Pay particular attention to the petal almost hidden behind the trumpet.

17  While the petal behind the trumpet is wet, add touches of French ultramarine and bright violet wet-in-wet near the edge to suggest the cast shadow.

18  Still using the size 12 brush, dampen the centre where the trumpet emerges from the centre of the petals and paint it using Winsor yellow. Keep the colour pale.

19  Paint the inside of the trumpet with the same colour, using brushstrokes that follow the direction of growth.

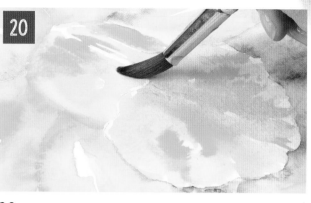

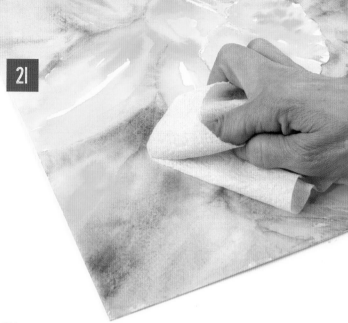

**20** Working wet-in-wet, add permanent yellow deep; again using light strokes that follow the direction of growth. Use the same colour to add some shading to the outside of the trumpet.

**21** Look over the painting while the trumpet dries. If any hard lines have emerged, you can soften them by gently wetting the area with clean water and softly lifting it out with kitchen paper.

**22** Once the trumpet has dried, use the size 12 brush to add some subtle shading in the mouth of the trumpet with dilute French ultramarine.

**23** Use the point of the brush to add some small triangular marks around the edge of the trumpet with dilute French ultramarine, in order to suggest shadows and shaping. Turn the painting to help you reach areas, if you find it helps.

**24** Adjust the colours on the trumpet if necessary, building up the shadow around it with French ultramarine and permanent yellow deep to help it stand forward of the petals.

**25** Allow the painting to dry, stand back and look to see if any areas need to be knocked back or brought forward. Here, the lower left-hand corner needed strengthening, so I have added some French ultramarine, applying it with the size 12 brush and working up to the edge of the petal. This adds some contrast between the petal and background, pushing the petal forward.

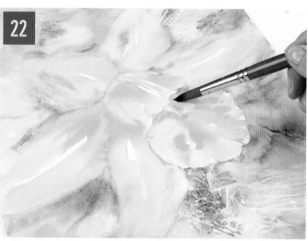

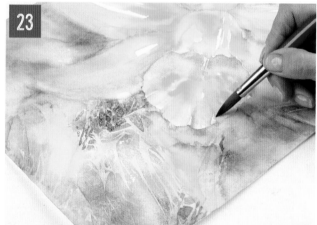

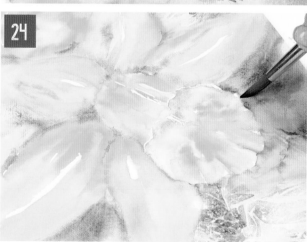

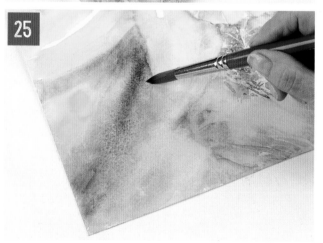

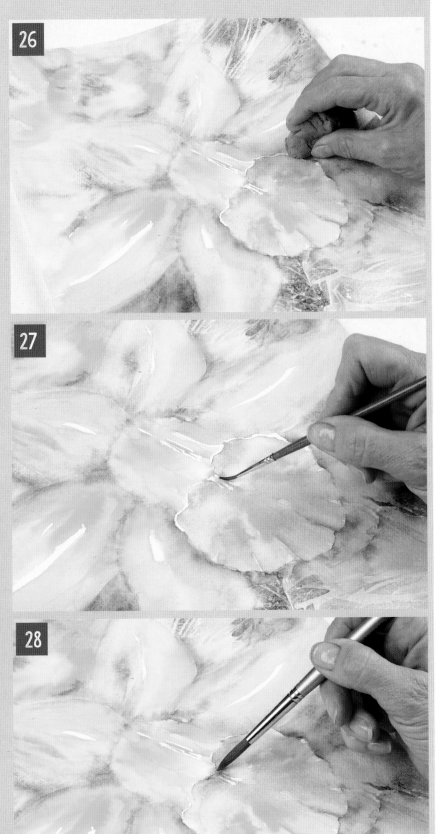

**26** Make any final adjustments, allow the painting to dry thoroughly, then use a clean dry finger to gently rub away the masking fluid. Use a putty eraser to remove any pencil lines this reveals.

**27** Use the tip of a size 2 brush to add a touch of permanent yellow deep to the base of the stamens, leaving the tips white.

**28** Change to the size 4 brush and wet it. Remove the excess water and soften the hard white highlights at the edge of the trumpet; then add a hint of French ultramarine at the very base of the stamens. Draw this down the edge of the stamens to emphasise them. Allow to dry to finish. The finished painting can be seen on page 81.

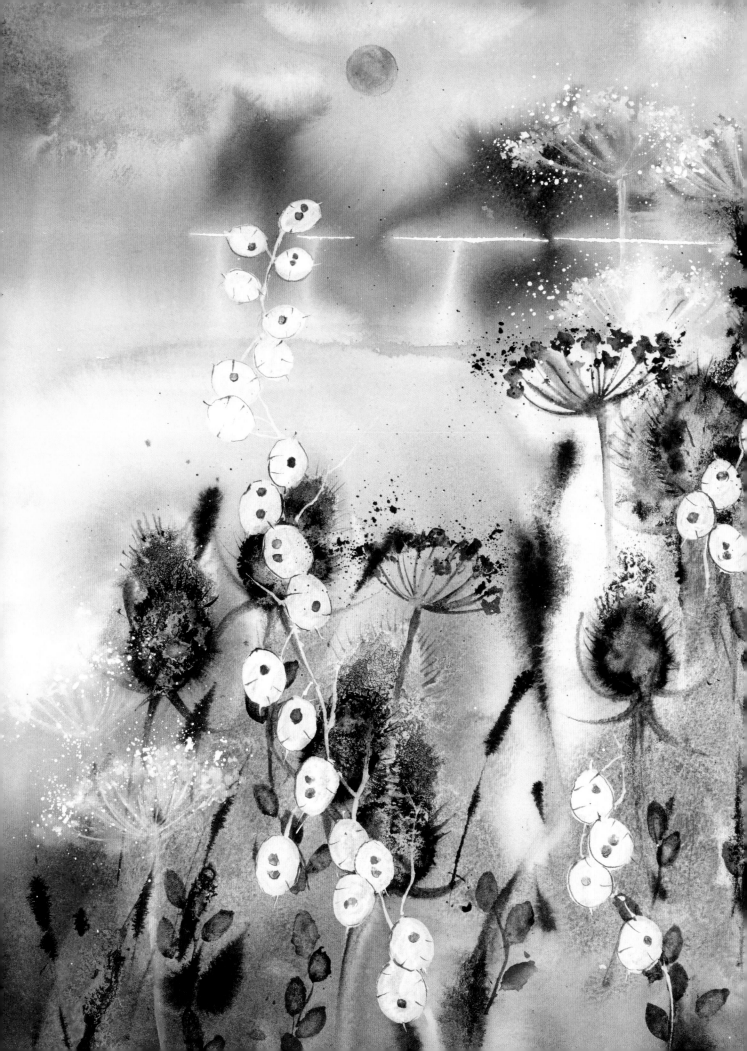

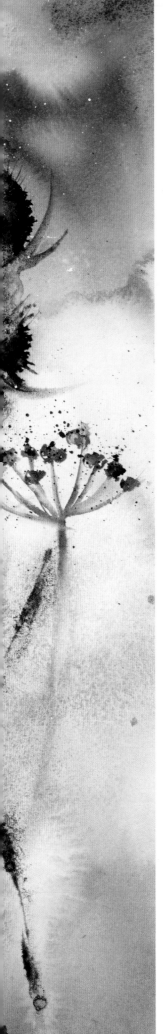

# HONESTY

No matter the time of the year, if you look hard enough there is always something Mother Nature has to offer as inspiration – such as the spiky teasels, berries, brambles, hogweed and seedpods in this wintry painting. I have called this painting *Honesty* because it was the lovely shimmering, silvery seedpods of this plant in a tangled hedgerow that caught my eye.

The painting emphasises the tangled foreground, with just a glimpse of moonlight in the distance. The background is painted in cooler colours to aid recession. A little warmth is added by a touch of violet and the honesty is painted in white ink, while the suggestions of teasels and hogweed are made with sepia ink.

## You will need

38 x 43cm (15 x 17in) 640gsm (300lb) Not surface watercolour paper

Watercolour paints: cobalt violet, lavender, indigo, French ultramarine, burnt umber

Brushes: large mop, size 16 round, size 12 round, size 4 round, size 2 round, size 10 round, size 0 rigger

Inks: white, sepia

2B pencil and ruler

Granulation medium and pipette

Spray bottle

Small leaf stencil

Small palette knife

Small coin

Kitchen paper

*The finished painting.*

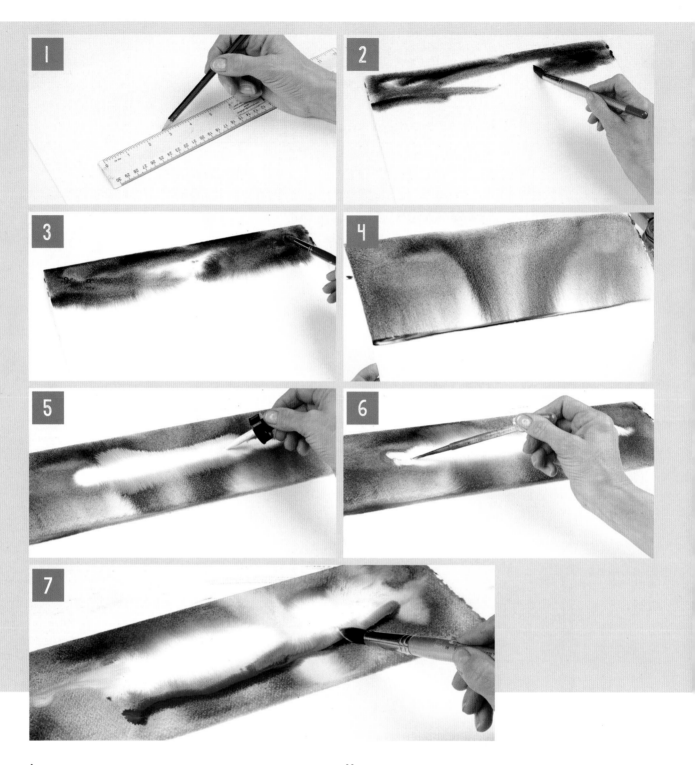

1. Use a 2B pencil and ruler to draw a faint horizontal line across the paper, 12cm (4¾in) down from the top. This will be the horizon line.

2. Prepare wells of cobalt violet, lavender, and indigo. Using a mop brush, wet the paper from the top down to the horizon line. Using a size 16 brush, lay in a wash of indigo across the upper half of the wet area.

3. Working wet-in-wet, add touches of cobalt violet with a size 12 brush.

4. Pick up the painting and tilt the paper a little to encourage the colours to merge.

5. Lay the painting flat and use the dropper tip to draw a strip of white ink across the centre of the sky.

6. Use a pipette to drop in granulation medium in spots across the sky.

7. Tip and tilt the paper a little, being careful not to let the colour form drips, then use a size 16 brush to add more indigo below the strip of white ink.

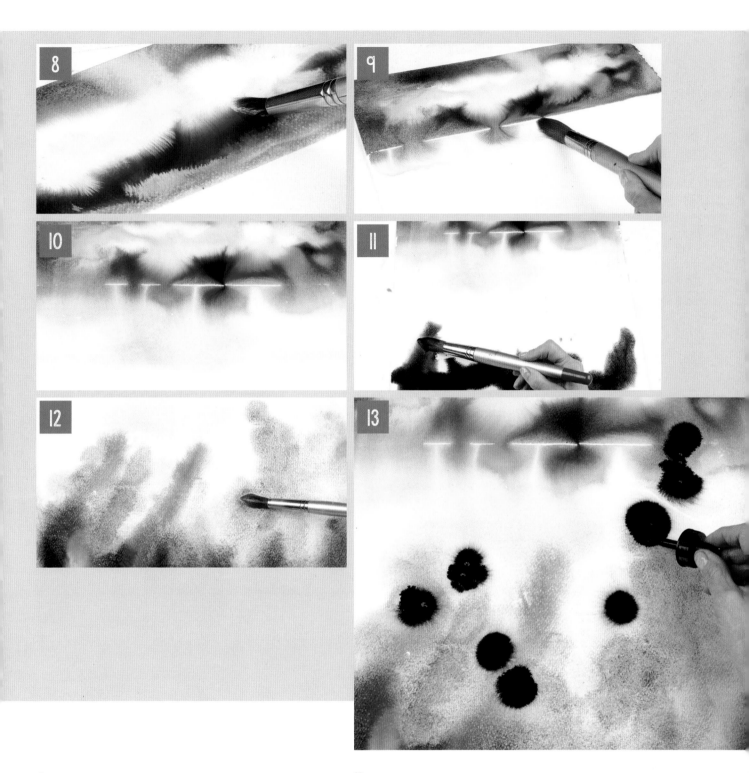

**8** Quickly rinse the brush, remove the excess water, then use the damp brush to draw in the wet paint from around the ink in order to break up the mass of white.

**9** Drop in granulation medium all over the ink using a pipette, then pick up the paper and gently tilt it in order to merge and disperse it. Lay the paper back down, load the mop brush with clean water and draw it smoothly in a line under the horizon, letting the tip touch occasionally to let the colour bleed down.

**10** Wet all the way down to the bottom of the painting.

**11** Load the mop brush with indigo and spread the colour all across the bottom of the painting, then tease it upwards in a few places.

**12** Working wet-in-wet, add in some areas of cobalt violet at the side with the mop brush, then pick up some lilac and build up the lower part of the painting into a variegated wash. Change to a size 16 brush and strengthen the wash with more cobalt violet.

**13** If the paper starts to dry, mist it using a spray bottle. Use the dropper to add dots of sepia ink across the central area of the painting.

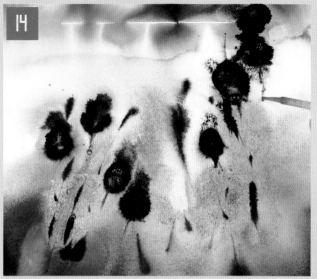

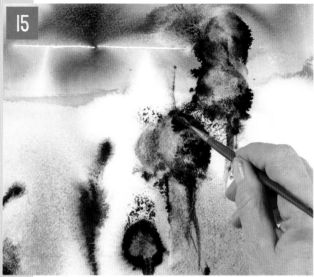

**14** Still working wet-in-wet, draw some marks upwards using the dropper of the sepia ink, then use a pipette to drop granulation medium into the centre of each of the ink drops. Use enough that the shapes start to break up, then use the tip of the pipette to draw a few of the spots out with downwards strokes.

**15** Change to a dry size 4 brush and tease some more lines down from the ink spots. Reshape any too-large inkspots into two separate ones by lifting out some excess ink from the centre and redrawing it with a size 4 brush and sepia ink.

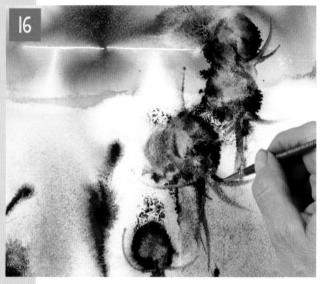

**16** Still working wet-in-wet, draw out the bottom parts of each large ink spot using the size 4 brush and strokes that curve upwards to form teasels.

**17** Use the dropper to add some more strokes of sepia ink, pulling them upwards from the very bottom of the painting. Add more granulation medium with the pipette to encourage these new marks to break up a little.

**18** Draw the wet ink out from the teasels into short spikes using the size 4 brush, then let the painting dry.

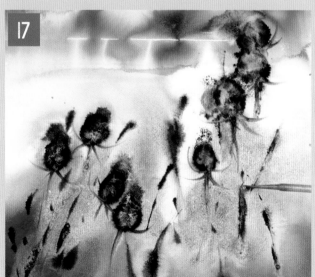

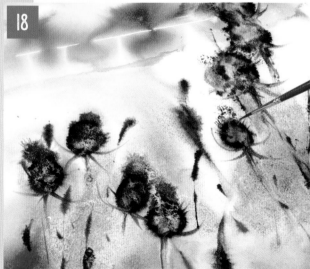

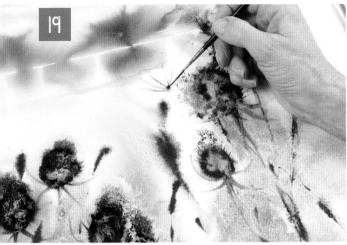

19

**TIP**

Due to the techniques used in the early stages of the painting, it is likely that you may have one or two 'backruns' – where wet paint has met drying paint and pushed the pigment into a cauliflower-like shape. Normally these are unwelcome, but here they can help you decide on placement for the additional plants in step 19. Backruns can be turned into part of the painting by using their shapes to suggest hogweed, cow parsley or a similar plant. Of course, if the background has worked perfectly, you can pick where to place the additional plants!

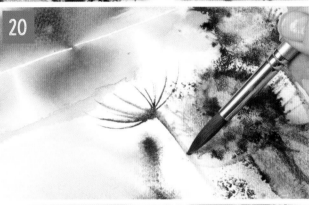

20

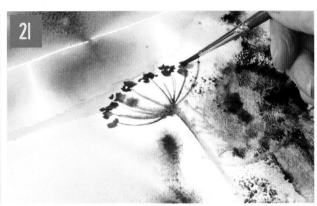

21

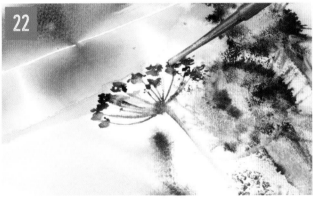

22

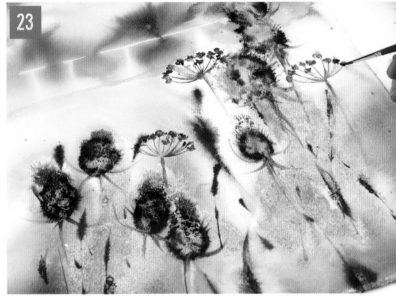

23

19 It is now time to add some additional plants. Make a dark mix of French ultramarine and burnt umber and use the size 2 brush to add a central spot. Draw some fine lines with the same mix in towards the central spot. Quickly soften them away with a little water.

20 Dampen a size 10 brush and draw the tip downwards from the central spot to form a faint stem.

21 Add some seedpods on the ends of the fine lines with a size 4 brush. Rinse the brush and use the damp tip to soften and blend them.

22 Add a little granulation medium to the seedpods using the pipette, then allow it to dry.

23 Add a few more additional plants across the painting. When deciding where to put them, look at the existing painting as a whole and decide where they can go to help balance the piece. Here I have added one to the lower left of the centre, and another roughly halfway up the right-hand side – the first one I painted helped me to decide where to place the supporting ones. Keep the left-hand side free of these additional plants, as this space is reserved for the honesty seedheads.

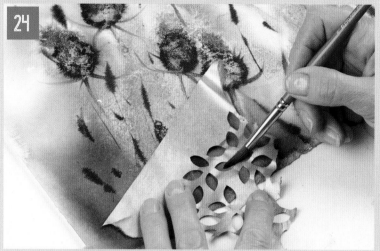

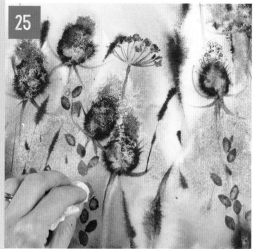

**24** To darken the bottom part of the painting, lay a leaf stencil over it and use a size 6 brush to paint a mix of burnt umber and French ultramarine over it. Use a fairly thick mix to help ensure you do not smudge the paint.

**25** Move the stencil around as you work to build up some darks around the stems. Wet the centre of a few of the leaf shapes with the brush, then use kitchen paper to lift out some subtle highlights.

**26** Still using the same mix, use a size 0 rigger to draw some fine stems and branches to join some of the stencilled leaves.

**27** Pick out a few more fine spikes and details on the teasels with the same mix and the rigger. Use a more dilute mix for the fainter, distant teasels.

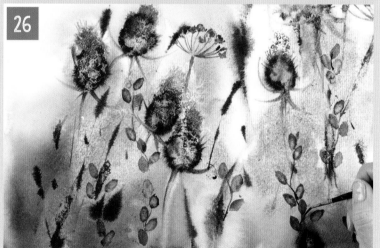

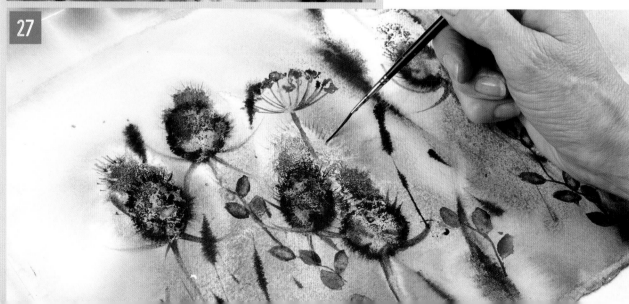

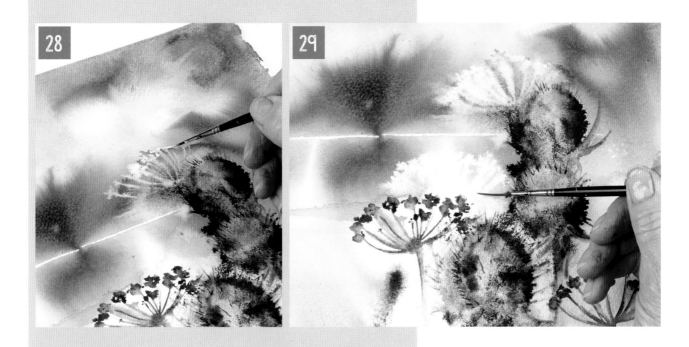

**28** Use a spray bottle to wet an area in the top right, then use the rigger to draw white ink into the area to lighten it. Add some dots and touches of the wet ink on the lines to represent seedheads.

**29** Add some more cow parsley heads nearby in the same way. Suggest stems on any places where they would be obvious. Allow to dry.

**30** It is now time to add the honesty on the left-hand side. Use a 2B pencil to mark the topmost part to help guide you before you start in with ink.

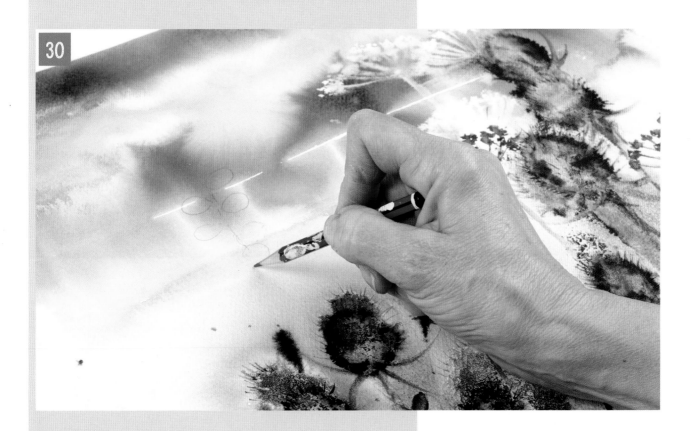

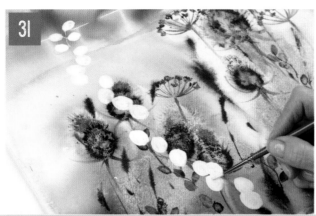

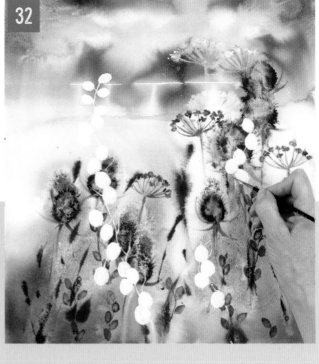

**31** Change to a size 4 brush and begin painting in the honesty using white ink. Do not use the ink sparingly; apply it quite thickly. Work down to the bottom of the piece, adding small groups of seedpods. Overlap a few. Work over everything else in the painting – this stem on the right-hand side is the focal point.

**32** Add one or two smaller sprigs of honesty on the right-hand side to help balance the painting, then draw in all the stems, connecting the groups of leaves. Use the size 0 rigger to add a little point to each seedhead.

**33** With the honesty in place, take a look at the overall balance of the painting. You may wish to strengthen areas or even add another one or two flower heads.

**34** Use the small palette knife to spatter white ink on to the painting over the cow parsley.

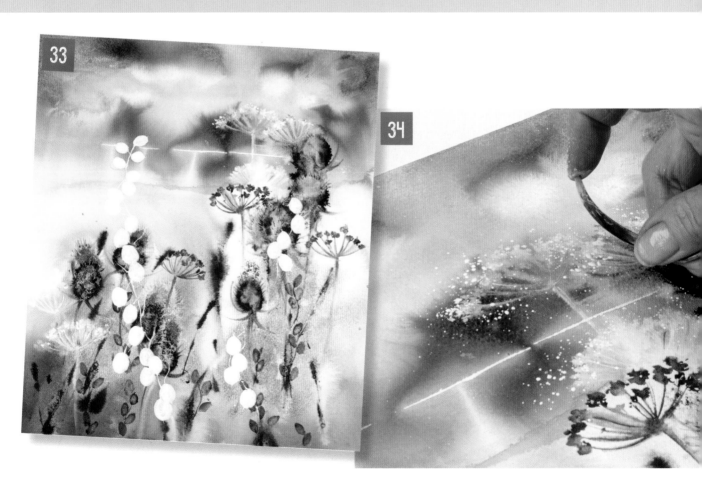

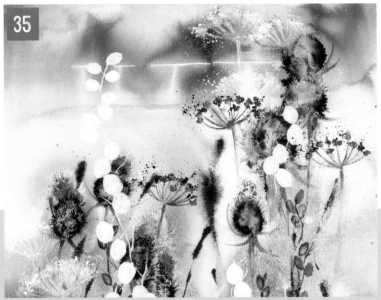

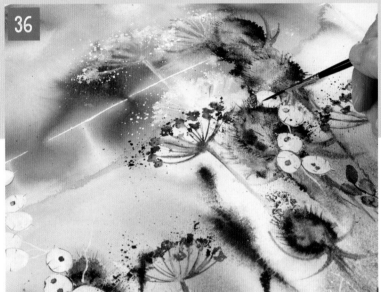

**35** Spatter some of the dark mix (French ultramarine and burnt umber) over the hogweed with the small palette knife.

**36** Paint small circles in each of the honesty seedheads using the size 4 brush and the dark mix. Add one to some, two to others, and leave some blank. Use the size 0 rigger to add details to the edges of the seedheads with the dark mix.

**37** To finish, add the moon by drawing round a small coin and then using a size 4 brush to paint it in using cobalt violet. Dab the wet paint lightly with kitchen paper to lift out some texture, then allow to dry to finish. See page 88 for the completed painting.

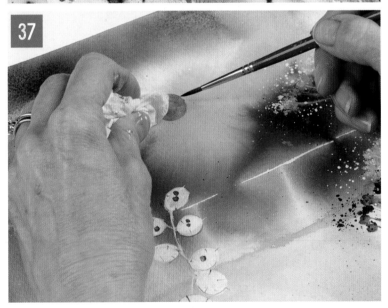

# AUTUMN

*Opposite:*
*The finished painting.*

On autumn walks in the countryside, I cannot help being inspired by all the rich golds, reds, purples and browns of the trees and hedgerows – the remnants of summer.

Scattered about are conkers, acorns and pine cones, but the real jewels in nature's crown are the many berries – deadly nightshade, rosehip, hawthorn; and a special favourite of mine, blackberries.

I have used warm, golden colours in this painting along with lovely purples, reds and blues for the blackberries. I painted some skeleton leaves gold and stuck them on to a wash that had been covered, in parts, in plastic wrap to give some organic background leaf shapes. The blackberries were painted last of all once I had removed their masking fluid.

## You will need

28 x 38cm (11 x 15in) 640gsm (300lb) Not surface watercolour paper

Watercolour paints: bright violet, French ultramarine, green-gold, burnt sienna, quinacridone gold

Brushes: size 16 round, size 12 round, size 6 round, size 4 round, size 8 round

Inks: sepia

Masking fluid and old brush

Plastic food wrap

Leaves

Baking parchment and roller

Leaf skeletons

White glue

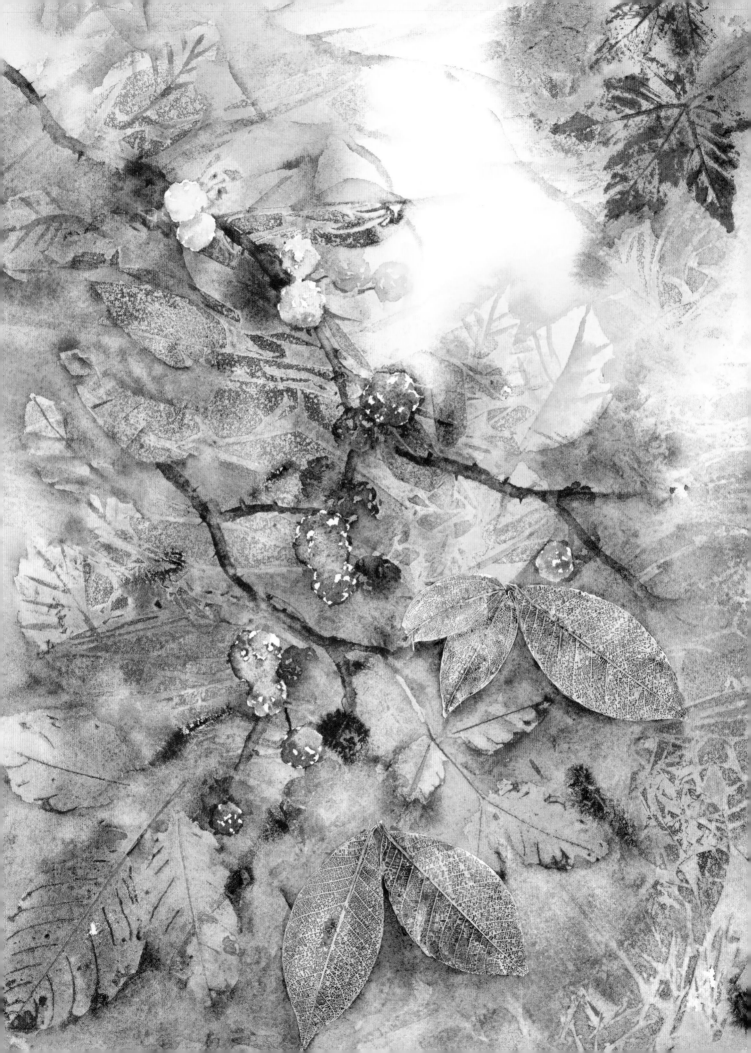

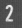

**1** Sketch the basic shapes on to the paper with a 2B pencil.

**2** Using the masking fluid and an old brush, mask out a few of the blackberries as shown, and allow to dry before continuing. It is not critical which ones you mask, but try to lead the eye into the picture by picking ones along a loose curve.

**3** Prepare the following wells of colour: bright violet, French ultramarine, green-gold, burnt sienna and quinacridone gold. Wet the whole painting with the large mop brush and clean water, then use a size 16 round to drop in areas of quinacridone gold – the lightest colour – near the top of the painting. Add the colour over the top half of the paper, leaving an area untouched near the centre.

**4** Working wet-in-wet, add green-gold across the painting in the same way. Leave the area untouched in step 3 clean. Add the paint in some clear areas, and over and into the quinacridone gold in some areas. Let the colours merge and bleed together. Build up a darker blue-purple area around the blackberries using French ultramarine and bright violet in this area.

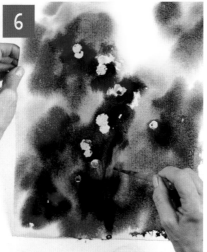

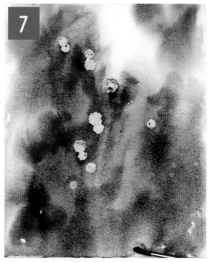

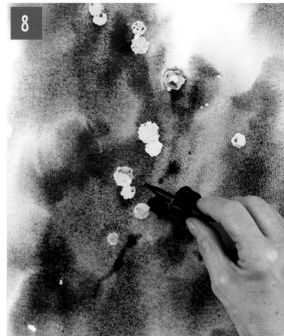

5 Continue adding the other colours here and there. It is not important where the colours go, but do try to emphasise bright violet and French ultramarine around the blackberries, and keep the top half of the painting light.

6 Tip and tilt the paper to encourage the colours to merge. Use a pipette of clean water to dilute any areas that are too strong, allowing them to drip and flow off the bottom of the paper.

7 Lay the paper down flat and use a clean damp size 12 brush to move the paint around if you need (or want) to.

8 When the paper starts to dry and the sheen disappears, drop in some sepia ink here and there to add some darks.

9 Place the leaves lightly on the wet paint, concentrating a group in the lower left, and a group in the top right.

10 Drape plastic wrap over the painting. Do not adjust it; once it touches the paint, let it fall.

11 Lay a flat heavy object, such as a block of wood or a book, over the leaves; then allow the painting to dry for at least two hours, and preferably overnight.

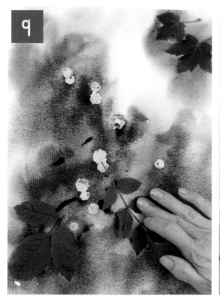

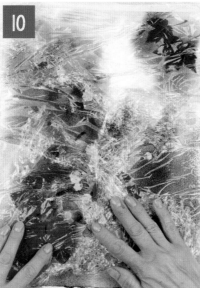

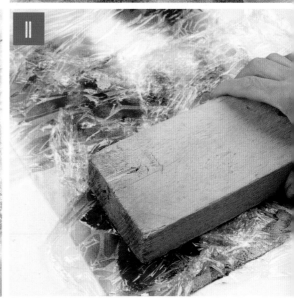

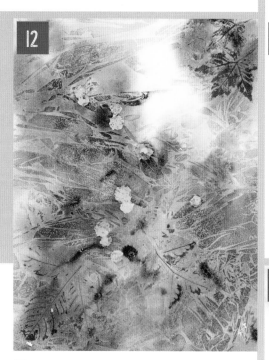

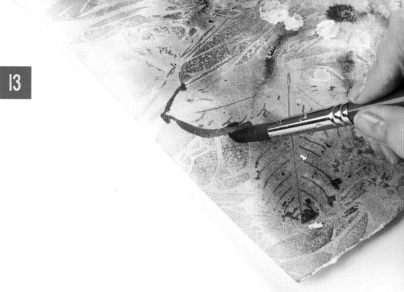

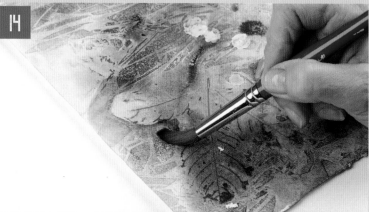

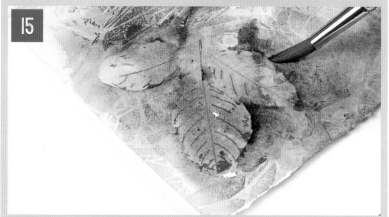

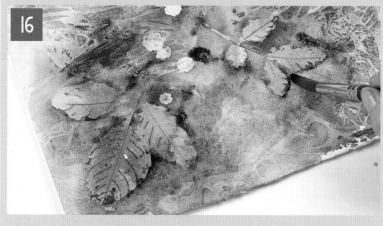

**12** Carefully peel away the plastic wrap and leaves to reveal the effect.

**13** Using the colours on your palette and a size 12 brush, begin to bring out the impression of the leaves. Working wet-on-dry, roughly match the colour you apply to the background area – for this part of the leaf on the lower-left I have used burnt sienna for this warm brown area – and paint outside of the outline of the leaf.

**14** Working quickly, rinse your brush, then use the water remaining on it to draw the colour away from the edge of the leaf and glaze the surrounding background. Soften it away quite a distance; you do not want to create a halo or hard line around the leaf.

**15** Work round the rest of the leaf in the same way; building up the background around the leaf. This will throw the leaf forward in a process called negative painting.

**16** Build up some of the other leaves in the lower part of the painting in the same way. Do not stick slavishly to the background colours when choosing the paint to overlay – part of the enjoyment of painting is choosing similar or complementary colours to those on the paper.

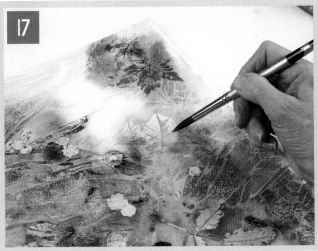

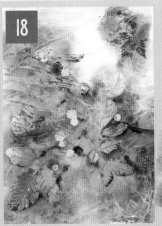

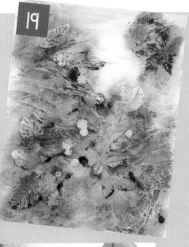

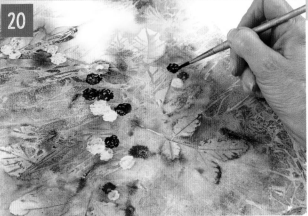

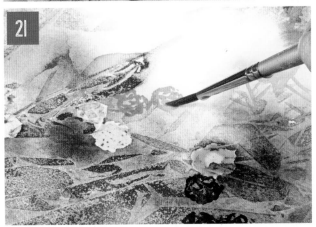

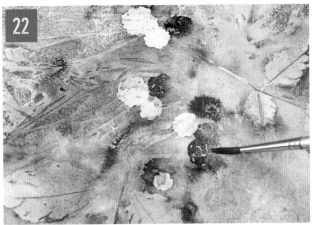

17 Work upwards through the painting, picking out leaf impressions with negative painting and the colours on your palette. Look for shapes created by the plastic wrap that are suggestive of leaves, too – these can be developed into new leaves through negative painting. You can also use the tip of the brush to add some details and strengthen the leaves.

18 Continue building up the picture through negative painting. A lot of this stage is interpretation of the random shapes the plastic wrap has created; pull out ones that catch your eye. Be careful not to overwork the painting. The random shapes made by the plastic wrap are part of the painting, so do not develop all of them into leaves.

19 Step back every few minutes to see how the painting is developing; and move on once you reach a point where there is a good balance between random shapes and more developed ones.

20 Use a purple mix of bright violet and French ultramarine to paint a few mature blackberries near (and overlapping) the masked-out areas. Apply the paint with the tip of a size 6 brush, using small circular motions and leaving spaces between the marks.

21 Paint some developing blackberries in the same way, using green-gold instead of the purple mix. Place these emerging into the light area of paper you reserved earlier.

22 While the paint remains workable on the purple blackberries, rinse your brush and soften the lower parts of each one to help knock them back into the painting a little.

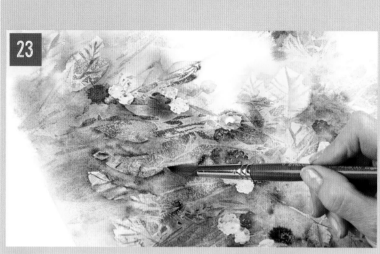

**23** With the blackberries in place, look again at the balance of the painting. You may wish to add some further leaf shapes. I have decided to add a few more definite leaf shapes on the left to draw the eye this way, using the techniques and materials described in steps 14–18. Allow the painting to dry

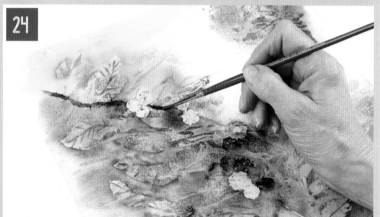

**24** Prepare a dark mix of burnt umber and French ultramarine, and use a size 4 brush to paint in the main foreground stem. Start at the top left-hand part of the painting. Here and there, add a drop of water to dilute the colour to show where sunlight is hitting the stem, and work past the blackberries nearest the top left. Add the suggestion of thorns with the tip of the brush.

**25** Continue painting the main stem down the painting, working towards the lower-right-hand side in a meandering, curving line. Split the main branch – or add an entirely new one, as you wish – to connect some of the blackberries, and work right past some of the others.

**26** Using more of the French ultramarine in the mix, add the suggestion of a few distant branches running over the sunlit area. To help suggest the distance, blend them away using a wet brush and do not add fine detail like the thorns.

**27** Allow the painting to dry, then remove the masking fluid by rubbing it away with a clean, dry finger.

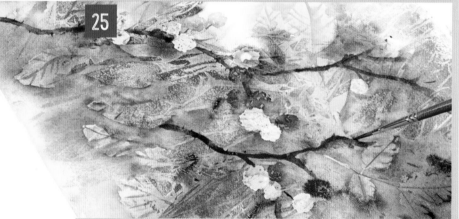

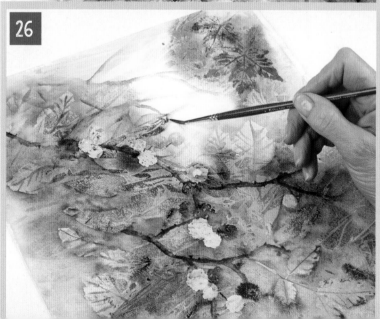

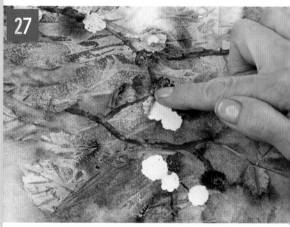

**28** Paint the revealed blackberries in the same way as the others, using the tip of the size 6 brush to add small curved strokes with spaces between. Use the purple mix (bright violet and French ultramarine) for the majority, and green-gold for a few. As these are in the foreground, there is no need to blend the lower parts of these berries into the surface.

**29** Paint the backs of some gesso-strengthened leaf skeletons with white glue and attach them to the surface in the foreground on the lower left-hand side. Use a variety of sizes.

**30** Lay baking parchment over the top of the leaves and use the roller to firmly press them in place. Allow the painting to dry before continuing.

**31** Once the glue has dried, use a size 8 brush to apply touches of green-gold, French ultramarine, burnt sienna and quinacridone gold to paint the leaves and help them complement the background. Allow the paint to dry.

**32** To finish, use the same colours to add any changes you wish to the leaves, then use the size 8 brush to apply dark shadows beneath the leaves to help them stand out a little from the painting using a dark mix of burnt sienna and French ultramarine. The finished painting can be seen on page 99.

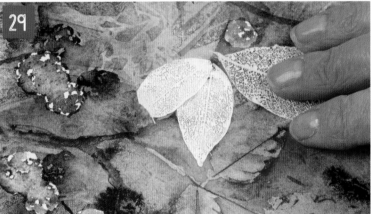

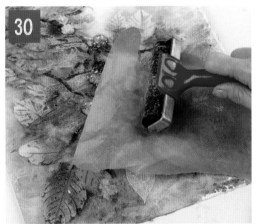

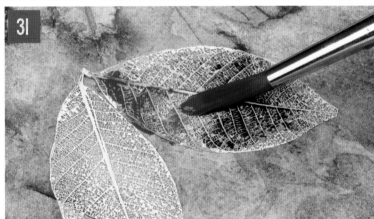

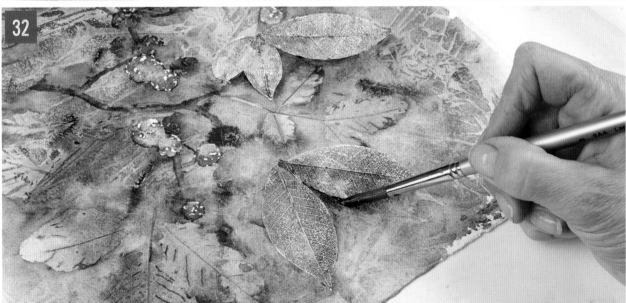

# SEASCAPE

Using a surface primed with gesso, I tried to capture the spray, the smell, the texture and general atmosphere of an afternoon relaxing on Porthmeor beach in St Ives, one of my very favourite places. On this particular day, the sky was very changeable and the sea at times seemed almost turquoise. I took lots of photographs and did some sketching, but it was the essence of being there that I took away with me and that made me want to interpret the images in the photographs into this scene.

The textured foreground is made up of crushed shells from the spot where I sat. I also added a few beads and really tiny whole shells. White ink was used to create the foam and splashes, and also the seagulls.

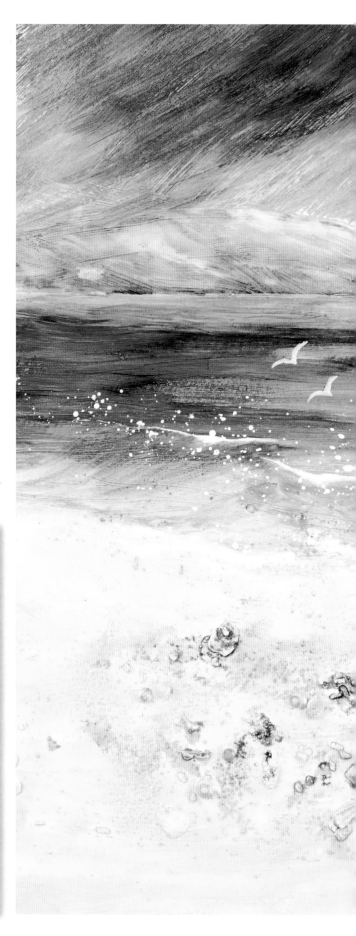

*The finished painting.*

## You will need

40 x 30cm (15¾ x 11⅞in) mount card

Watercolour paints: marine blue, cerulean blue, indigo, Naples yellow, sepia, burnt sienna, olive green

Brushes: 25mm (1in) hog hair, size 16 round, size 8 round, 10mm (⅜in) chisel brush, size 6 round, size 10 round, size 2 round

Inks: white

Large palette knife and gesso

Sand

Rock salt

Seashells – whole and crushed

Small square beads

Kitchen paper

Cocktail stick and tweezers

Ultra matt medium

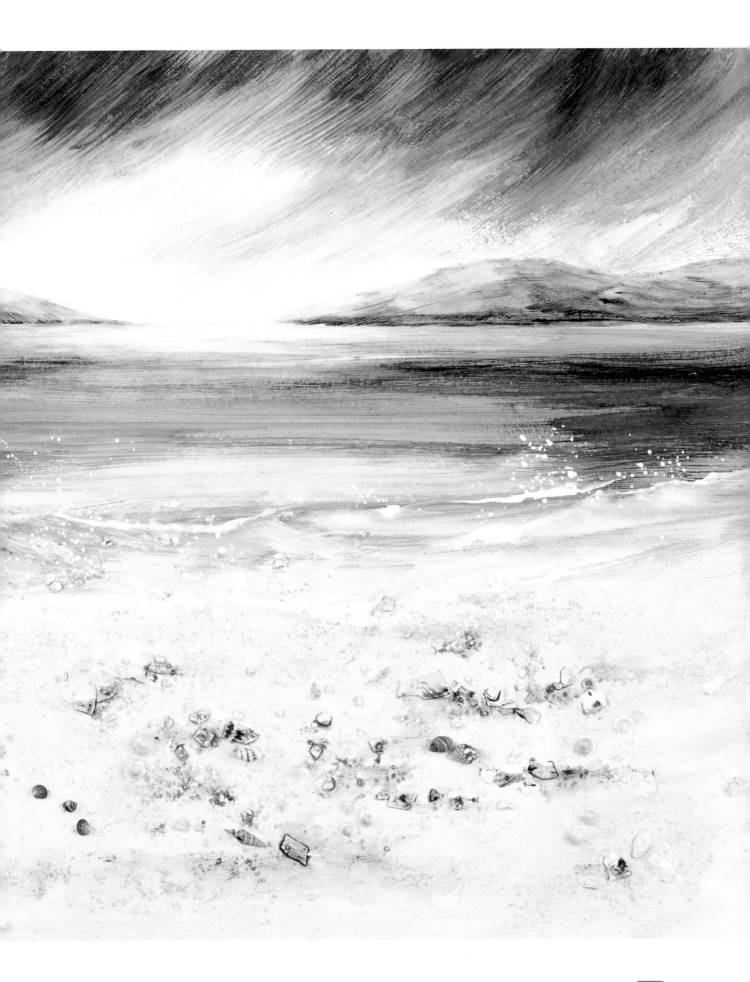

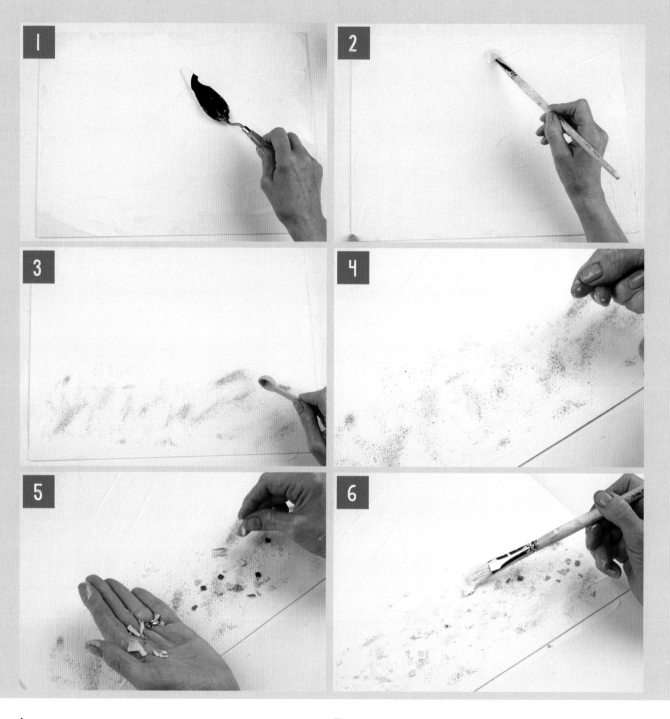

1   Use the large palette knife to cover the board with gesso.

2   Use the 25mm (1in) hog hair brush to spread the gesso out more evenly over the card, and make sure that it is completely covered.

3   Lightly sprinkle sand over the lower third of the painting, working fairly randomly.

4   Do the same with rock salt.

5   Add some fragments of seashell and square beads. Be more considered about the placement of these as they are larger and more obvious.

6   Cover all of the texture pieces (sand, salt, shells and beads) with gesso. The brush will move them around a little, so feel free to adjust the placement with your fingers.

**7** Using short sweeping strokes of the 25mm (1in) hog hair brush, suggest movement in the sky. Work from the top down towards the centre of the painting, as you will work over this area later.

**8** Roughly one-third of the way down from the top of the painting, suggest the texture of the distant headlands using the hog hair brush and choppier, almost horizontal strokes.

**9** Using long horizontal strokes of the brush that stretch right the way across the painting from one side to the other, draw the gesso into the suggestion of the surface of the distant sea. Start from just below the headlands to create a horizon line, and work towards the textured area (the beach).

**10** Towards the beach, curve the brushstrokes a little to suggest the waves at the beach edge.

**11** Allow the gesso to dry.

**12** Prepare wells of marine blue, cerulean blue, indigo, Naples yellow, sepia, burnt sienna and olive green. Use a size 16 brush to paint the beach in the foreground (from the bottom to just over one-third of the way up the painting) with Naples yellow.

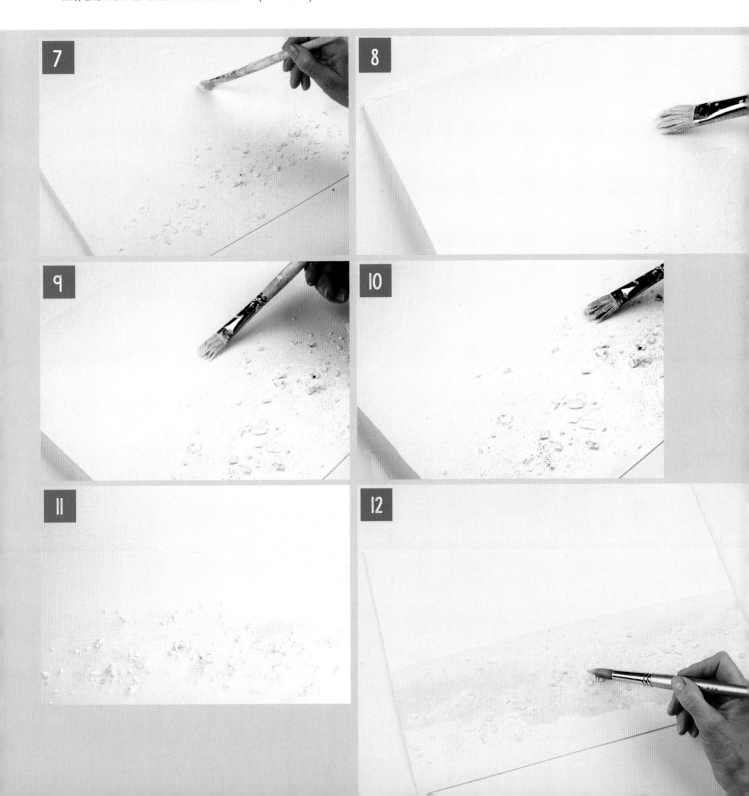

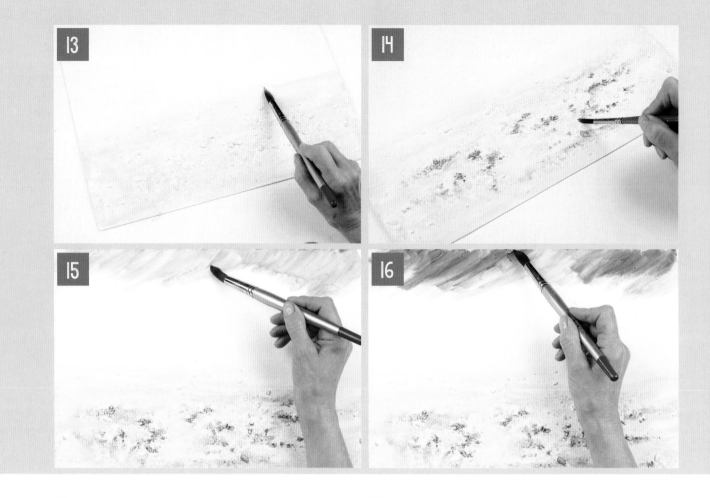

**13** Work in and around the shells and textured material to cover all of the white with Naples yellow. Use a stronger mix (i.e. less dilute) for the area closer to the bottom, and blend the top part of the beach into the background with clean water. This creates a smooth transition into the sea area.

**14** While the paint is wet, lift away some areas in the foreground with a damp brush to create some lighter areas and variation, then change to a size 8 brush to drop in touches of sepia and burnt sienna across the beach. Concentrate around the shells, and use slightly lighter mixes towards the sea and slightly stronger mixes towards the foreground. Allow the beach to dry.

**15** Use the size 16 brush to paint the sky area with cerulean blue, leaving white areas for clouds. Use the brush with sweeping movements, following the lines of the textured gesso.

**16** Working wet-in-wet, add marine blue into the upper part of the sky, leaving some areas of cerulean blue showing. Blend the areas of colour together.

**17** Still using the size 16 round brush, add in some small indigo areas at the very top of the sky, blending them in while the paint remains wet.

**18** Blend the colours together a little using a damp brush.

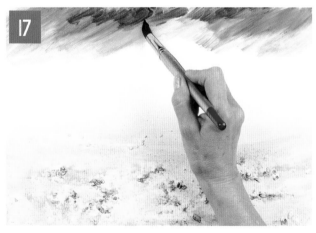

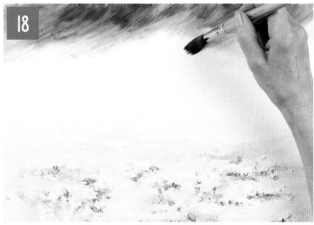

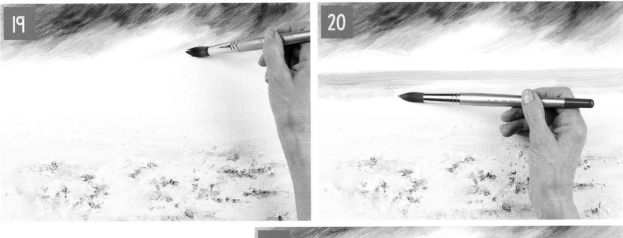

**19** As the paint begins to dry, draw the colour of the lower part of the sky down to the horizon.

**20** Starting at the horizon line, paint the distant sea using a wash of cerulean blue. Use long fluid brushstrokes from one side of the painting to the other, that follow the horizontal texture of the gesso. When you need to reload the brush, do not lift it away abruptly; instead take it away gradually, then start the brushstroke from the edge of the painting again.

**21** Towards the water's edge, add slightly more water, and work right over the top of the shoreline of the beach.

**22** Working wet-in-wet, add strokes of marine blue and indigo in the sea, again using long fluid brushstrokes to blend the colours together. Keep the indigo restricted to the sides; leave the centre of the sea lighter.

**23** While the paint remains wet, rinse the brush and blend the colours on the water's edge together. Follow the rolling shapes of the gesso.

**24** Dampen the 10mm (⅜in) chisel brush and use it to lift out a light area between the headlands. Be delicate when lifting out; the gesso surface will release the watercolour easily.

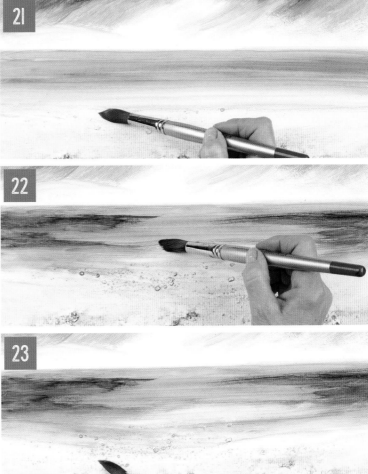

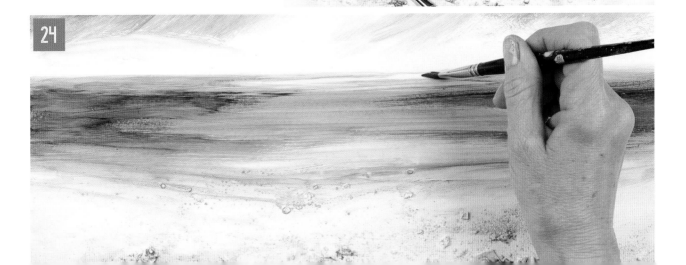

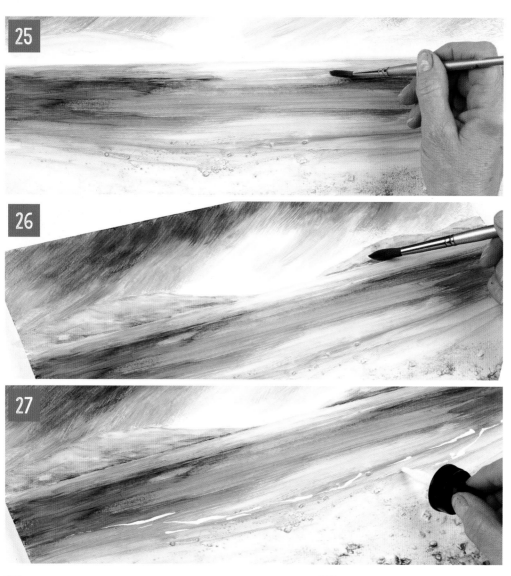

**25** Blend the edges of the highlighted area into the colour at the sides using a damp size 6 round brush.

**26** Change to the size 10 brush and use olive green to paint the distant hills on the horizon, blending in touches of a burnt sienna and French ultramarine mix for variety.

**27** Use the dropper of white ink to draw loosely horizontal marks across the lower part of the sea near the water's edge.

**28** Use a damp size 8 brush to blend the bottom of each of the ink lines downwards a little into the surrounding sea. Blend in a hint of marine blue to suggest cresting waves.

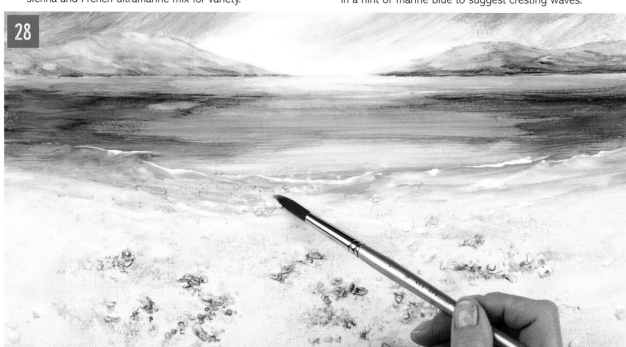

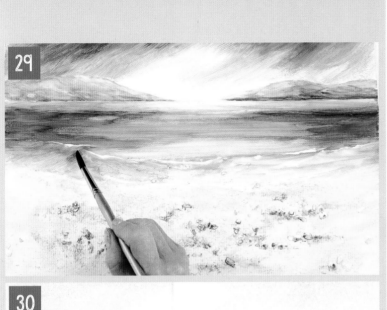

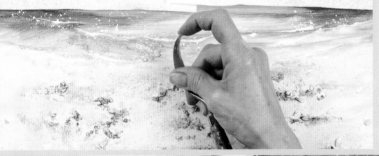

**29** Add a little more white ink on the very edge of the water and use a damp size 10 brush to blend in the colour in the same way. Build up a few of the waves with more diagonal strokes.

**30** Lay sheets of kitchen paper lightly over the top of the painting to protect the background sea and the whole of the sky, and then use the white ink and small palette knife to spatter the foreground waves.

**31** Remove the kitchen paper and use a size 2 brush to paint a small pair of seagulls on the left-hand side using pure white ink.

**32** To finish, use a cocktail stick and tweezers to attach a few tiny shells across the beach, securing them with acrylic matt medium. Do not add the shells randomly; look at the beach area and place them to complement the details and texture already in place. The finished painting can be seen on page 107.

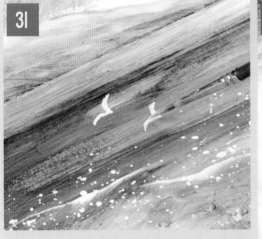

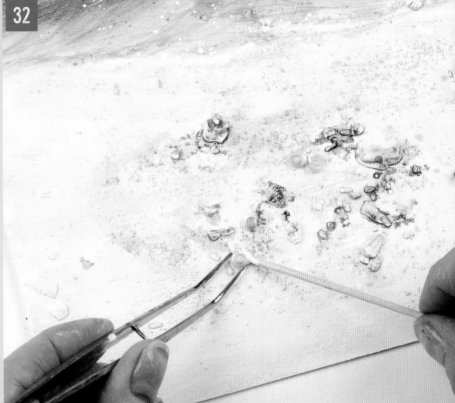

# CASTLE

This wonderful ruined castle dates back to the early fifteenth century, and was built by Sir William Hastings. It has lots of interesting features and is quite a complicated subject, so I have simplified it for this painting.

I have used the castle as a painting subject many times in many different guises as I happen to live in the lovely English town of Ashby-de-la-Zouch, where it is located. It is a perfect subject for collage work, and so this project will show you how to use gesso to add interesting effects in the background when watercolour is painted over the top. I also show how to use embossed wallpaper to suggest tree shapes and foreground markings.

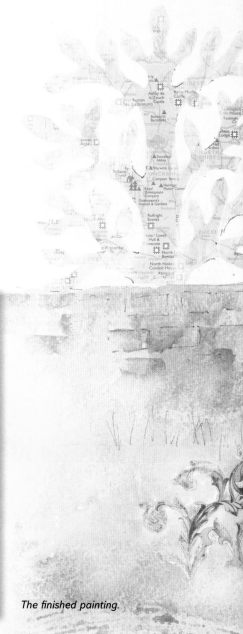

*The finished painting.*

## You will need

56 x 48cm (22 x 19in) 640gsm (300lb) Not surface watercolour paper

Watercolour paints: horizon blue, verditer blue, light red, French ultramarine, green-gold, raw sienna, cadmium yellow pale, burnt umber, cobalt green

Brushes: size 16 hog hair round, 37mm (1¼in) hog hair flat, large mop, size 8 round, size 16 round, size 0 rigger, size 12 round, size 10 round

2B pencil

Waterproof fine-tipped permanent black pen

Collage materials: papers themed to the piece, such as newspapers or local magazines, mediaeval-themed papers, maps of the area and fleur-de-lys paper; plus generic collage material such as textured wallpaper and decorative and floral papers

White glue and small old brush

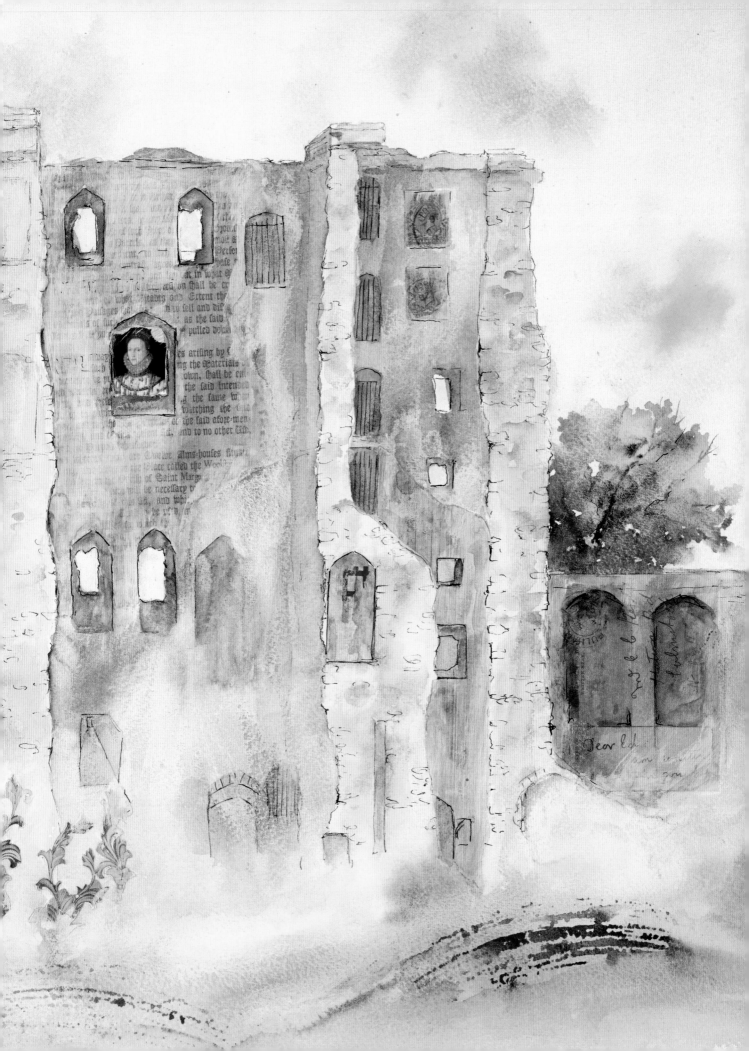

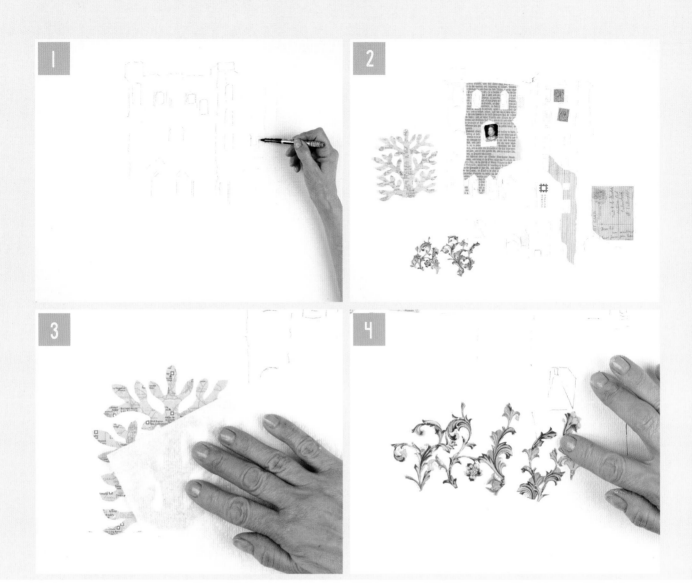

1 Sketch out the basic shapes of the castle on the paper using a 2B pencil, then use a waterproof fine-tipped black pen to lightly go over the lines. Use broken lines; you do not want them too strong or definite.

2 Position all of your collage material on the paper to check the placement. Adjust to your taste, adding some, taking some away or changing the materials and patterns. Once you are satisfied, put it all to one side.

3 Starting on the left-hand side, secure the tree collage material in place with white glue. Lightly lay a sheet of kitchen paper over it and rub over to ensure the tree is stuck down firmly, then remove the kitchen paper before it sticks.

4 Glue the backs of the fleur-de-lys floral pieces and secure them in the same way. Feel free to adjust the final placement if you change your mind.

## TIP
Small pieces of collage material like the fleur-de-lys used here can be delicate, particularly when wetted with glue. Use a small old brush and some diluted white glue to ensure they are stuck down firmly.

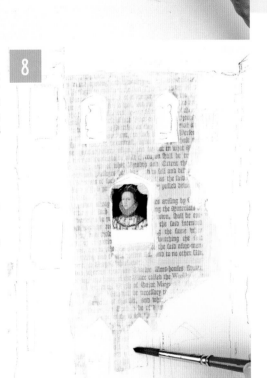

**5** Secure the main tower piece in the same way, then place the picture in the tower. Use white glue and the brush to stick down the delicate edges and small parts, as before.

**TIP**

Collage materials that have a connection to the piece, such as this image of Mary Queen of Scots (who stayed at Ashby castle) and the Tudor period style of the flowers and tree, can help to evoke the theme of the painting.

**6** Glue the rest of the collage material in place using white glue. Once you finish, double check that all of the edges of every piece are securely stuck down. Once dry, use a size 16 hog hair brush to apply some gesso over the tower, including some of the edges of the collage material to blend it into the background; also apply some hit-and-miss areas across the rest of the watercolour paper surface. Use a mixture of strokes – some larger, sweeping strokes alongside smaller, more considered areas.

**7** Work gesso over the rest of the painting in the same way, being sure to leave some areas – both collage and clean paper – uncovered. Leave most of the bright floral area showing. For the very large strokes in the background and sky, use an old 37mm (1¼in) flat hog hair brush. Leave the painting to dry.

**8** Use a large mop brush to wet the sky area with clean water, then change to a size 8 brush to wet carefully inside each of the windows.

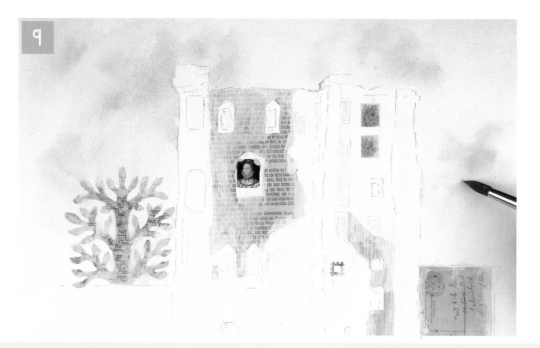

9 Prepare wells of horizon blue and verditer blue and paint the two colours across the sky area using the size 16 round brush. Work loosely, leaving some gaps as shown.

10 Change back to the size 8 brush and paint in the sky showing through the windows of the ruin. Let the painting dry completely before continuing.

11 Prepare the following wells of pure colours: raw sienna and burnt umber. Next, prepare a well of a shadow grey mix of light red and French ultramarine; and a split well with French ultramarine on one side and green-gold on the other. With this well, you will be able to take out the pure colour from one side, or a mix of the two from the centre.

12 Use a size 16 brush to wet the bottom part of the painting (the garden and low walls) and the light areas of the castle. Still using the size 16 brush, pick up raw sienna and paint in the light areas of the castle. Draw the colour over to the low wall on the right-hand side. Change to the size 8 brush and drop in burnt sienna here and there across the sunlit areas.

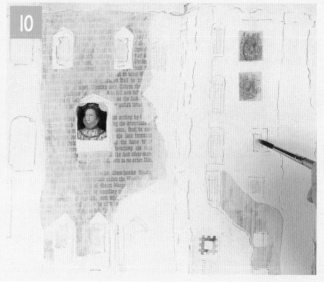

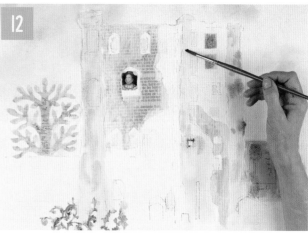

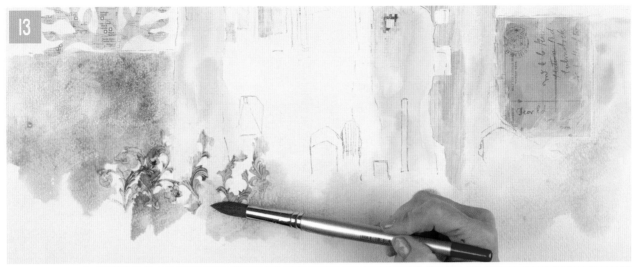

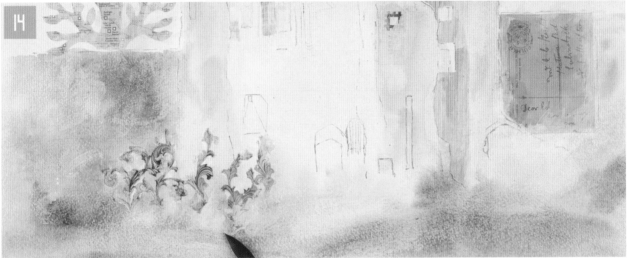

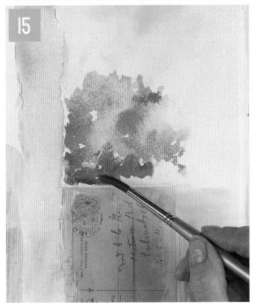

13 Still using the size 8 round brush, paint the low wall on the left-hand side using the shadow grey mix (light red and French ultramarine). Working quickly, pick up green-gold from the green-blue well and paint across the garden, letting the colour bleed up into the lower parts of the wall.

14 Without rinsing the brush, work French ultramarine from the green-blue well into the bottom of the garden area wet-in-wet, then blend the colours together across the garden using sweeping, horizontal strokes and allow to dry.

15 Prepare a split green well (see step 11) of cadmium yellow pale and French ultramarine, and a dark mix of burnt umber and French ultramarine. Pick up a little of the green mix on a size 8 round brush, emphasising the yellow side of the split well, and paint in a small tree on the right-hand side. Use the side of the brush to create a broken foliage effect. Pick up more of the green mix, this time from the blue side, to paint in the shadow area wet-in-wet. Leave a few small gaps of the background peeping through, as shown.

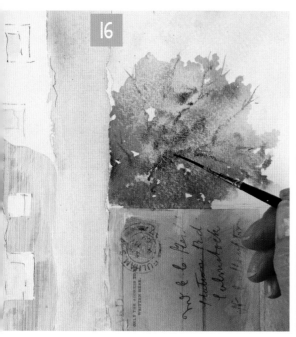

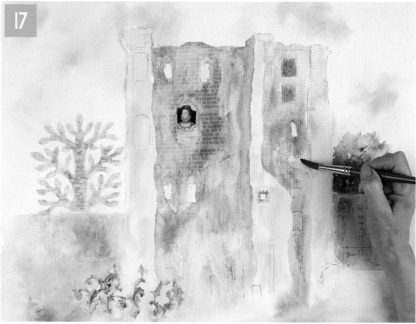

16 Allow the paint to dry a little, then pick up some of the dark mix on a size 0 rigger and use it to draw some broken lines as branches. Draw the branches up from where the trunk would be, which is slightly off-centre behind the wall.

17 Change to the size 12 brush and use the shadow grey mix (light red and French ultramarine) to paint in the darker areas of the castle. Paint straight on to the dry surface; this gives you more control. Use the tip to paint round the windows, and use the body of the brush in larger areas. Pick up more light red or more French ultramarine to vary the mix as you cover the area, and blend it away into the green area using clean water towards the bottom. Be sure not to paint round the collage areas or the underlying drawing; the aim is to blend the different parts of the surface (paper, collage, gesso) together into a coherent whole. Add some cobalt green touches across the wet shadow areas.

18 Paint the low wall on the right-hand side with the same mix and techniques, again blending it away into the green with clean water and adding cobalt green for interest. Next, change to a size 10 brush and use the shadow grey mix to paint the suggestion of some brick shapes on the left-hand low wall.

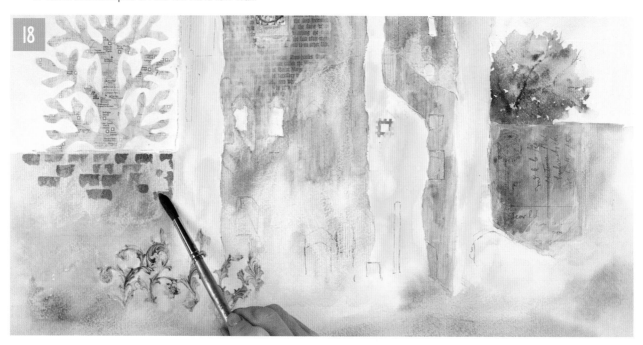

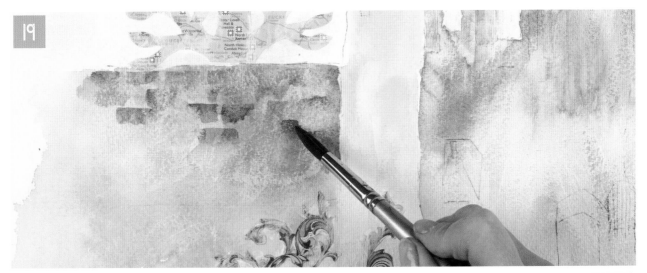

**19** Wet the brush, remove excess water, and use the damp tip to soften the edges of the shapes into the wall a little.

**20** Using the same brush, mix and techniques, add shadows across the sunlit area on the left-hand side of the main tower. In the recesses, keep the shadows on the left and blend them away to the right to show the direction of light.

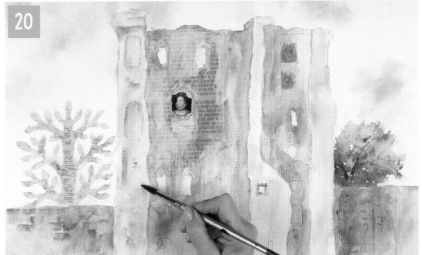

**21** Continue adding shadows across the painting. As you work, vary the hue by picking up more or less light red and French ultramarine, and vary the tone by picking up more or less water. This creates more natural-looking shadow, with the deeper recesses and details darker and bluer. Allow the area to dry, then go back and reinforce some smaller areas, such as around the windows by glazing the same mix over the areas in shadow. Use the tip of the brush to add the colour so you have more control. Keep the direction of light in mind as you work to help you work out where to put the shadows.

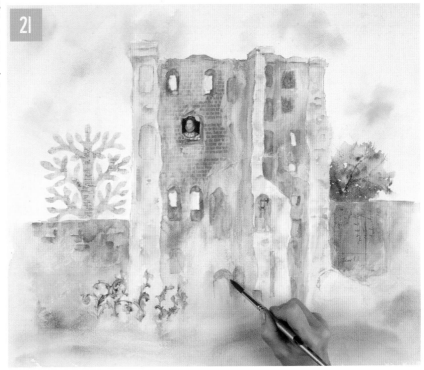

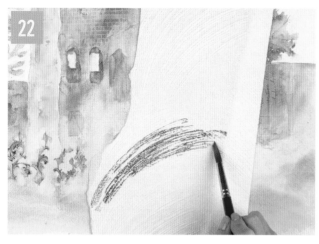 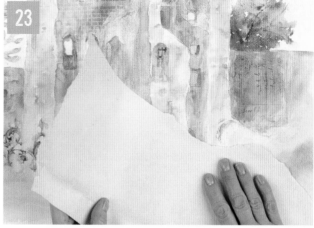

**22** Allow the painting to dry completely. Lightly paint a section of the textured wallpaper using the size 12 brush and the split green well (French ultramarine and green-gold).

**23** Turn the paper over and lightly press the wet section on to the garden to leave a print.

**24** Soften the print in a little using clean water, then repeat here and there over the rest of the garden. Keep the effect subtle – less is more.

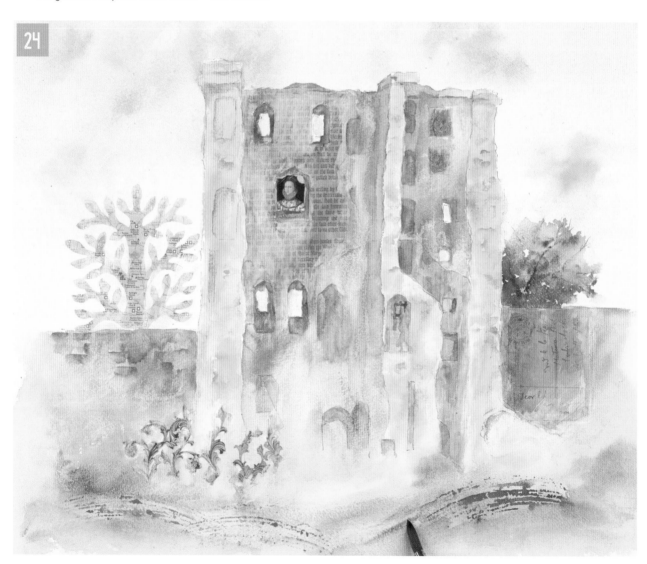

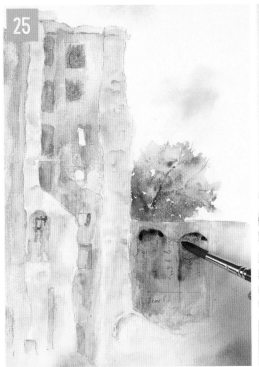

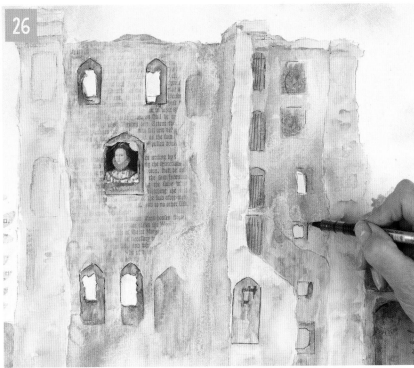

**25** Darken the arches on the right-hand side of the painting using the shadow grey mix (light red and French ultramarine) and the size 12 brush, then let the painting dry completely.

**26** Use a fine permanent black pen to pick out some of the important details across the painting, such as the railings, the windows and the arches.

**27** Keeping the marks light and loose, work across the rest of the painting with the pen, adding the suggestion of texture on the brickwork.

**28** Once you have added the penwork, you may feel that some areas need knocking back or otherwise adjusting. Here I have used a little of the shadow grey mix to darken the ground-level door, and added a few more pen marks. The finished artwork can be seen on pages 114–155.

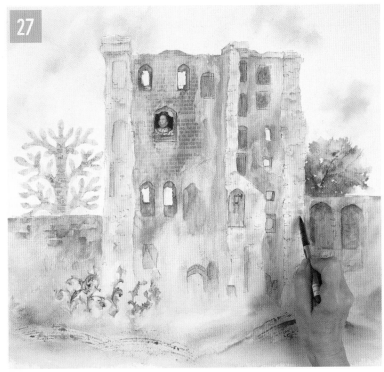

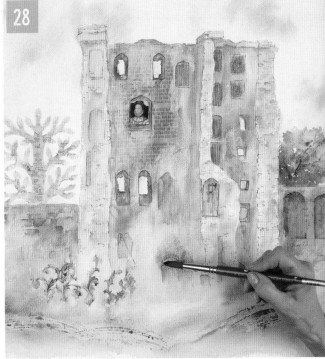

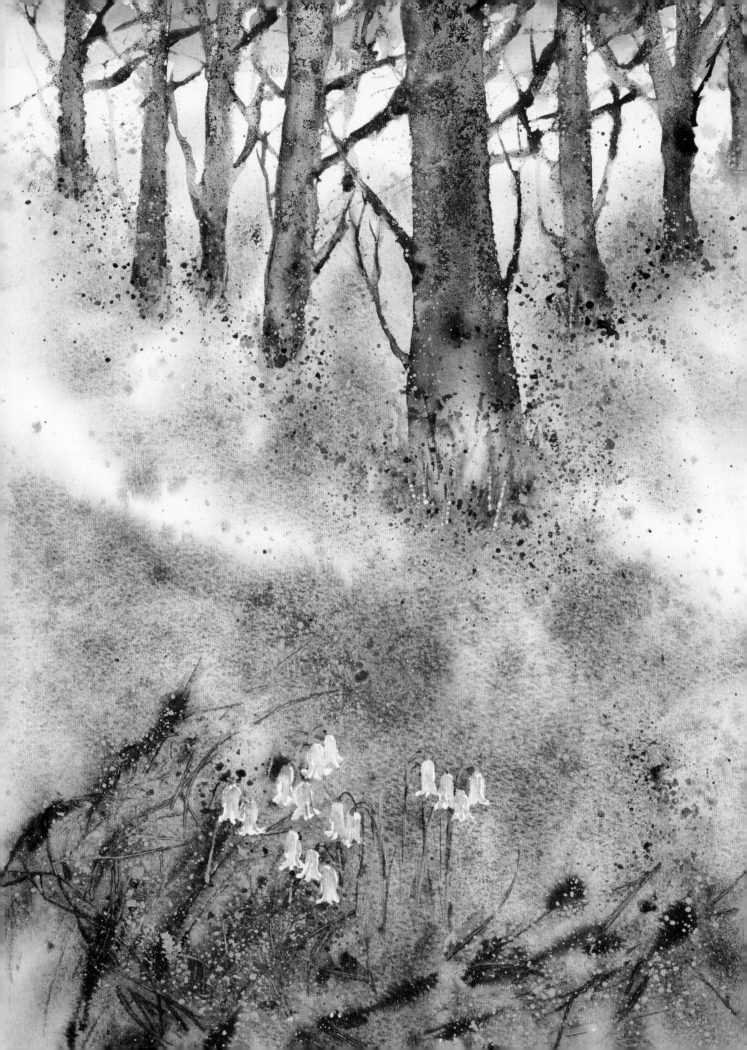

# BLUEBELL WOOD

The first glimpse of the lovely colour of bluebells, sometimes unexpectedly, is always a delight. To walk through a wood carpeted by bluebells is one of the joys of the English springtime. The colours can be especially surprising – sometimes they look blue and other times they appear purple.

  In this painting we explore masking out a few of the bluebells in the foreground, and concentrate on the carpet appearance of the remainder through soft watercolour and spattering. Ink and granulation medium are used to capture the tangled branches and interesting textures of the trees.

*Opposite:*
*The finished painting.*

## You will need

28 x 38cm (11 x 15in) 640gsm (300lb) Not surface watercolour paper

Watercolour paints: cobalt blue, cobalt violet, green-gold, French ultramarine, Winsor yellow, lemon yellow, burnt sienna

Brushes: size 12 round, size 5 round, size 4 round, size 16 round, size 8 round, size 6 round

Inks: sepia, antelope brown

Gouache paint: linden green

2B pencil

Masking fluid and old brush

Kitchen paper

Granulation medium and pipette

Palette knife

Baking parchment

Small sponge

Cotton thread and scissors

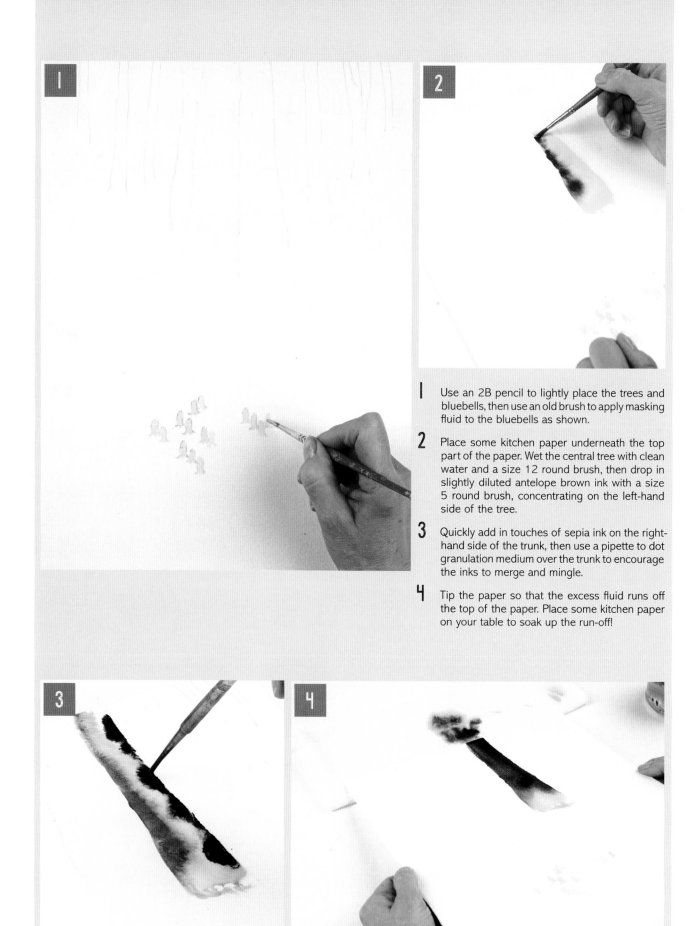

1. Use an 2B pencil to lightly place the trees and bluebells, then use an old brush to apply masking fluid to the bluebells as shown.

2. Place some kitchen paper underneath the top part of the paper. Wet the central tree with clean water and a size 12 round brush, then drop in slightly diluted antelope brown ink with a size 5 round brush, concentrating on the left-hand side of the tree.

3. Quickly add in touches of sepia ink on the right-hand side of the trunk, then use a pipette to dot granulation medium over the trunk to encourage the inks to merge and mingle.

4. Tip the paper so that the excess fluid runs off the top of the paper. Place some kitchen paper on your table to soak up the run-off!

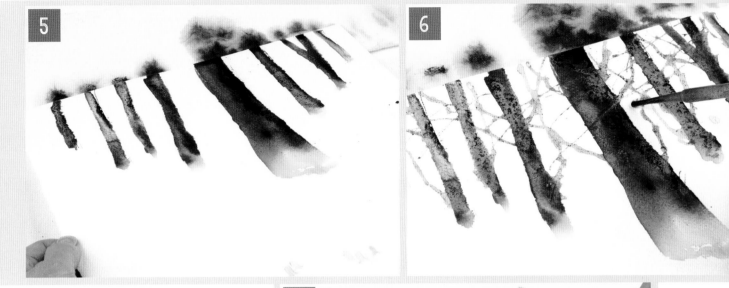

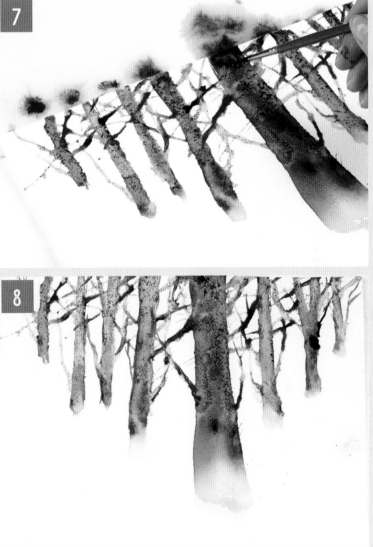

5  Lay the paper flat and paint the rest of the trees in the same way.

6  Tip the paper to remove excess ink, lay the paper flat, then use the pipette to draw lines of granulating fluid to represent branches and encourage the ink to flow into these branches.

7  While the painting is wet, add some of the diluted antelope brown ink into the branches. Use a size 4 brush so you have a little more control. Add a few touches of the sepia ink, too, but keep these subtle.

8  Rinse the brush and use clean water to blend away the bottom of the trees where possible, then allow the painting to dry.

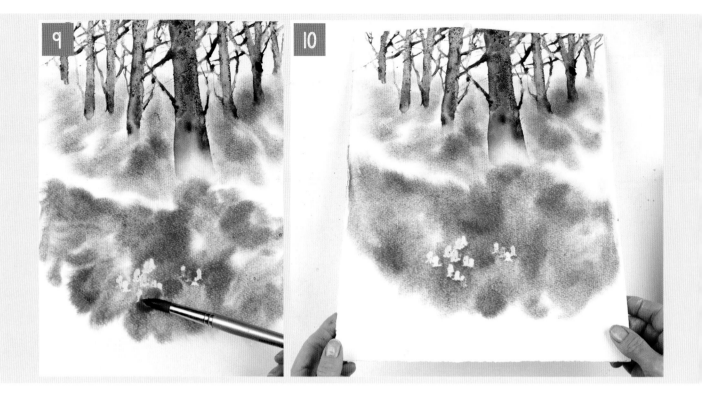

**9**  Wet the whole paper using a large mop brush, then lay in a variegated wash of cobalt blue and cobalt violet using a size 16 round brush. Start from the bases of the background trees and work down to the bottom of the paper. Strengthen the colours towards the foreground (the bottom of the painting).

**10**  Tip the painting away from you to let the colours bleed upwards a little.

**11**  While the paint remains wet, make a mix of green-gold and French ultramarine and use a size 8 brush to add it around the very bottom of the painting. Draw it out a little to suggest grasses.

**12**  Use the dropper to add a few small touches of sepia ink in the foreground.

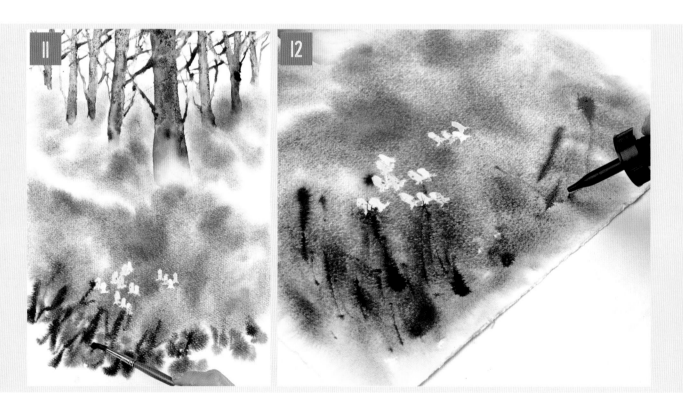

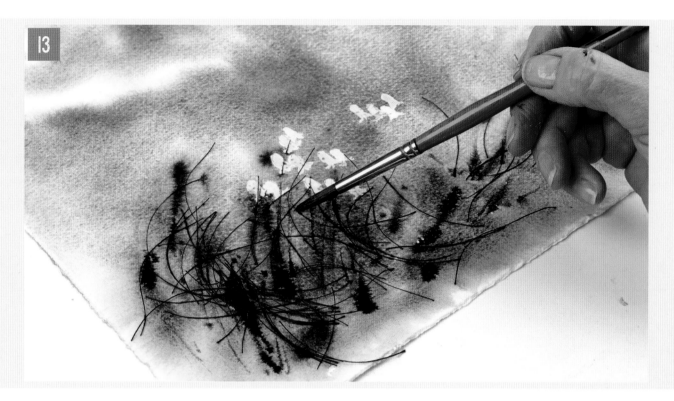

**13** Add short strands of dry cotton thread to the wet foreground area, laying them down mostly almost vertically, so that they represent grasses. Next, load the size 8 brush with green-gold and touch it lightly to the threads so that they lie flat.

**14** When the sheen goes from the wash as it starts to dry a little, spatter the whole area with cobalt blue using the palette knife and a size 6 brush. Add some cobalt violet to the mix and spatter the foreground only. Spatter more heavily in this area to create larger blobs.

**15** Lay a sheet of baking parchment over the cotton threads and press down to make sure they all lie flat. Allow the painting to dry completely before continuing.

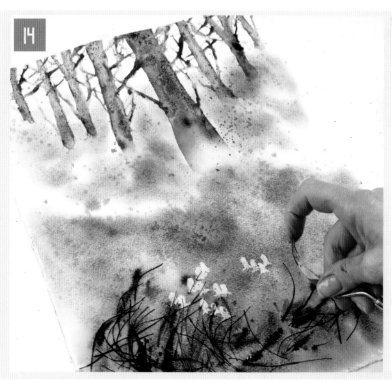

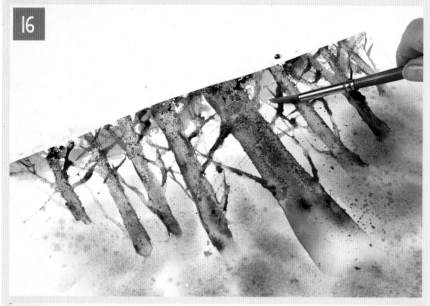

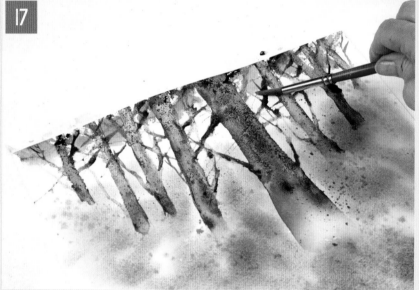

**16** Use the size 8 round brush to paint the woodland canopy using green-gold paint on the dry surface of the top of the paper. Leave a space of clean white paper between the canopy and the top of the blue-purple wash. Working wet-in-wet, add French ultramarine at the top of the green area and Winsor yellow at the bottom.

**17** Wet a few of the background trees and knock them back a little using touches of the cobalt violet and cobalt blue mix.

**18** Use the tip of the size 8 round to add short vertical strokes of green-gold at the base of each tree. Use longer strokes for the main foreground tree.

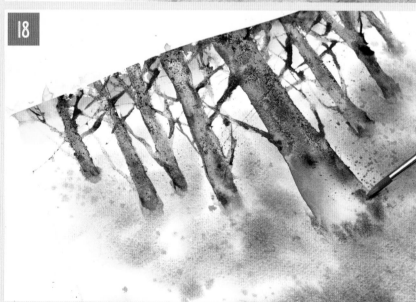

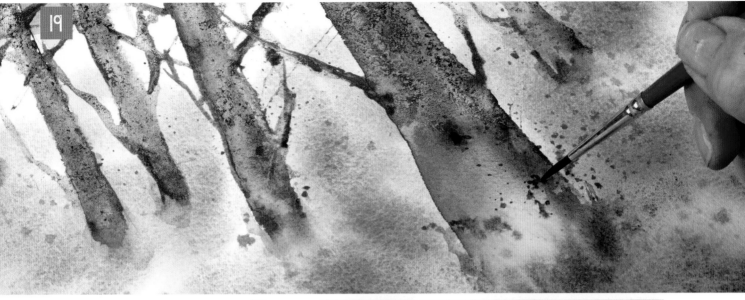

**19** Change to the size 4 brush and use the very tip along with the cobalt blue and cobalt violet mix to touch in some distant bluebell flower heads at the base of the bases of the trees.

**20** Dampen a small sponge and dip it directly into a pan of lemon yellow. Touch this lightly across the canopy and bases of the trees to add some lighter green areas; then repeat the process with the prepared well of green-gold.

**21** Use a size 4 brush to add a few branches to the foreground tree with a dark mix of French ultramarine and burnt sienna; and then add a few darker stems to the bases of the trees with green-gold and touches of French ultramarine.

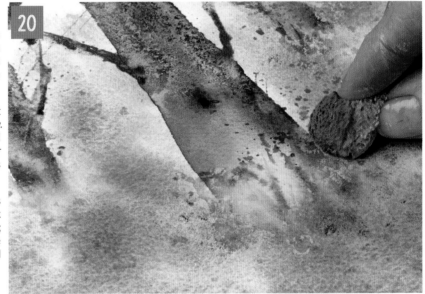

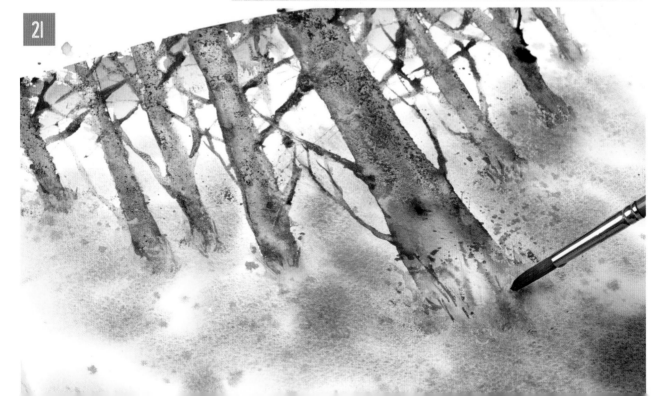

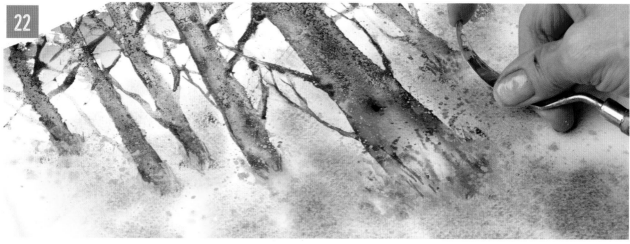

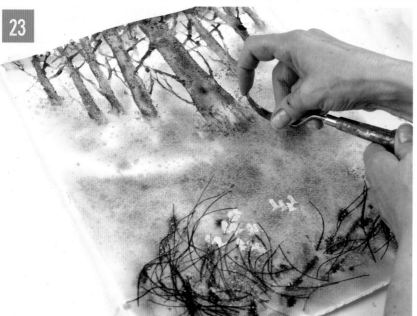

**22** Lightly spatter slightly diluted linden green gouache over the bases of the background trees and the canopy using the small palette knife.

**23** Spatter the foreground area with the same colour and technique, then spatter the bases of the trees using the cobalt violet and cobalt blue mix.

**24** Allow the painting to dry completely, then carefully brush away the cotton threads with clean dry fingers.

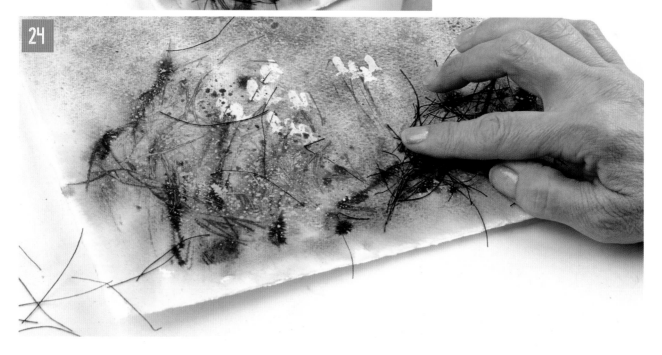

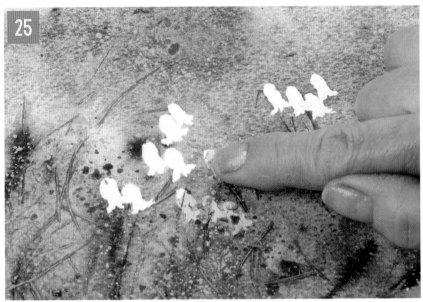

**25** Remove the masking fluid from the foreground bluebells by rubbing it away with a clean dry finger.

**26** Use the tip of the size 4 round to paint the individual bluebells one by one using cobalt blue with a little cobalt violet added. Leave some gaps for highlights and ridges.

**27** Add stems to the foreground bluebells using a mix of green-gold and French ultramarine; then add highlights with linden green gouache to finish. The completed painting is shown on page 124.

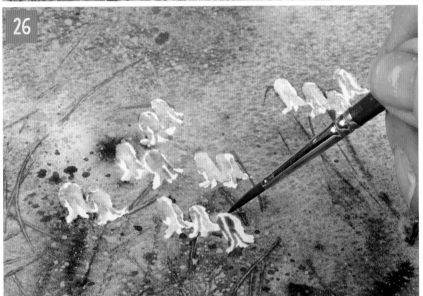

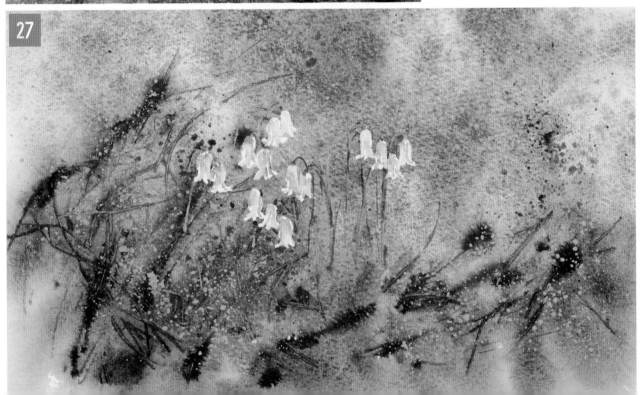

## MOORLAND

In my experience the weather conditions in Derbyshire, where I live, can be extremely variable. On one particular day when I was out walking, it was bright sunshine but we were suddenly enveloped by a thick mist. This created an eerie atmosphere of spooky, damp isolation and was quite disorientating and scary for a time. Half an hour later, there were blue skies again.

This experience inspired the painting on the following pages; a semi-abstract landscape interpretation of that experience.

In this project, I use a really sparkly blue for the sky and sepia ink on the rocky incline, and by adding granulation medium we can create the effect that the mist and some water are running down the hillside.

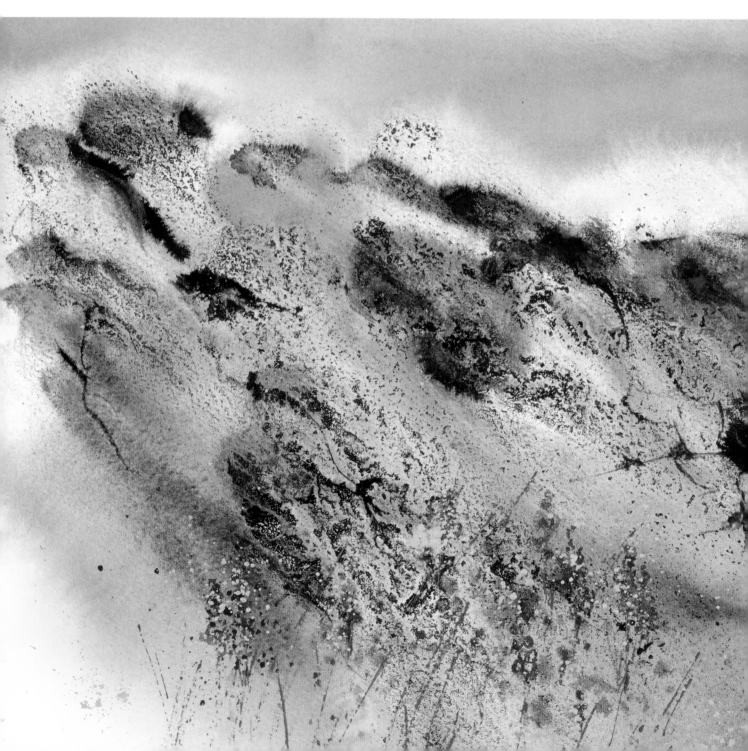

## You will need

56 x 28cm (22 x 11in) 640gsm (300lb) Not surface watercolour paper

Brushes: large mop, size 16 round, size 8 round, size 12 round, size 8 hog hair round, size 2 round

Watercolour paints: iridescent electric blue, green-gold, French ultramarine, quinacridone magenta

Inks: sepia, white

Watercolour pencil: ivory black 67

Gouache paints: zinc white

Granulation medium and pipette

Kitchen paper

Small palette knife

Green contour medium

*The finished painting.*

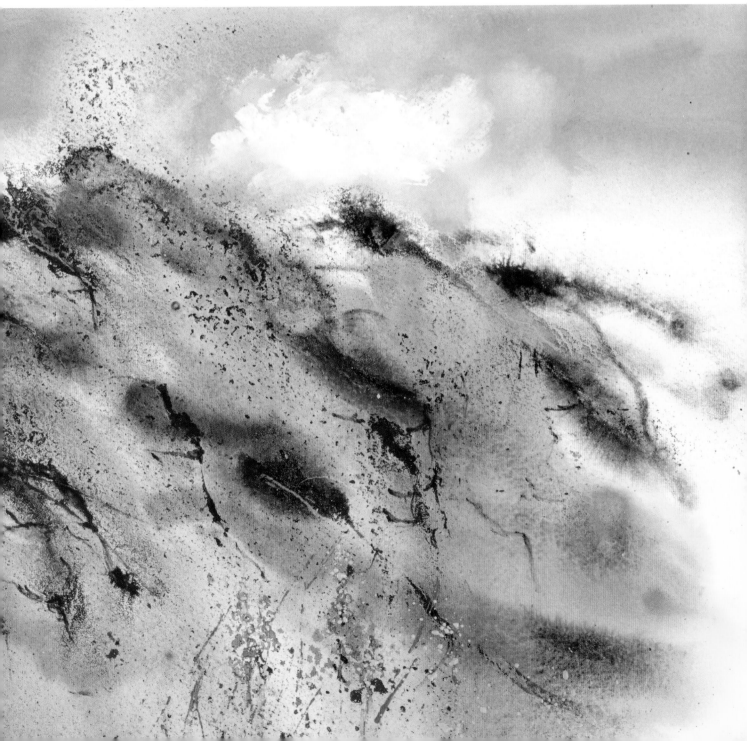

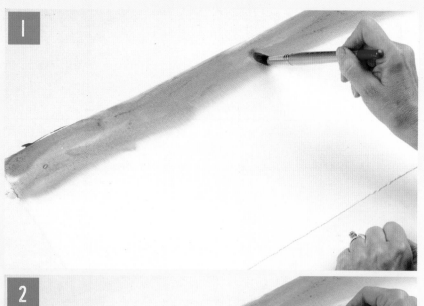

1 Use the mop brush to wet the whole piece of paper with clean water, then paint iridescent electric blue across the top third using a size 16 brush.

2 Add in strokes of sepia ink here and there in the central third to represent rock formations, using the tip of the dropper and drawing the ink in roughly horizontal lines.

3 Add colour to the middle third of the paper using a mix of green-gold and French ultramarine, applying the paint with a size 16 brush, and dabbing it in around the ink rock formations.

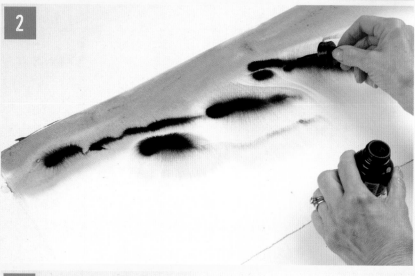

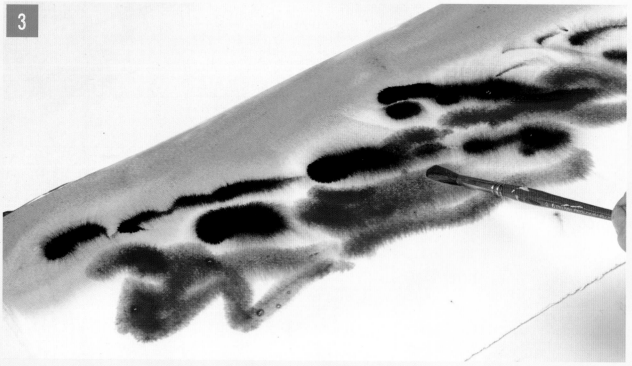

**4** Use a pipette to drop granulation medium into the areas of ink, applying enough that it runs and bleeds into the other colours.

**5** Tip the painting up and slightly to the right to allow the wet paint and medium to bleed downwards and to the right, in order to suggest diagonal rivulets.

**6** Break up the ink still further by adding more granulation medium while you tip the painting.

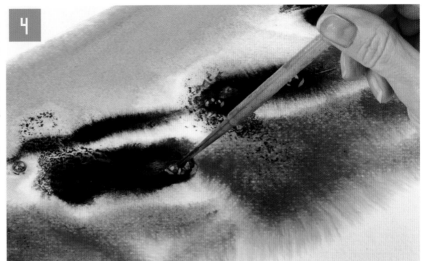

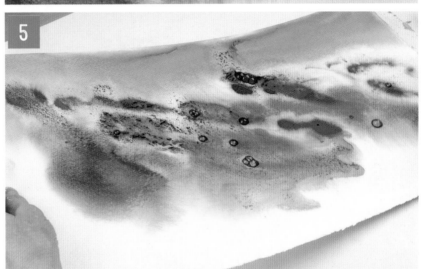

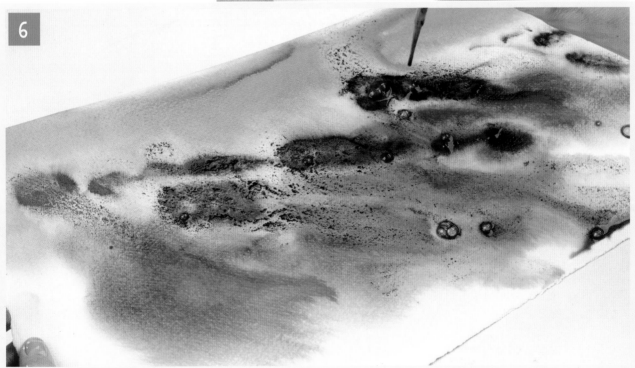

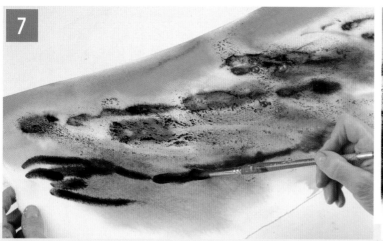

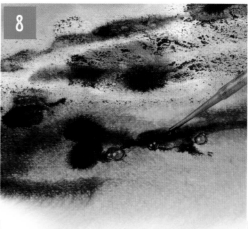

7 Use a size 16 brush to pick up more of the green-gold and French ultramarine mix, emphasising the French ultramarine; and use this to add sweeping strokes where needed to suggest the contours of the landscape.

8 Use a pipette to add more sepia ink and granulation medium to strengthen areas and add texture to them, if needed.

9 Tilt the paper upwards and slightly to the right, mopping up the excess paint that runs to the bottom using kitchen paper.

10 Fill any holes in the moorland with green-gold and French ultramarine mix, applying the paint with the size 16 brush.

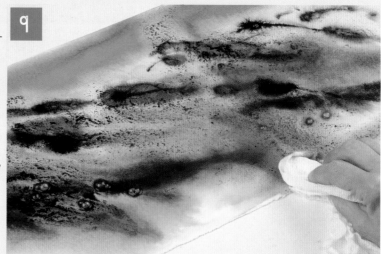

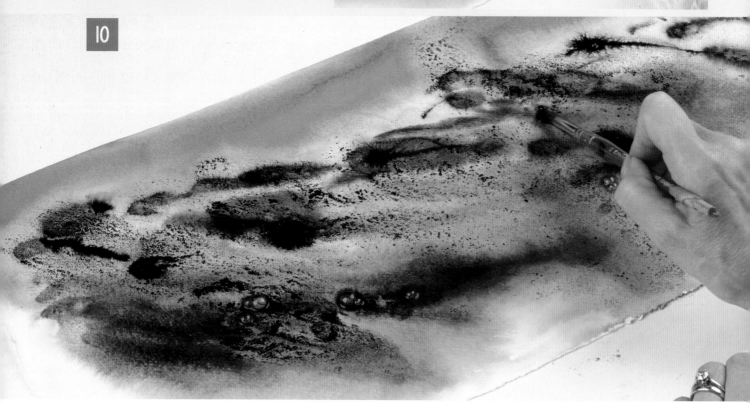

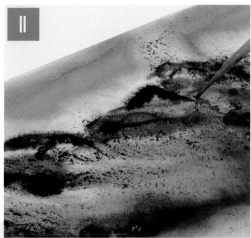

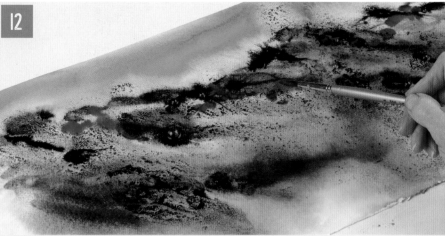

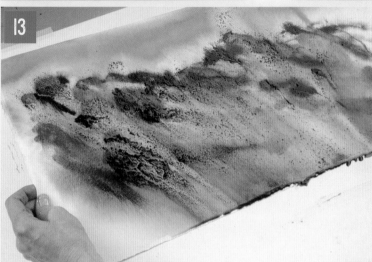

11  Add a few more touches of ink, and as before, drop in some granulation medium using the pipette. Be a little more deliberate when adding the ink to ensure you are creating more controlled and realistic rock formations.

12  Use a size 8 brush to add some iridescent electric blue touches in the middle third of the painting, then add some granulation medium over the blue areas. Add the paint and medium across the painting where the colours are running.

13  Tip the painting up and to the right to encourage the blue to merge into the midground.

14  If any areas on the hill come out too blue, add a little more ink and granulation medium.

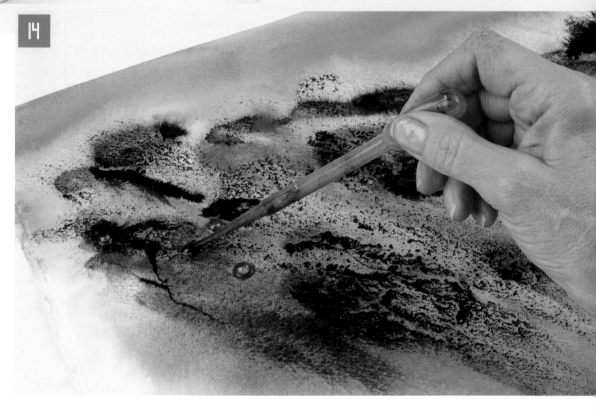

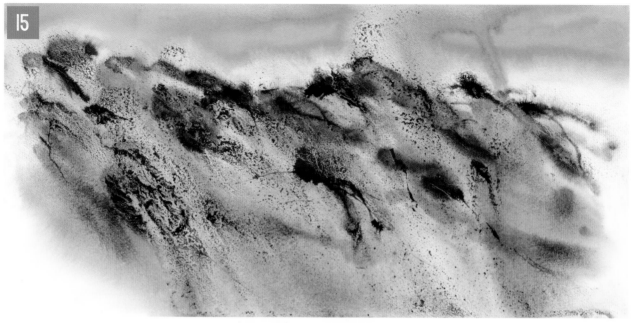

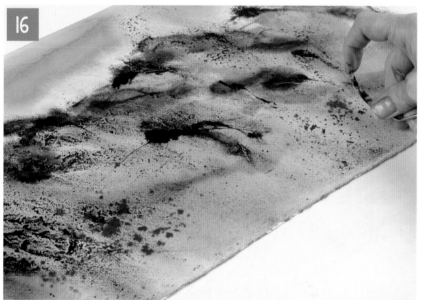

**15** Tip the painting once more to encourage the colours to run down towards the lower right-hand corner, then lay the painting flat and allow it to dry until it is only slightly damp.

**16** While the paint is drying, add the suggestion of foxgloves by using the small palette knife to spatter (see pages 58–59) quinacridone magenta over the green area of the painting, mainly on the lower left-hand side, and with just a little on the right.

**17** While the painting is still damp, use an ivory black watercolour pencil to draw some simple fine lines to suggest rock formations and add some shape to the ink. Add them sparingly; do not overpower the painting, and make sure they mostly run towards the lower right-hand corner.

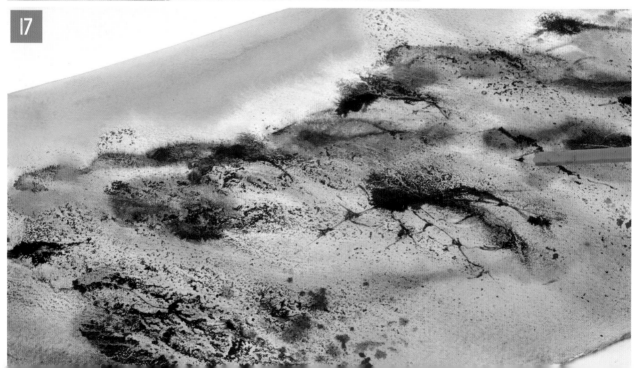

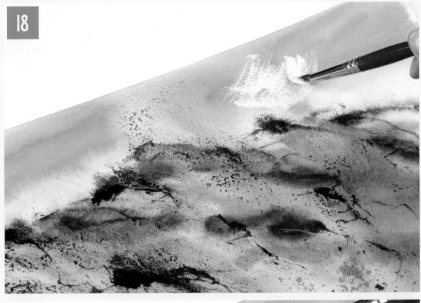

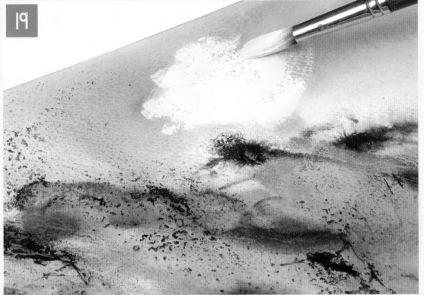

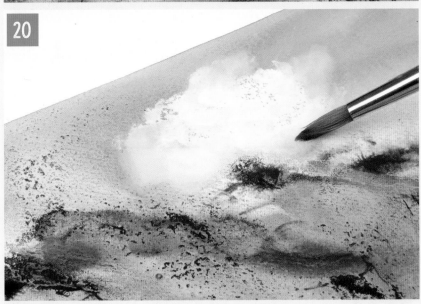

18 Use slightly diluted zinc white gouache to start adding clouds in the sky, applying the paint with light strokes of a size 12 brush.

19 The wet gouache will lift a little of the underlying blue and soften it into the background. For highlights on the cloud, use overlaying strokes of pure white to build up a variety of hues.

20 Rinse the brush, remove excess water, and use the damp brush to blend the paint in a little around the hillside.

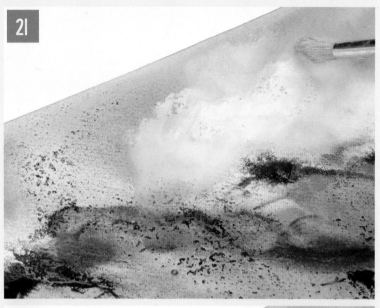

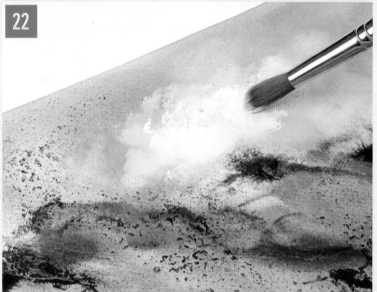

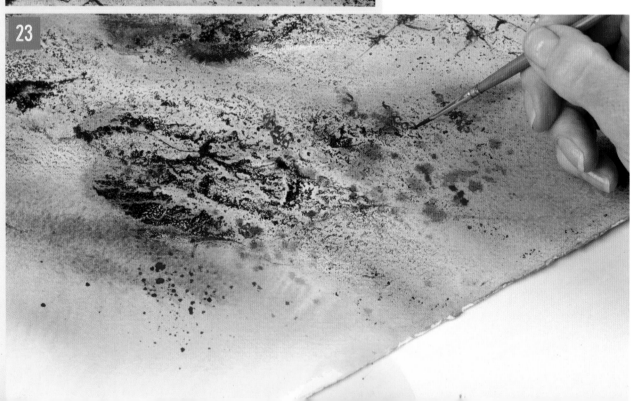

**21** Change to a dry size 8 hog hair brush and use it to lightly feather the paint away from the edge of the cloud into the surrounding sky.

**22** Pick up some more white gouache on the size 12 brush and re-establish some more textured highlights on the cloud.

**23** Use a size 2 brush to add quinacridone magenta around the spattered areas to develop the suggested foxgloves a little.

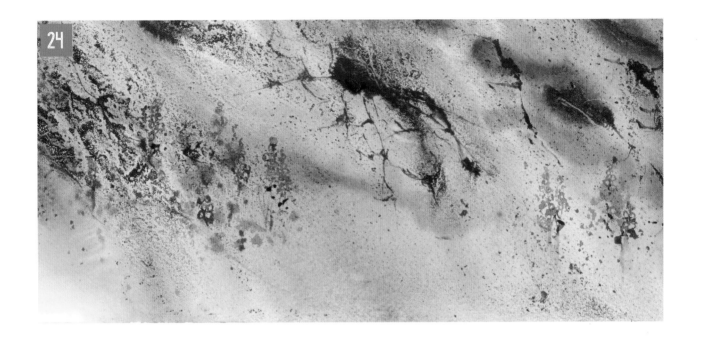

**24** Continue developing the foxgloves over the rest of the painting, then add a few stems using the mix of green-gold and French ultramarine and the size 2 brush.

**25** Allow the painting to dry completely; then use green contour medium to add some stems and fresh spring grasses to the foreground.

**26** To finish, mix quinacridone magenta into white ink to make a pale opaque pink, then use the small palette knife to spatter it lightly over the foreground, concentrating on the foxglove areas. The finished painting can be seen on pages 134–135.

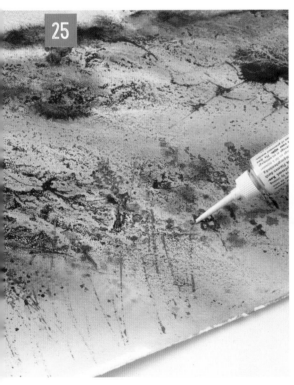

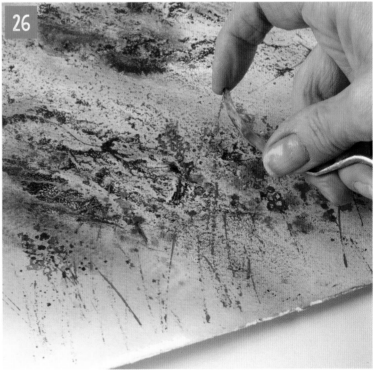

# INDEX